MW01485678

FLIGHTS OF PASSAGE

An *illustrated* natural history of bird migration

Mike Unwin and David Tipling

FLIGHTS OF PASSAGE

An *illustrated* natural
history of bird migration

Mike Unwin and David Tipling

Yale UNIVERSITY PRESS

New Haven and London

© 2020 White Lion Publishing
All rights reserved

This book may not be reproduced, in whole or in part, including illustrations, in any form (beyond that copying permitted by Sections 107 and 108 of the U.S. Copyright Law and except by reviewers for the public press), without written permission from the publishers.

Published in association with
Yale University Press
P.O. Box 209040
New Haven, CT 06520-9040
yalebooks.com

This book was designed and produced by
White Lion Publishing
The Old Brewery
6 Blundell Street
London N7 9BH

Senior Editor	Michael Brunström
Designer	Paileen Currie
Editor	David Callahan
Production Manager	Rohana Yusof
Editorial Director	Jennifer Barr
Publisher	Philip Cooper

Color reproduction by Alta Image
Printed in Singapore

ISBN 978-0-300-24744-2

Library of Congress Control Number: 2019954693

10 9 8 7 6 5 4 3 2 1

PAGE 1 An Atlantic Puffin with a beakful of fish on Inner Farne, Northumberland.

PREVIOUS A pair of Turtle Doves take to the air. Like many Afro-Palearctic migrants, this species is today in steep decline.

RIGHT Barnacle Geese gather on arable fields in the Solway Firth, Scotland, after a long flight south from Svalbard, in the Norwegian Arctic.

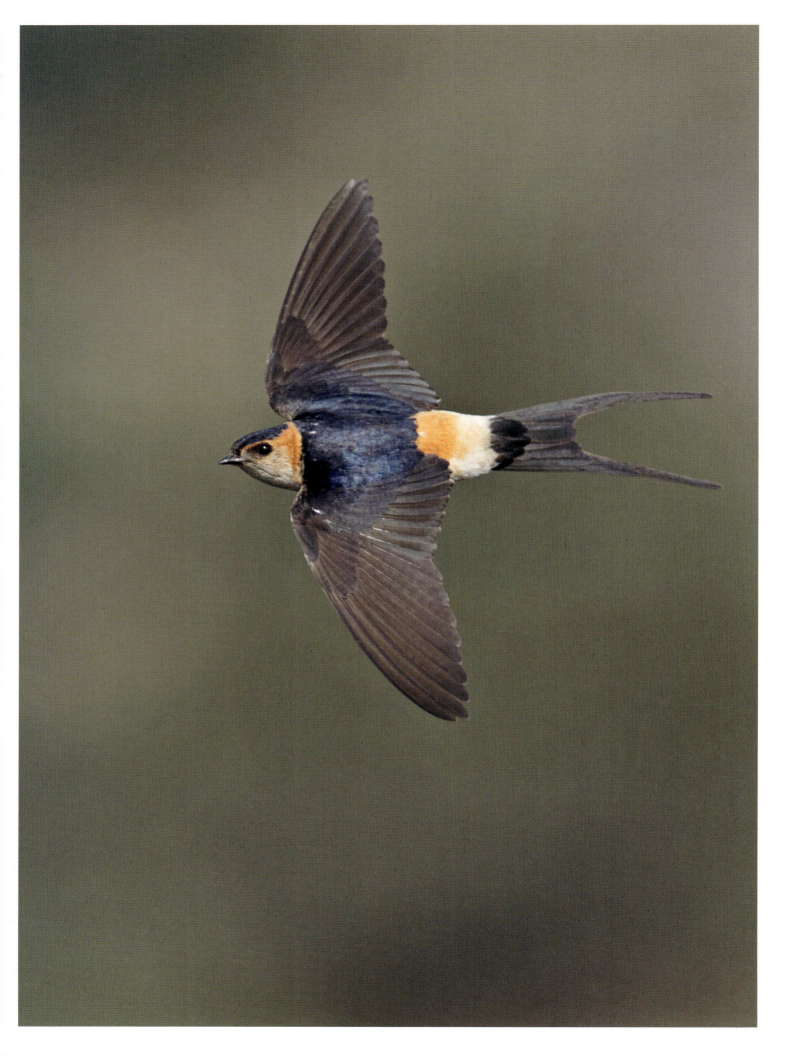

CONTENTS

OPPOSITE A Red-rumped Swallow flies by day, feeding on the wing, as it migrates from southern Europe to tropical Africa.

OVERLEAF The diminutive Wilson's Storm-petrel rides out the wildest seas as it journeys around the world's oceans.

THE MIRACLE OF MIGRATION

A BLIZZARD OF Short-tailed Shearwaters streams over an Arctic swell off the coast of northeast Russia, massing by the thousand for their return journey to New Zealand; silver-gray Montagu's Harriers, fresh from the Asian steppes, quarter the Serengeti savannah amid munching herds of wildebeest; a scattering of newly minted American warblers—Magnolia, Yellow, Chestnut-sided—flit like living jewels through the bushes of a Texas parking lot, having just crossed the Gulf of Mexico.

Few things in the animal world stir the imagination quite like bird migration—and, like many people, I have my own store of memorable experiences. But you needn't travel to exotic places to witness such marvels—as I write this on a blustery October day in a busy town on the south coast of England, Barn Swallows are passing over my house: birds that weigh less than a AA battery, embarking on a journey that may take them as far as Cape Town, South Africa. And this evening, if the skies are clear and I step outside just after dark, I may hear the thin *tseep, tseep* of Redwings—thrushes from Scandinavia, arriving off the sea to spend winter here, just as the swallows are departing for warmer, insect-rich climes to the south.

It is not only ornithologists who find these stories compelling. Celebrating the movements of wild birds is deeply engrained in our culture. From the "first cuckoo" of the UK spring prompting letters to *The Times* to the great overhead skeins of Snow Geese announcing fall in the USA, we have long seen migratory birds as harbingers of seasonal change. Over 3,000 years ago, Polynesian sailors plying the Pacific used migrating birds to guide them toward land, and early scholars, from Aristotle to Pliny the Elder, described migratory movements in their writings. Even the Bible takes note: "Yea, the stork in the heaven knoweth her appointed times; and the turtle and the crane and the swallow observe the time of their coming." (Jeremiah, 8:7)

Our fascination is easily explained. These feathered animals—many of them tiny and, to us, fragile—use flight, a power we can only dream of, to travel distances and perform feats of strength and endurance that challenge the realms of physical possibility. In the process, they cross daunting barriers, such as deserts, mountain ranges, and oceans, yet somehow manage to navigate precisely to their destination—sometimes the same tree—year after year.

Before we invented the aeroplane, our own species could not conceive of a journey such as that made by the Bar-tailed Godwit, which travels over 7,000 miles (11,300 km) across the open ocean from Alaska to New Zealand in just nine days. Even today, with the advent of GPS satellite technology, birds' orientation and navigation skills have scientists scratching their heads. Small wonder that Aristotle got it wrong when he attributed the annual autumn disappearance of swallows to hibernation. Would the truth—that they fly to Africa and back—have been any more convincing? Only in the last 200 or so years have we accepted bird migration as fact; and today, the more we learn, the more astonishing it becomes.

WHY DO BIRDS MIGRATE?

Defining bird migration is not always straightforward. In the broadest terms, it refers to the regular seasonal movement of birds between their breeding and wintering grounds. Typically, this involves birds that breed in the temperate or polar regions of the Northern Hemisphere migrating south in autumn to spend winter in the tropics or subtropics, and then returning north in spring to breed. For species that cross the Equator, entering South America or sub-Saharan Africa, this means, paradoxically, that they winter in the southern summer.

There are many variations on this basic model, as we will see later in this book. First, however, you might well wonder why birds put themselves through the perils of migration, with its herculean demands upon energy and stamina. The answer is: survival. Simply put, the risks of staying behind outweigh those of moving on. For the Barn Swallow that breeds in Europe, summer may offer abundant food and daylight for feeding a family but cold, dark winter, with the insect supply

OPPOSITE Sandhill Cranes drop from the evening sky onto the sandbars of Nebraska's Platte River valley, a major staging area on their northbound migration.

THE MIRACLE OF MIGRATION

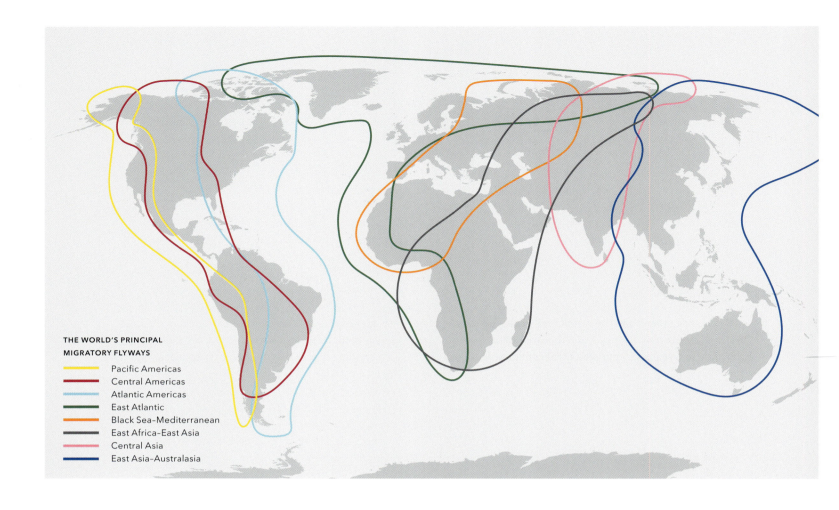

THE WORLD'S PRINCIPAL MIGRATORY FLYWAYS

- Pacific Americas
- Central Americas
- Atlantic Americas
- East Atlantic
- Black Sea–Mediterranean
- East Africa–East Asia
- Central Asia
- East Asia–Australasia

turned off, becomes a death trap. The bird heads to Africa, where it finds abundant warmth and food. Come the breeding season, however, it faces an army of local competitors for nest sites and returns north, where longer daylight hours also allow it to rear larger broods.

Certainly, migration is exhausting and hazardous. But for most birds, so is the daily experience of simply staying alive, wherever they find themselves. Indeed, survival rates among sedentary species—those that stay put over winter—are often lower than among related species that migrate. Besides, evolution does not usually produce a system that makes life more difficult; it doesn't work that way. Natural selection ensures that adaptations such as migration only evolve if they confer an advantage. Of course, migration is not restricted to birds—numerous other animals around the world migrate, from Humpback Whales to Monarch butterflies, and all do it for the same reason: to find the resources that will keep them alive so they can breed again.

The evolution of bird migration is thought to be rooted in glaciation. Most Northern Hemisphere species are descended from lineages that evolved in the tropics, when ice sheets covered the polar regions. As the ice retreated, so some species ventured north to exploit the new environmental niches

available, but in winter were still obliged to return south to survive. This pattern of behavior appears to have evolved independently in many different lineages of bird around the world, becoming genetically encoded in the species that each has subsequently produced.

Today, some 4,000 of the world's 10,000-plus bird species migrate in one way or another, with at least 1,800 doing it over long distances. In the tropics, where food and weather are more reliable, most species are sedentary or make only localized movements. In the Northern Hemisphere, however, the majority of species migrate to some extent, with at least 200 land birds undertaking regular long-distance return journeys between Europe and Africa, and 300 between North and South America. A few southern species buck the trend—intra-African migrants, such as the Woodland Kingfisher, for example, migrate within the Southern Hemisphere.

DIFFERENT TYPES OF MIGRATION

The classic idea of migration is an outward and return journey—a regular to-ing and fro-ing between two locations. This typically follows a broadly north–south axis and may be long distance, such as the Purple Martin's 6,000-mile (10,000 km) return journey between Canada and southern

Brazil, or rather shorter, such as the Redwing's 600-mile (1,000 km) journey between Scandinavia and Britain. These migrations often show a strong element of site fidelity: In other words, the bird returns to the same location at both ends of its journey.

Birds migrate along shared routes known as "flyways," which reflect the prevailing weather conditions and topography of the areas they fly over. Some follow coastlines while others cross oceans or continental interiors, using river valleys and other "leading lines." Many incorporate mountain passes, sea straits and other bottlenecks, where migrants congregate in large numbers. All include key pit stops—often wetlands or estuaries—where the birds can top up on food, water, and rest.

Worldwide, there are three main global flyways: the African-Eurasian, the Americas, and the Asian-Australasian. Each of these vast areas comprises a number of more localized routes. In North America, for example, four major flyways have been identified: the Pacific American, the Mississippi American, the Atlantic American, and the East Atlantic. Each charts a different course between the Arctic and the tropics. Similarly, the African-Eurasian flyway can be subdivided into three main routes: the East Atlantic Flyway, the Black Sea-Mediterranean flyway, and the West Asian-East African Flyway. The Asian-Australasian flyway falls into three more: the Central Asian Flyway, the East Asian-Australasian, and the West Pacific flyway.

Within one broad flyway, each species follows its own route—and their migrations do not necessarily follow straight lines. Many show a kinked trajectory, where the bird is obliged to deviate east or west in order to overcome a geographical obstacle such as a mountain range or ocean, or where its route meanders to take advantage of seasonal weather patterns or food resources. Such migrations are known as "arched" or "hooked." Although they may add many miles to the journey, they are often the most efficient means of completing it successfully. Blackpoll Warblers from central Canada first migrate east to New England in the fall, before heading south to Brazil to take advantage of the quicker sea crossing over the western Atlantic, rather than heading due south through the center of the North American continent.

A return journey may also take a different route from the outward—meaning the bird completes a "loop migration." Rufous Hummingbirds, for example, follow a coastal route in spring on their way from Mexico to Alaska but take an interior southbound route via the Rockies in autumn, to feed on wildflowers along the way. Loop migration is common among seabirds and shorebirds, many of which use seasonal variations in wind patterns to aid their flight. It explains why, for example, birdwatchers in the UK see plenty of Little Stints

and Curlew Sandpipers passing through during autumn, on their flight south from their Arctic breeding grounds, but very few in spring, when they take a more easterly route.

Some species follow more than one route. Spotted Flycatchers that breed in western Europe follow a westward route into Africa, via the western Mediterranean, whereas those from eastern Europe take an easterly route, via the other side of the sea. Consequently, somewhere in Central Europe this species has what is known as a "migratory divide": the point at which two populations of the same species diverge in their strategy. With a few species, however, evolutionary history dictates a route that—from a glance at the atlas—appears counter-intuitive. Northern Wheatears in Canada undertake a mammoth migration to Central Africa, crossing the Atlantic and heading south through Europe, rather than joining other Canadian breeding species that migrate over the much shorter distance south to Central America. This is because, historically, the species' breeding range expanded west from Eurasia and, as the birds colonized the New World, they took a genetically inherited migration route with them from the Old World.

There are many species in which one part of the population is migratory, while another part—typically the more southerly one—stays put. Such birds are known as partial migrants. In North America, Red-winged Blackbirds that breed in the southern states remain on or near their breeding grounds all year, whereas those that breed in the northern states or Canada head south, often as far as Mexico. Such species must strike a balance between the relative advantages and disadvantages of moving on or staying put. In some cases, the northern wanderers will pass over their sedentary southern cousins in what is known as a "leapfrog" migration. Thus, twice a year, Western Ospreys that breed in Quebec and winter in Brazil pass right over the heads of their stay-at-home cousins in Belize. The two populations are now so distinct in behavior that they have evolved into separate subspecies and no longer mix with one another.

Migratory behavior may also differ by age and sex within a species. In shorebirds such as the Red Knot, females embark on their journey south almost as soon as the eggs have hatched, leaving the males—who remain to rear the hatchlings—to follow a couple of weeks later. Females typically migrate further, while males return earlier the following spring, eager to secure breeding territory as soon as possible. Indeed, the breeding imperative means that in most migrants, spring return migration is quicker than outward autumn migration, with fewer stops and more direct routes. In some species, such as the Common Swift, young birds that have migrated immediately after fledging do not return the following year but remain on their wintering grounds, growing and learning until they are ready to head back and breed in the following year.

A few long-lived species such as albatrosses may not return to their breeding grounds for seven or eight years.

North–south is not the only axis along which birds migrate. Some species are also altitudinal migrants. The Wallcreeper, for example, breeds at heights of up to 9,800 feet (3,000 m) in Eurasian mountain ranges such as the Alps, but in winter sometimes descends to sea-level, exchanging its bare summits for village walls, which offer more food in that season. Some such journeys are very small—the migration of a Rock Ptarmigan, for example, may take it just 1,970 feet (600 m) up and down the same mountain—but each follows the same principle: the bird must move to wherever it finds what it needs to survive.

Not all migrations follow the classic annual outward–return model. Some species undergo periodic movements known as irruptions, arriving en masse at winter quarters where they may not have been seen for years. This typically happens when a winter food shortage follows a bumper breeding season, forcing a newly expanded population to move on. In the UK, for example, Bohemian Waxwings arrive across the North Sea in large numbers every decade or so, having exhausted the berry crop in Scandinavia. Northern predators that depend upon the fluctuating population of voles follow similar boom-and-bust irruption cycles—Snowy Owls in the USA sometimes appear thousands of miles south of their breeding range.

Other birds may undertake "escape" migrations, when severe weather obliges them to move on spontaneously. This is especially true of wildfowl whose lakes freeze over, or ground-feeding species, such as the Northern Lapwing, that cannot access food in the frozen soil.

A few species migrate with a one-way ticket. Red Crossbills, for example, time their breeding to coincide with the seed crop of spruces and pine trees, which is erratic at the best of times. They move to wherever the best crop is available, breeding in mid-winter if necessary, then move on again to a completely new area for the next available crop. This itinerant lifestyle is typical of many birds in tropical arid zones—including the deserts of southern Australia, where Budgerigars and various finch species pursue a nomadic existence, constantly heading off to wherever the rain is falling and grass seeds are sprouting.

PREPARING TO LEAVE

Birds do not simply set off one day on a whim; they have to be ready. This does not entail any conscious planning, however, but is driven by endogenous programming. It is the changing day length—the shortening of days in autumn and lengthening of days in spring—that triggers the process, by inducing a hormonal shift within a bird.

Migrating birds undergo significant physiological changes before their journey. Many put on an additional layer of subcutaneous fat, which converts to energy twice as fast as their usual carbohydrate-based diet to provide the required extra power for flight. They do this through hyperphagia—a sustained feeding binge prior to departure, often switching

ABOVE Barn Swallows gather on wires during a period of restless activity, known as *Zugunruhe*, immediately prior to their migration south.

to newly available autumnal foods such as berries. Species that undertake non-stop flights may double their body mass at this time—from 0.35–0.7 oz (10–20 g) in the case of the Sedge Warbler in Europe, for example. At the same time, some may shed unnecessary weight in other ways: In a Bar-tailed Godwit, for example, the reproductive organs shrivel to very little during the course of migration.

Most small migratory birds also complete a full moult before departure, exchanging their tatty, post-breeding plumage for a durable new suit of traveling feathers—although for many other birds, including shorebirds and gulls, this happens after they reach their destination. Many wildfowl and other waterbirds moult all their primary feathers at once, leaving them unable to fly until they regrow. Some undertake a special "moult migration" for this purpose: Common Shelducks from all over Europe, for example, converge in September on the Wadden Sea, a vast expanse of intertidal mud off the coast of the Netherlands, where they complete their moult safe from predators, before continuing to their winter quarters.

As the day of departure approaches, birds become increasingly restless, moving about and feeding frenetically. This behavior—known as *Zugunruhe*—was first described in 1795 by German naturalist Johann Andreas Naumann (1744–1826). Again, this is a response to genetic programming. Experiments have shown that even captive birds, raised behind bars, display *Zugunruhe* during migration season. What's more, the direction in which they hop up and down on their perch corresponds exactly to the direction in which they should be migrating. This restlessness subsides at the very point when the bird's migratory journey would come to an end, were it undertaking the real thing. It suggests that a bird knows when it has reached its destination not just from sensory clues but from the state of its metabolism: Having filled the tank with the precise amount of fuel for the journey, in other words, it will know it has arrived when the needle points to zero.

THE JOURNEY

Once migrants are ready to go, they wait for the weather to fire the starting gun. Clear skies and a tail wind typically provide the right conditions. In general, migratory species start off on a broad front—flying as individuals, rather than in a flock, but all heading in roughly the same direction, maintaining contact with calls, where close enough, and often coming down to rest in the same place. Parallel streams may coalesce at geographical pinch points, such as mountain passes, where these broad fronts narrow into clearer flyways.

Some long-lived social species, including cranes and geese, migrate in flocks. They generally fly in "V" formation, each bird gaining lift from turbulence generated by the wingtips of the bird in front and the flock rotating positions so that each, in turn, feels the benefit. Large flocks may comprise family groups of adults and newly fledged young. They fly and rest together, and may slow down or delay departure in order to allow a struggling individual to catch up.

ABOVE LEFT Western Sandpipers mass along a tidal creek on the Copper River Delta, Alaska, as they head north to their Arctic breeding grounds.

ABOVE RIGHT The Sedge Warbler, like many small migrants, almost doubles its body weight in extra fat reserves prior to its non-stop migration flight.

Many birds, including most passerines, waders, and wildfowl, migrate largely by night. This has various advantages: The air is less dense and more stable, reducing in-flight turbulence; the risk of predation from diurnal predators, such as raptors, is reduced; there is less danger from overheating, and they can put down in the morning and feed during the day. Others primarily migrate diurnally, however—these include aerial insectivores such as swifts and swallows, which can feed on the wing as they travel.

Large, broad-winged birds, including storks, raptors, and pelicans, also migrate by day. The biomechanics of their heavier build means that they cannot sustain long periods of flapping flight. Because of this, they rely upon thermals—columns of warm air rising from the sun-heated ground—to gain enough lift to glide toward their destination. These birds generally avoid crossing large water bodies, where no thermals are found, so their migration flyways converge on the narrowest sea straits—such as Gibraltar and the Bosphorus, at the western and eastern ends of the Mediterranean respectively. Huge numbers will gather at such bottlenecks, waiting for thermals to lift them up and over natural barriers. Raptor migrations in Mexico's Veracruz province, along the narrow strip of land between the mountains and sea, may see up to five million hawks, kites, and Turkey Vultures passing through in just a few days.

All migration flyways incorporate traditional staging areas—food-rich pit stops, where birds can rest and refuel for a few days before continuing their journey. Brent Geese flying from Russia to the UK put down in the Wadden Sea, feeding up on the plentiful invertebrates beneath the tidal mudflats, while the millions of shorebirds of various species heading down the West Pacific flyway from Arctic Russia and Alaska stop off in the Yellow Sea, off the coast of China and Korea. Individual species' flyways have evolved around these pit-stops: All Pied Flycatchers heading for West Africa from Europe, whether from England or Sweden, take a break in northern Spain before heading further south.

Migration distance varies by species. Record breakers such as the Arctic Tern or Sooty Shearwater may rack up more than 37,000 miles (60,000 km) in a year. Others fly nothing like as far. Distance is not really a problem: As long as the birds are fit enough and have adequate pit-stops along the way, they can keep going as long as required. Some rattle along: The Great Snipe may complete the 4,225-mile (6,800 km) journey from Scandinavia to sub-Saharan Africa in just three or four days, reaching speeds of 60 mph (97 km/h) en route. Others travel rather more slowly: A Barn Swallow takes around three months to reach its African wintering quarters from northern Europe. Most small birds average a flight speed of 18–24 mph (30–40 km/h); pigeons average around 37 mph (60 km/h), and waders 43–49 mph (70–80 km/h).

Height is another variable. Studies suggest that most migrating birds fly within an altitude range of 490–1,970 feet (150–600 m), gradually losing altitude toward dawn. Some species will fly much higher in order to surmount mountain ranges, with the Bar-headed Goose regularly topping 20,000 feet (6,100 m) on its annual crossing of the Himalayas. Land birds tend to fly higher during ocean crossings, and species such as Bar-tailed Godwits and Pacific Golden Plovers may fly high enough during their non-stop trans-Pacific marathons to gain assistance from the jet stream—thinner air means that faster flight is more efficient at high altitude: Whooper Swans have been recorded flying from Iceland to Scotland at 26,000 feet (8,000 m), completing the journey in just twelve hours.

FINDING THE WAY

Migratory birds exhibit astonishing powers of orientation and navigation. In a famous 1952 experiment, a young Manx Shearwater taken from its nest burrow on the Welsh island of Skokholm was flown by aeroplane to the USA and released off the coast of Boston. It reappeared in its burrow in Wales 12 days later, before the letter confirming its release had crossed the Atlantic. Orientation and navigation are not the same thing, however: The former is an innate ability to head in the right direction, and is guided by an internal compass with which a bird is born; the latter is a more precise process that uses cognitive skill and experience to locate and identify the final destination.

The sun provides an essential compass for migrating birds, which use an internal clock to orient themselves by its position, as it moves from east to west across the sky. Experiments with captive Common Starlings show that they cannot orient themselves if the sun is not visible, and will head in the wrong direction when mirrors are used to alter its apparent position in the sky. Even once the sun has set, birds' ability to see polarized light means that they can detect its final position on the horizon several hours later, enabling them to stay on track through the night. After dark, however, they can also use the position of the stars, adjusting their position in relation to various constellations as they revolve around the fixed point of the Pole Star.

But how do birds find their way on cloudy nights with no visual clues? Hearing may help. Birds can detect low-frequency infrasound, which means that they may pick up distant geophysical sounds inaudible to us, such as wind around mountain peaks or surf breaking on a shore. There is also evidence that some species can pick up olfactory clues: Seabirds such as petrels and albatrosses, which use a stronger sense of smell than most birds to track down food on the ocean surface, may also follow scent gradients toward their destination. Perhaps most interesting is magnetoreception: a sense denied to humans. The discovery of minute quantities

of magnetite—an iron compound—in the bills and skulls of pigeons, suggests that these birds, and presumably many others, have the ability to detect the earth's magnetic field and orient themselves accordingly.

It is probable that birds combine all of these orientation abilities into an integrated system, using each to a greater or lesser extent according to species. When it comes to navigation, however, they must draw upon cognitive skills—building up a precise mental map from a first journey and then recognizing key landmarks the second time around. Studies of Western Ospreys show that older, more experienced individuals deviate much less in finding their way, and are also better able to correct for confusion factors, such as wind drift.

SURVIVING THE JOURNEY

Migration is fraught with perils. For all the birds that survive their journeys, there are countless millions that don't—especially first time around, when the newly fledged travelers are young and inexperienced.

Severe weather can spell disaster for thousands of birds at a stroke. Strong side winds blow migrants off course, sometimes far out to sea, never to return. Headwinds may prevent them from making landfall, sending them crashing into the waves just short of their destination, while, conversely, mist and fog may cause them to overshoot or be grounded. Storms at sea sometimes carry seabirds far inland, leaving them "wrecked" on waterways, without the energy to find their way back. Unseasonal weather at the migrant's final destination, such as

a late snowfall, may leave it unable to feed when it arrives—just when it has most need of replenishing its exhausted reserves. In such circumstances, birds may undertake a "reverse migration," retracing their steps down the flyway to somewhere they can find food and wait for conditions ahead to change.

Disrupted migration can be thrilling for birders, as rare species can turn up unexpectedly on their local patch. Such birds are called vagrants or "accidentals." For example, strong Atlantic westerlies may whisk southbound American birds eastward over the ocean, depositing the likes of the American Robin or the Baltimore Oriole on the British coast. Conversely, the east coast of Britain sometimes receives a small influx of Siberian species, such as the Pallas's Warbler, which can be initially thrown off its usual southbound course by strong easterlies and diverted along a different flyway all the way across to Europe. During migration season, especially in autumn, many birdwatchers make for the islands and headlands where such birds usually end up first. Thrills for birders usually means disaster for the birds, however, as very few of these lost and exhausted wanderers survive their trauma, let alone find their way home.

Other natural dangers for migrants include heat exhaustion: Crossing the Sahara is probably the greatest challenge for most Afro-Palearctic migrants. There are also predators waiting to pick off tired birds wherever they touch down. Some species, notably the Eleonora's Falcon of Mediterranean regions (see pages 218–221), specialize in feeding on migrants, even delaying the raising of their young to exploit this seasonal

ABOVE A Manx Shearwater at its nest burrow in Skokholm, Wales. This species was the subject of one of the first experiments to investigate orientation in migratory birds.

THE MIRACLE OF MIGRATION

food glut. Large gatherings at pit-stops, such as the huge West African roosts of Barn Swallows, also draw an army of predators, from raptors to snakes. Such gatherings can become a reservoir of disease, with birds crammed together in close proximity and thus more susceptible to acquiring ticks, lice, and pathogens such as avian influenza.

Migrants have, of course, evolved to overcome the challenges posed by nature: storms, droughts and predators are all part of the deal. However, they struggle to withstand the human impact (see below). Anthropogenic threats to migrants range from hunting—the barrage of guns and snares that await migratory birds along their flyways—to collision with the numerous obstacles that we have placed in their way—from urban high-rises to power lines and wind turbines; illuminated structures, such as gas flares and lighthouses, take an especially heavy toll. Large birds may even strike flying aircraft, with fatal consequences for bird and, occasionally, even for the aircraft. Snow and Canada Geese have been responsible for many such incidents in the USA, and the collision of an aircraft with a Rüppell's Vulture in the skies over the Ivory Coast inadvertently produced the highest avian flight record: an astonishing 37,100 feet (11,300 m).

Most serious, though, is habitat loss or damage. This ranges from pollution—the dumping of plastics or spillage of oil—to wholesale destruction and agricultural and urban development along the flyways. Climate change is also having an increasingly serious impact. Many species that breed in the Arctic are finding that the northern advance of the boreal forests is reducing their tundra breeding habitat, while the desertification of the Sahel in Central Africa, due to overgrazing and climate change, is extending the desert crossing for species on the Afro-Palearctic flyway and is thought to contribute to the ongoing decline of many species.

UNDERSTANDING MIGRATION

Our observations of bird migration date back thousands of years—however, it took scientists some time to begin to understand what was happening. Various outlandish theories attempted to explain the seasonal appearance and disappearance of certain European birds: These included Common Redstarts "transmuting" into European Robins, and Barnacle Geese turning into barnacles. As late as 1789, celebrated British ornithologist Gilbert White (1720–1793) continued to promulgate the idea, first put forward

ABOVE The European Bee-eater is among many Afro-Palearctic migrants illegally hunted over the Mediterranean.

LOOP MIGRATIONS
— American Golden Plover
— Manx Shearwater

MONTAGU'S HARRIER MIGRATION ROUTES

This map charts the routes taken by four satellite-tagged Montagu's Harriers migrating from Britain to West Africa, as recorded in a 2016/2017 RSPB project. Each individual departed on a different day and transmitted data throughout its journey, revealing its location in real time. The final reading for all birds was taken on January 20, 2017.

— Mark (departed August 11)
— Sally (departed August 13)
— Roger (departed August 19)
— Beatrice (departed August 24)

by Aristotle, that Barn Swallows hibernated in crevices, or even in the mud at the bottom of ponds, the latter perhaps explained by the discovery of their corpses below reedbed roosts.

By the late eighteenth century, the idea of migration was gaining credence. Thomas Bewick's *A History of British Birds* (1797) cites a ship's captain's reports of swallows flying north in great numbers between the islands of Menorca and Majorca. He rejects the idea that they "retire into water," suggesting instead that: "they leave us when this country can no longer furnish them with a supply of their proper and natural food." By the early nineteenth century, there were credible reports of swallows at sea on the English Channel, the Mediterranean, and off West Africa, all supporting the idea that they and other species made long seasonal journeys. One notable piece of evidence came in 1822 when a White Stork pierced by an African arrow, which it still carried in its body, appeared near the German town of Klütz (see page 139).

Only in the twentieth century, however, did ringing ("banding" in the US) provide the smoking gun. This practice—the fitting of a small metal ring to a bird's leg that, if recovered elsewhere, reveals where the bird started its journey—began in 1899 with Danish ornithologist Hans Christian Cornelius Mortensen. One particular British record proved pivotal: A

Barn Swallow ringed in May 1911 by solicitor John Masefield was retrieved eighteen months later at a farmhouse in Utrecht, South Africa. This showed that Barn Swallows breeding in Britain migrated to winter in South Africa, traveling more than 5,000 miles (8,000 km) and crossing the Sahara Desert in the process. Since then, more than 20 million birds have been ringed around the world, with the data they have provided laying the foundations of our knowledge of migration today.

Nonetheless, ringing has drawbacks. No matter how skilled and dedicated the ringers (and qualification for this work takes years of training), the birds necessarily suffer a degree of trauma in the capture process. Some may even be captured by canny predators before they can be retrieved. Most significant, from a scientific point of view, is the very low rate of return: With small birds, such as warblers, fewer than one in 1,000 is recaptured—with many flying to remote parts of the world where there are no ringers at work. There are other traditional methods of tracking migrants that do not require them to be recaptured—include marking with colored leg rings, colored dyes, or wing tags, so they can be observed and recorded at a distance. Such methods can only work with large birds, however, such as geese or raptors.

In the last couple of decades, tracking technology has taken our knowledge to a new level. The earliest radio transmitters

were relatively large: they could only be fixed to big birds such as geese, and had a limited range and lifespan. The advent of GPS satellite technology, however, now allows scientists to follow every detail of a bird's journey, with transmitters that send a continuous stream of data. Light-level geolocators use an electronic sensor to record the levels of daylight, which help to trace a bird's location with the aid of latitude and longitude calculations. These may weigh as little as 0.01 oz (0.3 g) and can be fixed to the very smallest species when attached to a band on their legs. Many conservation organizations make their data available online, allowing anybody interested to track the movements of individual birds—almost in real time.

A range of other technologies have been used over time. Radar, developed during World War II, soon proved capable of detecting migrating birds at night, the clusters of dots on the screen providing information about numbers, direction, and altitude, though not identifying species. In the laboratory, the use of registration cages—circular enclosures in which captive birds make small marks on the walls as they move around—has revealed much about birds' innate capacity for orientation.

An important modern tool is stable isotope analysis, which works on the basic principle of "you are what you eat." Stable isotopes are forms of common elements that don't decay over time—typically of substances such as carbon, oxygen, and nitrogen—and, therefore, remain in the bodies of animals that absorbed them in their food. The analysis of stable isotopes in a bird's inert tissues such as its feathers or bill can reveal the composition of its diet at different points in its life. The feather of a Dunlin captured in Spain, for example, can reveal that it hatched in Siberia.

Finally, there is simple observation with the naked eye. American ornithologist George Lowery (1913–1978) pioneered a technique for observing bird migration at night by training a telescope on the surface of the moon and recording birds that flew past. However, you needn't be a scientist to observe visible migration—by heading out in spring or autumn to key migration locations such as coastal headlands, mountain passes, and sea straits, you can observe large numbers of birds on the move for yourself. Some places, such as Spurn Head in the UK, Hawk Mountain in Pennsylvania, and Falsterbo in Sweden, are hotspots for birders. A few, such as Kenya's Great Lakes with its spectacular flamingo gatherings, are even top tourist attractions.

PROTECTING MIGRATORY BIRDS

The last Passenger Pigeon died in captivity in Cincinnati Zoo on September 1, 1914. Named Martha, her death marked a dark day for bird migration. Just decades earlier, Passenger Pigeons—which bore the appropriate scientific name *Ectopistes migratorius*—migrated across North America in flocks of unimaginable size. In 1866, one flock in southern Ontario was described as being 0.93 miles (1.5 km) wide and 310 miles (500 km) long, and took 14 hours to pass—it probably held more than 3.5 billion birds. Incredibly, just fifty years later, the species had been hunted to extinction.

The demise of the Passenger Pigeon is a salutary reminder of the impact our own species can have. Today, migratory birds around the world are struggling. On the Afro-Palearctic flyway alone, many species are in steep decline. Data from the UK reveal that, from 1995–2010, the European Turtle Dove declined by 74 percent, the Common Cuckoo by 65 percent, the Wood Warbler by 61 percent, and the Whinchat by 57 percent.

Anthropogenic threats take many forms. The most atavistic is hunting. Around the Mediterranean alone an estimated 500 million birds are killed annually, the majority on migration between Europe and Africa. Habitat loss is even more devastating: The tidal mudflats of the Yellow Sea—the most important staging site along the East-Asian–Australasian flyway, hosting millions of migrants every year—have lost more than 40 percent of their area to industrial development in the past fifty years. At sea, migratory seabirds are ingesting floating plastic or perishing on the end of longline fishing hooks—the latter responsible for the death of around 100,000 albatrosses every year, leaving eighteen of the world's twenty-two species threatened with extinction.

Climate change is also likely to take an ever-increasing toll. The Dunlin is among a number of Arctic species whose tundra breeding grounds are shrinking; studies suggest this diminutive wader will lose up to 58 percent of its breeding habitat if CO_2 levels double by 2070–2090, as some models predict. Global warming may also help explain the decline of the Common Cuckoo in the UK. This species—a brood parasite that lays its eggs in the nests of host birds—has evolved to synchronize its annual arrival from Africa with the breeding of its hosts. With the UK spring now coming on average 5.1 days earlier than fifty years ago, many of its host species are arriving earlier at their breeding grounds, leaving the Common Cuckoo too late to find suitable nests.

For many species, the story involves a complex combination of factors. Research into the UK decline of the European Turtle Dove, for example, has identified ecologically unfriendly farming techniques on its European breeding grounds, uncontrolled hunting over its Mediterranean migratory route, and habitat loss in its West African winter quarters as all playing a part. This illustrates the problem that every migrant faces by virtue of its globe-trotting existence: How can you protect a species in one country if it is shot or left homeless in another?

OPPOSITE Volunteers from BirdLife Malta release four European Honey Buzzards, rehabilitated after being illegally shot by hunters while migrating over the island.

There is some hope, however. Today, scientists and conservationists are working with government and communities worldwide to protect migratory birds. "Migrants in Africa," for example, is a collaboration between conservation organizations in Ghana, Burkina Faso, and the UK (under the umbrella of BirdLife International), which studies Afro-Palearctic migrants on their West African wintering grounds in order to investigate the impact of changes in land use. The Albatross Task Force brings together dedicated instructors from seven countries to work with fishermen to introduce mitigation to help protect albatrosses. Results are already impressive: For every hundred albatrosses killed in fisheries in South African waters in 2006, eighty-five are now being saved by the simple adoption of modified fishing gear.

Elsewhere, dedicated volunteers are taking on the hunters. The tiny island of Malta occupies a strategic location on the European-African bird migration route—more than 170 species from at least forty-eight countries regularly overfly the island in significant numbers—but is also home to around 12,000 hunters, the highest density in Europe, who have long taken a heavy toll on migrant birds. Today, dedicated volunteers from BirdLife Malta are helping the authorities police illegal hunting while engaging the local community in outreach programmes. Hearts and minds can be changed: In Nagaland, northeast India, a concerted public information campaign has brought an end to the slaughter of migrating Amur Falcons, which as recently as 2012 were being killed at their roost by local villagers for subsistence at rates of up to 15,000 per day.

Research remains essential. The more we know about migratory birds the better we are able to protect them, and improving technology now allows greater insights. Sociable Lapwings are among the world's rarest birds—once thought to number no more than 300 worldwide. In 2008, three adults satellite-tagged by the RSPB at their breeding grounds in Kazakhstan were tracked to a previously unknown migration pit-stop in Turkey, where scientists found a flock of more than 2,000; conservation actions could then be targeted accordingly.

All conservation work requires legal back-up. Legislation specifically targeted at protecting migratory birds dates back to the Migratory Bird Treaty Act, a US federal law first enacted in 1916. Today many other conventions exist. The Agreement on the Conservation of African-Eurasian Migratory Waterbirds (AEWA), for example, is an intergovernmental treaty dedicated to the conservation of the wildfowl and wading birds that migrate along the African-Eurasian Flyway; it covers 254 species of bird and 119 "Range States." The Convention on Wetlands of International Importance, universally known as the Ramsar Convention after the city in Iran where it was signed, is an international treaty for the conservation of wetlands—vital as staging posts for migrants. As of May 2018, the convention listed 2,331 Ramsar Sites, covering a total protected area worldwide of 810,000 square miles (2.1 million sq km).

Such projects are forging new connections, both between nations and between scientists and local people. Migratory birds teach us that some important things go beyond borders. After all, whose birds are they anyway? Those of us in the UK might talk about our Turtle Doves but, given that these birds spend less than five months on British soil, couldn't the people of Ghana or Burkina Faso make an equal claim? Turtle Doves, of course, are not worried about nationality—they were migrating back and forth between Africa and Europe long before humans started carving up the map. If there's anything that illustrates how we must all work together to address the huge problems that our planet faces over the next century, it is surely the migration of birds.

ABOUT THIS BOOK

This book is, first and foremost, a celebration of the wonders of bird migration. The images aim to convey both the marvel of the birds themselves—their intricacy of form and artistry of movement—and the drama of the journeys they undertake, often through some of the most spell-binding landscapes on the planet.

The sixty-seven species individually described have been chosen to showcase migratory behavior across a broad spectrum. The six chapters into which they fall are organized by loose association—seabirds, songbirds, and so forth—but do not attempt to represent a watertight taxonomic approach. Due to this, the wildfowl chapter groups together grebes and loons with unrelated ducks and geese on the basis that both share a similar environment (water) and some similar migratory challenges.

Among the species chosen are some of the true celebrities of bird migration—record-breakers such as the Arctic Tern and crowd-pullers such as Snow Geese. Others are less familiar but their stories and images no less extraordinary. There are huge birds and tiny birds; tropical birds and polar birds; birds that fly alone and others that swarm in millions; birds that crest mountains and others that circumnavigate oceans. Each has its own story to tell. It would have been just as easy to select sixty-seven other species—all migratory birds are worthy of our attention.

The maps are simple, at-a-glance approximations of the migratory distributions of each species. They indicate the breeding range (yellow), wintering range (blue), and, for some species, the regions in which they are permanently resident (green). Where possible, arrows indicate some of the flyways used in moving between these areas.

OPPOSITE ABOVE The Spoon-billed Sandpiper is Critically Endangered as a result of habitat loss and now the subject of an intensive conservation project.

OPPOSITE BELOW White Storks spiral into a storm sky above Zambia's Luangwa Valley, preparing to fly north to their breeding grounds in Europe.

01 | WILDFOWL AND DIVING BIRDS

THE ANNUAL MIGRATION of wild geese embodies for many the changing of the seasons, the birds' straggling, honking skeins strung out across the sky signaling that nature is on the turn. Such movements create truly dramatic spectacles, with some species forming flocks many thousands strong.

The Anatidae family worldwide comprises 146 species of geese, duck, and swan, known collectively as "wildfowl." Those that breed in temperate or polar latitudes are among the world's great migrants. In winter, when their breeding wetlands freeze over and snow blankets the surrounding terrain, they must head for warmer climes to find the food they need to survive.

The boggy Arctic tundra holds the greatest wildfowl breeding populations, and it is there that many start their journey. In Eurasia, Tundra Swans head southwest in autumn from Western Siberia, while Pink-footed Geese head south from Greenland and Svarlbard, all following ancient flyways and dropping down at regular staging posts en route to the temperate coasts of western and southern Europe. In North America, Snow Geese migrate from their Canadian and Alaskan breeding grounds to wintering grounds in Mexico and the southern states, sometimes overwhelming wetlands with their numbers.

Geese and swans are among the relatively few bird groups that migrate in flocks, each one comprising smaller family groups that keep in contact with calls while flying. If one member is struggling, the whole flock may land and wait until it can continue. In the air, they form loose "V" formations. This helps each individual save energy by capitalizing on the lift created from the wingtips of the bird immediately in front. The birds rotate position within formation, so each gets its buoyant share.

Wildfowl are the among the highest flying of migrants, with some species crossing mountain ranges. The Bar-headed Goose passes over the Himalayas between its breeding grounds in Central Asia and wintering grounds in southern India. Special adaptations, including large lungs and enhanced blood oxygenation, enable it to survive at altitudes of more than 22,960 feet (7,000 m).

Unlike geese and swans, ducks do not generally form lifelong pair bonds or family groups, and so do not travel in large flocks. Nonetheless, huge numbers of many northern species migrate to shared wintering grounds, often gathering on calm coastal waters, where there is abundant feeding. The Redhead, for instance, migrates south to winter along the Gulf of Mexico, where up to 80 percent of the US population may gather in Laguna Madre.

Wildfowl in tropical climes are generally more sedentary, finding enough resources on their breeding range to sustain them year round. A few, however, make localized seasonal movements: The Magpie Goose of Australasia, for example, migrates between wetlands, following seasonal rainfall to the richest feeding grounds. The Common Shelduck, meanwhile, is one of several species that undertake "moult migrations." These birds are flightless for a few weeks during their annual moult so travel to favorite moulting grounds—often large undisturbed mud flats—where they can complete the regrowth of their feathers in relative safety.

Ducks and geese are not the only swimming water birds that migrate. Others, including coots, do it under cover of darkness, moving to large, ice-free freshwater lakes when their breeding grounds freeze over. Loons (aka divers) and grebes are fish-eating birds that breed on freshwater lakes but migrate south to spend winter largely at sea. Some grebes also make a "moult migration": The Black-necked Grebe uses inland saline lakes for this purpose, before heading to its winter quarters on the coast.

When satellite technology made it possible to track birds' individual migration journeys, geese and swans were among the first to be studied in this way. Large enough to be fitted with the earlier, larger transmitters and relatively easy to monitor on their wintering grounds and staging posts, wildfowl have significantly advanced our understanding of bird migration— revealing much about how birds navigate and how they sustain themselves en route. Some enterprising researchers have even taken to the air in microlights to fly alongside migrating geese and study just how they complete their marathon journeys.

OPPOSITE Geese, like these Pink-footed Geese in Britain, migrate in "V" formation, the birds in front creating turbulence that provides extra lift for those following behind.

SNOW GOOSE

Anser caerulescens

SIZE
L: 25–31 in (64–79 cm)
Wt: 4.5–9.9 lb (2–4.5 kg)
WS: 53–65 in (135–165 cm)

APPEARANCE
Medium-sized, with heavy body, long neck, long wings, short pink bill, and webbed red feet; plumage all-white with black wing-tips (white morph), or blue-gray, with white head, neck, and tail (blue morph).

LIFESTYLE
Feeds on grasses, tubers, and other ground plants; nests on open ground; pairs mate for life; female lays 2–6 eggs.

RANGE AND MIGRATION
Breeds on Arctic and sub-Arctic tundra, from western Greenland, across northern Canada to Alaska and northeast Russia; winters further south on wetlands, coastal plains, and arable land from British Columbia to southern USA and northern Mexico.

STATUS
Least Concern; worldwide population estimated at more than 6 million.

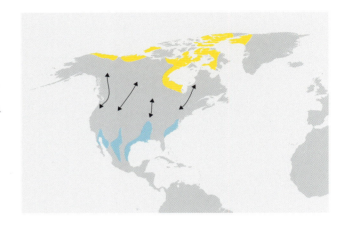

A FEBRUARY MORNING in Bosque del Apache, New Mexico. In the pre-dawn chill, an impatient murmuring drifts across the wetlands. As the light gathers, it swells in volume, passing from the baying of distant hounds to a jet-engine roar. Then, just as the sun peeps above the mountains, the birds take flight: tens of thousands launching skyward in a cacophony of cackling calls. For a short while they almost blot out the sky, swirling overhead in a blizzard of wings until the mass separates into straggling lines, each spreading out toward the feeding grounds.

The annual migration of Snow Geese is one of North America's most dramatic wildlife events, rivaling in its own way the great migrations of bison that once swept the prairies. The geese breed north of the timberline in the high Arctic but head south every autumn to spend winter on arable land, wetlands, and coastal plains further south, some reaching central Mexico. Here they assemble in huge flocks, making daily flights between their roosting and feeding grounds. Come spring, they head back north, stopping off at traditional staging posts en route.

The Snow Goose is named for its snow-white plumage, relieved only by black wing-tips, a pink bill, and rose-red feet

and legs. It also occurs in another color form known as the "blue goose," however, which is a smoky blue-gray, except for its white head and tail. The two were once considered separate species but are now known to freely interbreed. Young birds tend to mate with individuals of their parents' color but, if hatched to a mixed pair, may choose either color as a partner.

Irrespective of color morph, scientists recognize two subspecies of snow goose: the Lesser Snow Goose (*Chen chen caerulescens*) and the Greater Snow Goose (*C. c. atlanticus*). The two appear identical in all respects but size, with the more numerous Lesser being slightly smaller. The main distinction is a geographical one. The breeding range of the Lesser Snow Goose extends from central northern Canada west across the Bering Strait to northeast Siberia. Its autumn migration takes it south down the Central, Mississippi and Pacific flyways, with birds wintering across a broad sweep of the southern USA, from California to the Gulf Coast of Texas, while some continue into northern Mexico. Greater Snow Geese, by contrast, breed in northeast Canada and northwest Greenland, and winter on the Atlantic coastal plain from New Jersey to North Carolina.

OPPOSITE Lesser Snow Geese roost on water at their wetland staging posts during the long journey south.

LEFT Snow Geese take to the air in their thousands on their wintering grounds, commuting between their roost and nearby fields, where they feed on spilt grain from the autumn harvest.

Snow Geese migrate in family groups that coalesce into larger flocks at traditional wetland staging posts along their flyways. On migration, they may cover up to 500 miles (800 km) a day, keeping in contact with their honking calls. Each breeding population favors traditional wintering grounds. For example, the 300,000 or so Lesser Snow Geese that winter in Skagit and Fraser Valleys in Washington State breed on Wrangel Island, across the Bering Strait in Arctic Russia. The geese leave their wintering grounds from late February to March, heading back north. It is on this spring return migration that numbers reach their highest, flocks gathering at staging posts such as Middle Creek in Pennsylvania, where more than 200,000 Greater Snow Geese may spend a week or so before continuing north to Nunavut, Arctic Canada.

On their Arctic breeding grounds, flocks spread out and split up for breeding. Snow Geese form long-term pairs from their second year, generally breeding in their third year. Nesting starts from late May, the pair choosing a raised site on the tundra, often close to water. The nest comprises a shallow depression lined with plant material and down feathers, and may be used several years in succession. The female lays a clutch of two to six eggs, which hatch after an incubation of twenty-two to twenty-five days. As in all wildfowl, the young leave the nest within a few days, following their parents in search of food. At forty-two to forty-five days, they can fly but will generally stay with their family for two to three years. In their early days, the chicks are vulnerable to predators such as Arctic Foxes and Arctic Skuas (known in the US as Parasitic Jaegers) but the parents will defend them aggressively. Snow Geese sometimes nest close to Snowy Owls in order to gain protection against nest-robbers from the proximity of this formidable predator.

On their wintering grounds, Snow Geese divide their time between feeding and roosting on open water, with dense flocks covering the surface like sea ice. They depart at dawn to nearby feeding grounds and return at sunset. These birds are voracious feeders, foraging for more than 50 percent of their time. On their breeding grounds, they eat mostly grasses, bryophytes, and other ground-plants, using their strong bills to tear up the roots, tubers, and rhizomes. During winter, however, many populations have adapted to feed on left-over grain, shifting their feeding grounds away from coastal marshes onto surrounding agricultural land.

The readiness of Snow Geese to exploit new feeding opportunities provided by agriculture has seen their numbers rise dramatically. Today's estimated six million Lesser Snow Geese represents a population increase of over 300 percent since the 1970s. This has caused degradation in the bird's tundra breeding habitat—especially around the shores of Hudson Bay—with deleterious effects for other Arctic breeding species and causes localized damage around some migration staging posts. In 1999, the Conservation Order for Light Geese was mandated, relaxing hunting restrictions with the aim of reducing the Snow Goose population to sustainable levels. So far, however, the population continues to grow, and the blizzards of white wings become more spectacular every year.

ABOVE A blizzard of wings catches the first light of dawn as Snow Geese take to the air en masse.

OPPOSITE Migrating flocks of Snow Geese usually comprise small family groups.

BAR-HEADED GOOSE

Anser indicus

SIZE
L: 28–30 in (71–76 cm)
Wt: 4.1–7.1 lb (1.87–3.2 kg)
WS: 55–62 in (140–160 cm)

APPEARANCE
Medium-sized goose; pale gray with white head and neck capped by two prominent black bars across crown; black nape and flight feathers; orange feet, legs, and bill.

LIFESTYLE
Feeds on short grasses and cereal crops; nests on open ground; pairs mate for life; female lays 3–8 eggs.

RANGE AND MIGRATION
Breeds on high plateau of Central Asia and winters south on Indian subcontinent; migration route crosses Himalayas.

STATUS
Least Concern; worldwide population estimated at 97,000–118,000.

SOME BIRD SPECIES are renowned for the great distance of their migrations; others, for the impressive speed at which they travel. The Bar-headed Goose is remarkable for the height it reaches. Eye-witnesses have recorded a flock overflying the summit of Mount Makulu on the Tibet–Nepal border at 27,825 feet (8,481 m)—the fifth highest mountain in the world. Individual birds of other species, including the Rüppell's Vulture, have occasionally been recorded venturing higher, but no other species is known to undertake regular migration at a higher altitude.

The reason for this extraordinary feat is simple: The birds must cross the Himalayas to breed on the high-altitude lakes and steppes of Tibet, Kazakhstan, Mongolia, and Western China. They spend winter to the south, on the low-lying wetlands and plains of the Indian subcontinent. Traveling between the two involves flying twice a year over the world's highest mountain range.

Precise data on exactly how high the birds fly is in short supply. So far, reports of birds above peaks as high as Mount Maluku—and even Mount Everest—remain anecdotal. In a 2012 project from the University of Bangor, Wales, in which ninety-one Bar-headed Geese were fitted with satellite transmitters, the highest altitude recorded from one individual was 23,920 feet (7,290 m). This, nonetheless, is an impressive height and represents a feat of endurance at the very limits of birds' capabilities.

Such altitudes pose significant problems for flying birds. The temperature is well below freezing and the air contains less oxygen than at sea level. Respiration is thus harder, and the birds struggle to power their muscles in order to flap hard enough to generate the extra lift required for the thinner air. Bar-headed Geese rise to this challenge with a number of special adaptations. They have larger lungs than other similar-sized goose species, more capillaries in the left ventricle of the heart, and a higher capacity for carrying hemoglobin in the blood—all of which means that they can breathe more deeply and efficiently under hypoxic conditions and get more oxygen to the flight muscles. They also have a larger wing area than other similar-sized geese, giving extra thrust and lift.

Satellite tracking has shown that Bar-headed Geese may cross the Himalayas from sea level in a single non-stop flight of as little as seven hours. Their ascent is the greatest rate of continuous climbing ever recorded for any bird and, contrary to earlier assumptions, they are now known not to use tail winds to cross this obstacle but to follow a "roller-coaster" flight path, dropping down into valleys and passes in order to

OPPOSITE The high-altitude journeys of Bar-headed Geese take them over the very top of the Himalayas.

lower their heart rate, then to use breezes rising off ridges to regain height and cross the highest peaks. They generally fly at night when the air is colder and denser, allowing the kind of lift equivalent to flight at lower altitudes.

The Bar-headed Goose is the only member of the *Anser* (gray goose) genus endemic to Asia. A medium-sized goose, its plumage is largely pale silver-gray, with black flight feathers, a black line along the nape of its long neck, and two distinct black bars on the crown of its white head. Its legs, feet, and bill are bright orange. Like other geese, it is primarily a grazer, using the serrated edges of its stout bill to crop short grass.

On its Central Asian breeding grounds, this species forms large, loose colonies, sometimes numbering in the thousands. Pairs are monogamous and mate for life. A female lays three to eight eggs in a nest on the ground, with the male helping deter predators such as ravens, crows, and foxes. Within these colonies there may be some intraspecific brood parasitism, where lower-ranking females covertly lay their eggs in the nest of higher-ranking females. Either way, incubation lasts twenty-eight to thirty days and the young, which leave the nest a few days after hatching, can fly at fifty-five to sixty days.

After their winter migration, around one-quarter of the Bar-headed Goose population remain on the southern Tibetan plateau. The others disperse across India, from Assam to Tamil Nadu and into Bangladesh, settling on wetlands and low-lying cultivated plains. There they feed largely on crops, foraging for barley, rice, wheat, and corn and, in some places, causing appreciable economic damage.

The Bar-headed Goose is listed by the IUCN as Least Concern, with the population estimated at 97,000–118,000 and thought to be increasing. In Qinghai, China, this species has suffered localized mortalities from outbreaks of the H5N1 (bird flu) virus. Healthy adult birds must sometimes dodge the attacks of Golden Eagles while migrating through the mountains but otherwise have few natural predators. In captivity, where this species is popular around the world, a lifespan of twenty years has been recorded.

RIGHT Bar-headed Geese on their winter grounds at Keoladeo National Park, Rajasthan, India.

TUNDRA SWAN

Cygnus columbianus

SIZE
L: 45–59 in (115–150 cm)
Wt: 7.5–21.2 lb (3.4–9.6 kg)
WS: 66–83 in (140–160 cm)

APPEARANCE
Large and long necked, though the smallest and shortest-necked of northern swans; all white plumage; head and neck often tinged rusty orange from iron-rich bog waters; bill black with variable amount of yellow at base; legs and feet black; immatures pale gray.

LIFESTYLE
Feeds largely on aquatic vegetation and, on winter grounds, crops; nests on open, raised ground beside water; pairs mate for life; female lays 3–5 eggs.

RANGE AND MIGRATION
Circumpolar distribution, breeding on Arctic tundra and wintering on coastal floodplains to the south; two subspecies recognized: Whistling Swan in North America; Bewick's Swan in Eurasia.

STATUS
Least Concern; worldwide population estimated at 317,000–336,000.

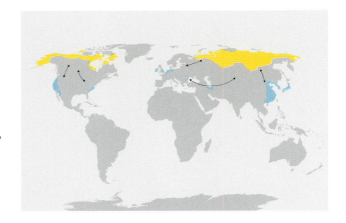

IT WAS BACK in 1963 that celebrated artist and conservationist Sir Peter Scott made the first brushstrokes in what was to become the world's longest unbroken study of a migratory bird species. While observing the Bewick's Swans that splashed down every October on the wetlands near his home in Gloucestershire, southwest England, he noticed that each individual could be distinguished by the patterning of black and yellow on its bill—patterning which is as unique as any fingerprint. By recording these in a series of paintings he was able to identify the same individuals from one year to the next.

Now treasured works of art, Scott's paintings contributed vital early data to our understanding of the migration of Bewick's Swans, which each year depart from their frozen Arctic breeding grounds to spend winter in Western Europe, traveling more than 2,000 miles (3,218 km) in the process. As technology has since advanced—from leg rings, via color-marking to today's satellite geo-locators—we have learned ever more about the journeys these remarkable birds undertake.

The Bewick's Swan was named, appropriately, after celebrated eighteenth-century artist and ornithologist Thomas Bewick. It is now known to be one of two subspecies of the

Tundra Swan. The other is the Whistling Swan, found in North America, which is distinguished by its larger size and having much less yellow on its bill. Both subspecies breed far north on the Arctic and sub-Arctic tundra on their respective continents. They migrate south in autumn to take up winter residence on grasslands and marshlands near the coast.

The Bewick's Swan (*C. c. bewickii*) breeds on the coastal lowlands of Arctic Russia, arriving in mid-May and departing in late September. Those that breed west of the Taimyr Peninsula migrate west via the White Sea, Baltic, and Elbe Estuary to winter in Denmark, the Netherlands, and the UK. Those that breed further east migrate southeast via Mongolia and northern China to winter in Korea, Japan, and southern China. A smaller population also winters beside the Caspian Sea in Iran.

In the New World, the Whistling Swan also has distinct populations. Those that breed in western Alaska winter down the Pacific Coast, with some heading inland into the California Central Valley. Those that breed further east and in Arctic Canada head south via the Great Lakes region to winter along the Atlantic coast of the USA, from Maryland to South Carolina. All depart their wintering grounds in mid-March,

OPPOSITE The Tundra Swan—seen here in its Eurasian form, Bewick's Swan—is the smallest and shortest-necked of the northern swans.

ABOVE A Bewick's Swan spreads its large webbed feet to provide extra air resistance as it comes in to land on water.

arriving back on their breeding grounds in late May.

Wherever they occur, the ecology of Tundra Swans is the same. On their summer breeding grounds they inhabit boggy terrain with scattered pools, where they feed largely on aquatic vegetation such as eel grass and pondweeds, up-ending to forage beneath the surface with their long necks. On their winter quarters they are increasingly reliant on cereals and potatoes, foraging in open fields for harvest left-overs then switching to natural grasses as winter deepens.

Breeding takes place from late May. Pairs form monogamous life-long bonds until one dies, whereupon the survivor may not pair up again for years. Nests consist of a large, raised mound of plant material near open water. The female (or pen) lays three to five eggs, which she incubates for twenty-nine to thirty days (Bewick's) or thirty to thirty-two days (Whistling) while the male keeps guard. He will drive away smaller predators such as Arctic Foxes or Northern Ravens and will attempt to intimidate predators as large as Brown Bears by running at them with wings raised. Cygnets leave the nest early and will move with their parents into shallow water if danger threatens. They fledge at forty to forty-five days (Bewick's) or sixty to seventy-five days (Whistling) and stay with their parents for the next year or two, not reaching sexual maturity until three to four years. There are exceptional records of individuals living up to twenty-four years.

The Whistling Swan is the more numerous of the two subspecies, with an estimated 170,000 individuals in North America. The Bewick's Swan, by contrast, is in decline, with the wintering population in northwest Europe having fallen by some 40 percent since the mid-1990s. Today this western population is estimated at 16,000–17,000, with a further 20,000 wintering in east Asia and 1,000 in Iran. Threats include illegal hunting, as the swans are sometimes mistaken for geese when flying in low light. Others include the ingestion of lead shot (around 4,000 Whistling Swans are also poisoned in this way in North America every year) and collisions with wind turbines and power lines. Underlying these threats is the ongoing degradation of wetland habitats, leaving the birds increasingly dependent on crops such as dropped potatoes and spilled grain as natural aquatic plants decline.

Research continues into the migration of Tundra Swans, with a census conducted in the UK every five years and individual birds satellite-tracked using solar-powered, collar-mounted data loggers. In 2014, WWT scientist Sacha Dench took to the air in a paramotor to accompany Bewick's Swans on their annual autumn migration from Russia to the UK, touching down wherever they did. Her journey covered 4,350 miles and spanned eleven countries. As well as discovering from the birds' perspective exactly which conditions they experience during their journey, this exercise brought communities together, amply demonstrating how people can work across borders in order to protect migratory birds.

ABOVE Whistling Swans in flight over British Columbia, Canada.

PINK-FOOTED GOOSE

Anser brachyrhynchus

SIZE
L: 24–30 in (60–75 cm)
Wt: 4–7.5 lb (1.8–3.4 kg)
WS: 53–67 in (135–170 cm)

APPEARANCE
Medium-sized goose; mid gray-brown, with deeper brown head and neck; wings grayish, with black flight feathers, rump and tail white with black tip; feet and legs pink; bill short and pink with black base and tip.

LIFESTYLE
Feeds on tundra plants on breeding grounds and largely crops on wintering grounds; nests on crags and rocky ground; female lays clutch of 3–6 eggs.

RANGE AND MIGRATION
Two populations: One breeds in eastern Greenland and Iceland and winters in UK; the other (smaller) breeds in Svalbard and winters in Belgium, the Netherlands, and northern Germany.

STATUS
Least Concern; worldwide population 375,000–400,000 individuals.

A NOVEMBER EVENING on the Norfolk coast, eastern England, and the darkening sky fills with the clamor of birds. Skein after skein of Pink-footed Geese arrive above the mudflats from the fields beyond, at first scribbled across the sunset in long wavering lines but soon forming a single swirling mass. The chorus of high, honking calls merges overhead into an overwhelming rush of sound as the birds rain down onto the mudflats in their thousands. Soon the sky has emptied as dramatically as it filled and the noise has fallen to a muted murmuring as the birds settle at their roost.

As recently as the 1970s, Pink-footed Geese—known to UK birdwatchers as "Pink-feet"—were almost unknown in Norfolk. Today, more than 150,000 arrive every autumn from their breeding grounds in Iceland and eastern Greenland and their noisy presence has come to define winter along this flat, marshy stretch of the English coastline. Other flocks find other corners of the British Isles: Some choose Lancashire, northwest England; others the east coast of Scotland. Their combined total of some 375,000 represents 90 percent of the species' global population.

A separate smaller population of the same species,

comprising some 40,000, breeds in Svalbard, high above the Arctic circle in Norway. These birds follow a different migration route, flying south through Norway and Denmark to spend winter along the coast of Belgium, the Netherlands, and northern Germany. However, ringing recoveries have shown that enough Pink-feet from the UK and Iceland turn up in Svalbard from time to time to ensure a small but steady genetic flow between the two populations.

Wherever it breeds, the Pink-footed Goose is a medium-sized goose, with a relatively short neck. It is distinguished from other European "gray" geese by its pink legs and feet, its short, black-tipped pink bill, and the contrast between its deep brown head and neck and its paler brown and gray body plumage. In flight, it shows a white rump and black-tipped white tail; bold markings that help individuals follow one another in the air.

Back on their northern breeding territories, Pink-feet separate out into territorial pairs. They build their nests on crags, rocky outcrops, glacier edges, and other inaccessible spots—often near seabird colonies—where they hope to avoid the depredations of Arctic Foxes and other egg thieves. Some

OPPOSITE Pink-footed Geese move around the coastline of eastern England, having arrived during October from their breeding grounds in Greenland.

also choose small islets on lakes. The female lays a clutch of three to six eggs in late spring (mid-May in Iceland and late-May in Svalbard), which she incubates for some twenty-six to twenty-seven days. After hatching, the young walk with their parents to the nearest lake, where they can find some protection from predators until they are able to fly—usually at fifty-six days. Casualties are high, however, with a 2004–2014 WWT survey in Iceland finding that breeding success was only 17–23 percent, each pair raising on average of 1.85 chicks to fledging.

In Iceland, Pink-feet start preparing for their southbound journey immediately breeding is over. They spend August mostly on the water, taking around twenty-five days to complete their moult. Then, as food is running out and the temperature falls, they await the right moment to depart— generally heading out one day in mid- to late September, when the wind conditions are suitable. They fly due south into the North Atlantic, first reaching the Faroe Islands, where they take a day to recover and refuel, and then continuing south to the UK. Here they first gather at traditional sites in eastern Scotland, including Loch of Strathbeg and Montrose Basin; 85,632 (one quarter of the world population) were counted on one day at the latter site in October 2015. Some use these locations as pit-stops en route to traditional sites in Norfolk and elsewhere in England; others may remain in Scotland for the winter.

The Pink-foot population explosion of recent years reflects improved protection on the species' UK winter grounds, where a reduction in shooting and an increase in food supply has enabled them to increase their numbers more than tenfold since the 1950s. On their summer breeding grounds, these geese eat a range of tundra plants, both on land and in water. In winter, however, they graze mostly on agricultural crops, including oilseed rape, potatoes, grasses, and sugar beet. The recent spread of sugar beet farming is thought to have been especially important: After harvesting the beet, many farmers now leave the leaves, stalks, and tops, which prove irresistible to geese. By polishing off these leftovers, the birds help minimize the spread of crop disease from year to year. Their availability also helps dissuade the geese from moving on to other more valuable crops, where they might be less welcome.

LEFT Pink-footed Geese, known locally as "Pinkfeet," touch down in a field on the Norfolk coast, eastern England, having flown in from their roost on the tidal mudflats.

WILDFOWL AND DIVING BIRDS

REDHEAD

Aythya americana

SIZE
L: 15 in (38 cm)
Wt: 2.4 lb (1.08 kg)
WS: 33 in (84 cm)

APPEARANCE
Medium-small duck; adult male
has chestnut-red head and neck,
black breast and tail, silver-gray
back and flanks, yellow eyes, and
blue bill with black tip; female and
non-breeding male are browner,
without red head.

LIFESTYLE
Dives to feed on aquatic plants and
animals; breeds on freshwater lakes
and winters on sheltered coastal
waters; pairs mate anew every
breeding season; female produces
brood of 5–7.

RANGE AND MIGRATION
Breeds in northern and western
North America, as far as northern
Canada; winters further south on
Pacific and Atlantic coasts and in
the Gulf of Mexico.

STATUS
Least Concern; worldwide
population estimated at 1.4
million.

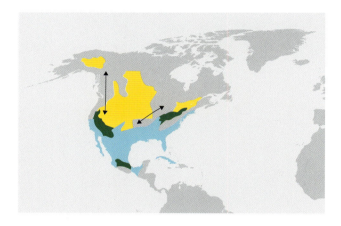

THE LAGUNA MADRE in southern Texas is one of the saltiest water bodies in the world. Squeezed between the mainland and the barrier islands of Padre and South Padre, this narrow, sheltered lagoon on the Gulf of Mexico measures nearly 130 miles (209 km) long but has an average depth of just 3.6 feet (1 m). In winter it hosts more than one million Redheads—some 75 percent of the global population in this relatively small space. The Redhead is a smallish, rotund diving duck related to Europe's Common Pochard (*A. ferina*) and named for the breeding male's rich copper head. It dives beneath the water's surface to feed and has its legs set far back on its body, making it cumbersome on land.

Redheads breed on freshwater marshes and ponds on the prairies of western North America as far north as northern Canada. They leave their winter quarters from late January, arriving just as rising temperatures thaw their breeding quarters. Many will have already paired off, migrating north together. Unpaired birds migrate in small groups known as "courting parties" and may pair up en route.

At their breeding pools, Redheads make circular nests of plant material. Females typically produce a brood of five to seven after an incubation period of twenty-three to twenty-nine days. Redheads can be brood parasites, with females laying eggs in the nests of other pairs or of closely related species such as Canvasbacks (*A. valisineria*). The young fledge after sixty to sixty-five days, the female abandoning her clutch a week before they can fly.

After the breeding season, adult Redheads first head north to large lakes where they are flightless for almost a month as they complete their moult. September finds them heading back south toward their winter quarters. Most travel overland across the central plains to the Gulf of Mexico.

During winter, Redheads switch from a summer diet of aquatic invertebrates to shoal grass and other plants. The salty nature of their winter habitat makes regular visits to freshwater pools necessary, where they purge excess salt through nasal glands, the birds often gathering for this purpose in breathtaking dawn flights of many thousands.

Redhead numbers have increased recently but studies in the Gulf of Mexico have shown that the birds have an aversion to wind turbines, often changing feeding areas to avoid them. Scientists fear that this may cause them to lose condition over winter and thus damage their breeding prospects.

OPPOSITE Around 80 percent of America's Redhead population overwinters in the Laguna Madre in the Gulf of Mexico.

KING EIDER

Somateria spectabilis

SIZE
L: 20–28 in (50–70 cm)
Wt: 3.45–3.68 lb (1.56–1.66 kg)
WS: 34–40 in (86–102 cm)

APPEARANCE
Large, solid duck; breeding male
has black body with pinkish
breast, pale blue/green head and
red bill with bright yellow knob;
female is warm brown with paler
head.

LIFESTYLE
Dives to feed on molluscs,
crustaceans, and other bottom-
dwelling marine organisms;
nests on open tundra; female
lays 4–7 eggs.

RANGE AND MIGRATION
Breeds on Arctic tundra from
western Greenland across northern
Canada to northern Alaska and
northeast Russia; winters at sea
south to edge of sea ice; migrates
around coastlines.

STATUS
Least Concern; worldwide
population estimated at
790,000–930,000.

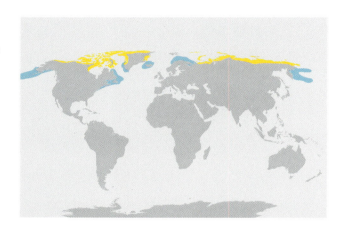

IT'S MID-APRIL AT Point Barrow, Alaska, the northernmost outpost of the North American mainland. Spring seems far away: a white crust of sea ice still stretches from the barren shoreline out across the Chukchi Sea and yet birds are streaming past. Wings beating fast, they move in low "V"-shaped formations, thousands following the coastline eastward in an unbroken stream. An hour later and they are still coming.

These robust-looking birds, flying with such power and purpose, are King Eider, the largest of the Northern Hemisphere seaduck species and one of the most northerly breeding birds in the world. They have spent winter out in the Bering Sea, dispersing southward to the southern limit of the sea ice. Now they are heading back around the coast toward their breeding grounds in the Canadian High Arctic. Many will have paired up en route and others will do so when they arrive, the gaudy males using their head-bowing displays and low crooning calls to impress the more soberly clad females. By early May, they will be inland at their nest sites among the hummocks of the tundra, each female sitting tight on her clutch, her shallow scrape of a nest snug with the soft down

feathers for which all eiders are celebrated.

King Eider have a circumpolar distribution, breeding along the Arctic coasts of northeast Europe, Asia, and North America. Here they use various tundra habitats—generally choosing low, marshy areas along the coast or beside lakes. They are only on their breeding grounds from May to July, however, and spend most of the rest of their time at sea, wintering in Arctic and sub-Arctic marine areas, notably the Bering Sea, the West coast of Greenland, northeastern Canada, and northern Norway.

Movements between these areas, especially during the return spring migration, can be on a spectacular scale, with the birds passing by for hours on end. Point Barrow, also known as Nuvuk, sees the biggest flypast, involving several hundred thousand birds. King Eider are among the first of the Arctic birds to return to their breeding grounds. They do not migrate overland but follow the coastline, their journeys thus taking place mostly over frozen seas, with the birds often resting on ice floes.

This duck derives its genus name *Somateria* from the Ancient Greek for "woolly body," which refers to the

OPPOSITE King Eider off the Arctic coast of Norway in January,
as the drakes begin to acquire their breeding plumage.

exceptionally soft insulating down feathers with which all eider species line their nests. The species name *spectabilis* means "worth seeing," and a male King Eider in breeding plumage is indeed a sight to behold, with his black, white, and peach-tinged body, soft blue and green head, and bright red bill crowned with a large yellow knob. Females, as in most ducks, lack the males' colors, their warm brown tones being an adaptation for camouflage when on the nest. They are also slightly smaller than males, and can lose significant weight while brooding their clutch, as they may not feed for days on end.

Breeding gets under way by early June. A female incubates her clutch of four to seven eggs for twenty-two to twenty-four days. She shows extraordinary dedication to the task, flattening her body to the ground to escape detection by an intruder, such as an Arctic Fox or Arctic Skua, and may sit tight even if touched by a human observer. The hatchlings join other broods to be raised collectively by the females in crèches. The precise date of fledging is not known but it is likely that the ducklings take their first flight at around fifty days. In their first autumn, youngsters moult into their mottled black-and-white immature plumage. They spend their first year at sea and don't reach breeding maturity for three years. A longevity record for this species of twenty-two years has been recorded from one female banded in Alaska.

On their breeding grounds, King Eider forage for small invertebrates near the surface of freshwater lakes and ponds. Out at sea, however, they get most of their food from the seabed, diving to depths of 80 feet (24.4 m) in search of molluscs, crustaceans, and echinoderms, such as sea urchins, starfish, and sea anemones.

The non-breeding movements of the King Eider center upon some of the most remote parts of the Arctic, so it is hardly surprising that for a long time they remained largely a mystery to scientists. However, satellite tracking has now revealed that these birds winter further out into the Bering Sea than other wildfowl and that they travel widely over this period. King Eider are thus thought vulnerable to factors that affect this habitat, including global warming, which is reducing the annual extent of sea ice, and oil and gas exploration. Nonetheless, the species is currently listed as Least Concern by the IUCN, with a population estimated at 790,000–930,000.

RIGHT King Eider (with a few Common Eider behind) take flight off the Barents Sea coast of Arctic Norway.

COMMON SHELDUCK

Tadorna tadorna

SIZE
L: 23–25 in (58–64 cm)
Wt: 1.8–3 lb (0.8–1.4 kg)
WS: 43–51 in (110–130 cm)

APPEARANCE
Large, goose-like duck; mostly white, with black and chestnut markings on body and wings, dark green head, and red bill.

LIFESTYLE
Inhabits estuarine habitats, feeding on plant and animal food from intertidal mud and breeding among sand dunes, often in old rabbit burrows; female lays 8–10 eggs; young raised in crèches by non-breeding adults.

RANGE AND MIGRATION
Breeds in Central Europe and in scattered locations across Central Asia; adults make post-breeding moult migrations to traditional refuges such as the Wadden Sea in Germany; generally winters south of breeding areas.

STATUS
Least Concern; worldwide population estimated at 3.9–4.2 million.

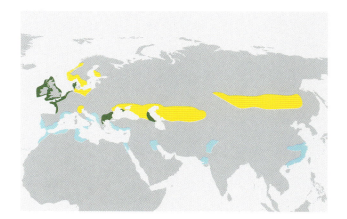

EVERY JULY SEES a curious spectacle on the vast intertidal mudflats of the Wadden Sea off the North Sea coast of Germany. Large, pale, goose-like birds gather by the thousand, paddling across the wet sands and taking to the water at high tide. These birds are Common Shelducks and at this time of year none of them can fly.

Wildfowl are unusual in that during their post-breeding moult, they shed their primary flight feathers simultaneously, rather than one by one; this means that for about a month they are flightless. To escape predators, some hide away in thick vegetation or stay out on the open water but Common Shelduck have found a different solution: they migrate.

The shelducks on the Wadden Sea come from all over northern Europe. They breed in May, with each female laying eight to ten eggs in an abandoned rabbit burrow or among tree roots and incubating them for twenty-nine to thirty-one days. A few days after hatching, the parents lead their chicks to a nursery area such as a concealed pond and leave them there. They then set off, often overnight, for the Wadden Sea.

The shelduck's moult migration continues into September. The shallow Wadden Sea is the perfect retreat for up to 180,000

of them: its tidal expanses are largely inaccessible to predators and packed with the tiny marine invertebrates required to fuel the growth of new feathers. Back at the nursery areas, the abandoned ducklings band together into crèches, presided over by a few non-breeding adults until they fledge in forty-five to fifty days.

After moulting, British Common Shelducks migrate to wintering quarters around the UK by late October while other populations head to the Mediterranean coast of southern Europe and North Africa, where they begin to pair up. By spring, they are back on their breeding grounds with males fighting vigorous territorial skirmishes.

The Common Shelduck is widespread in Central Europe, although other populations also occur across Central Asia. Goose-like in size and shape, it is unmistakable in its handsome livery of black, white, and chestnut, the male sporting a knob on his bright red bill during the breeding season. Scientists did not learn about the moult migration to the Wadden Sea until 1949. They have since discovered a number of other locations that serve the same purpose—including Bridgewater Bay in southwest England, where 5,000 or so birds gather every summer.

OPPOSITE A Common Shelduck with its recently hatched duckling. Parents leave their young in the care of non-breeding adults while they embark on a moult migration to the Wadden Sea in the Netherlands.

ABOVE An aerial view of the Wadden Sea reveals thousands of moulting Common Shelducks gathered on the tidal mudflats.

BLACK-NECKED GREBE (EARED GREBE)

Podiceps nigricollis

SIZE
L: 11–13 in (28–34 cm)
Wt: 9.3–15.9 oz (265–450 g)
WS: 22–23.5 in (56–60 cm)

APPEARANCE
Small, rounded, and apparently tail-less; long neck, short bill, red eye; breeding: chestnut flanks, brown back, black head and neck, golden ear tufts; non-breeding: black cap, dark gray/brown above, pale white/gray below.

LIFESTYLE
Feeds on insects, fish, tadpoles and other small aquatic animals, at surface or by diving; breeds in colonies on freshwater lakes; female lays 3–4 eggs.

RANGE AND MIGRATION
Breeds across northern hemisphere in Europe, Asia and North America, also in east and southern Africa; migrates to winter in coastal areas, generally to south of breeding areas.

STATUS
Least Concern; worldwide population estimated at 3.9–4.2 million.

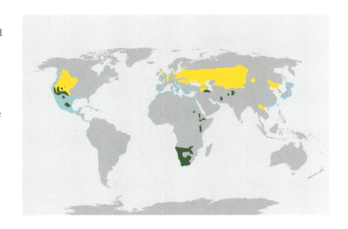

GREBES ARE BUILT for swimming. Legs set far back along their bodies power them deep below the surface but are next to useless for locomotion on land. Indeed, even their nest is built floating on the surface so they don't have to clamber ashore. They are also highly inefficient flyers and may go months without taking to the wing. It may seem surprising, then, that the Black-necked Grebe—known in North America as the Eared Grebe—undertakes annual migrations that may cover thousands of miles, even traveling across deserts to reach its moulting grounds and winter quarters.

This species is the commonest of twenty-two grebe species worldwide, best identified in breeding plumage by its rich rufous flanks and the golden "ear" tufts behind its striking red eyes. It breeds on freshwater lakes across the Northern Hemisphere and in scattered locations in southern and eastern Africa, where its large breeding colonies are often built alongside those of other waterbirds. Each pair builds a floating nest of aquatic vegetation anchored to a water plant, often so close together that brood parasitism is common between neighbors.

After the chicks hatch at twenty-one days, the parents desert the nest and head out separately with their progeny divided up between them. Just a few days later, they leave the youngsters to fend for themselves.

After breeding, Black-necked Grebes set out to find a safe place in which to moult, such as a saline lake, where their usual diet of insects, small fish, and other freshwater animals switches to one tiny crustacean: the Brine Shrimp. Huge numbers gather at such sites: Over 750,000 Black-necked Grebes have been recorded in late October at Mono Lake, central California. The birds are unable to fly for two months or more while completing their moult but their diet allows them to pile on the fat reserves needed for onward migration to the coast where they overwinter generally south of the breeding grounds: birds breeding in Central Europe winter in the Mediterranean, while those breeding in the central USA winter around Baja California and the Gulf of Mexico.

Migration can be dangerous for Black-necked Grebes and, in unseasonal bad weather, the birds may crash land: thousands have died en masse when struck by early snowstorms. On their winter quarters, the birds are also vulnerable to marine hazards such as oil spills. Nonetheless the Black-necked Grebe is a numerous species, and is listed as Least Concern by the IUCN.

OPPOSITE Winter sees the Black-necked Grebe shed its rich breeding colors and exchange the quiet pools on which it breeds for choppier coastal waters.

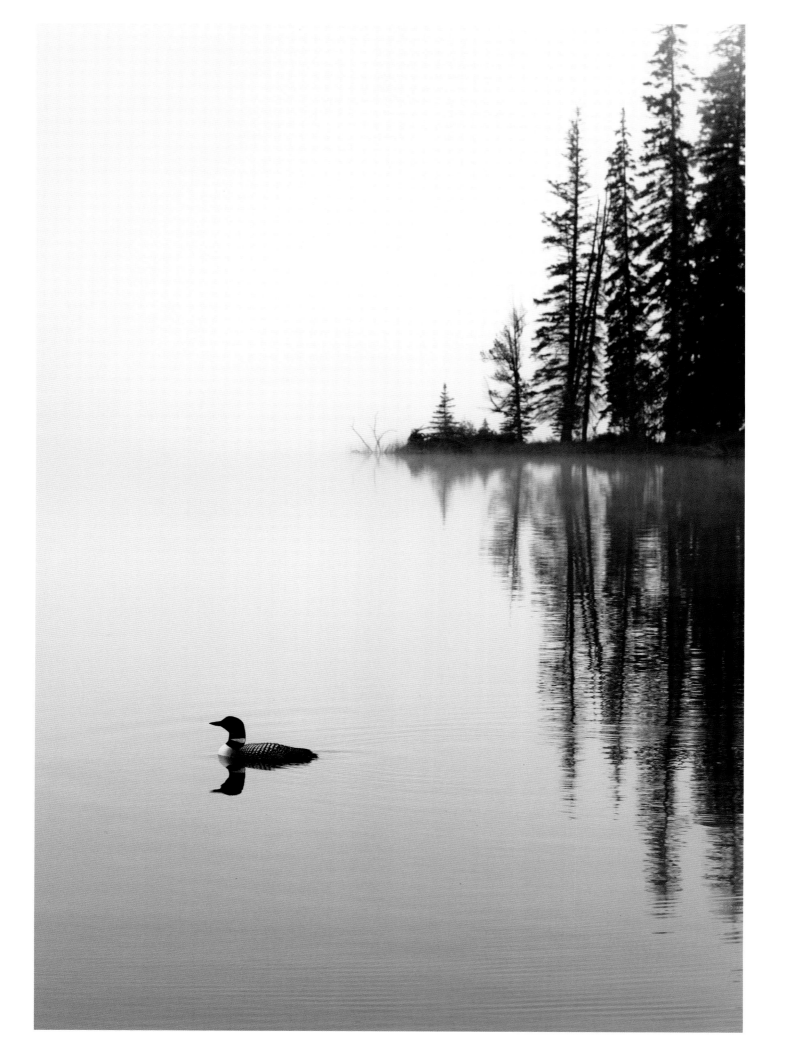

GREAT NORTHERN DIVER (COMMON LOON)

Gavia immer

SIZE
L: 26–36 in (66–91 cm)
Wt: 4.9–16.8 lb (2.2–7.6 kg)
WS: 4 ft 2 in–4 ft 10 in
(127–147 cm)

APPEARANCE
Large waterbird with thick
neck, powerful bill, and no visible
tail; sits low in water; breeding
plumage: blue-black head and
neck with white "necklace"
markings, black upperparts
with white checks and spots;
non-breeding plumage: gray-
brown above, pale below.

LIFESTYLE
Captures variety of fish and some
other aquatic prey by deep diving
below surface; takes up individual
territories on forest lakes, raising
1–2 young each year.

RANGE AND MIGRATION
Breeds on freshwater lakes across
northern North America,
Greenland, Iceland and Svalbard;
migrates south to winter on coast
and ice-free lakes.

STATUS
Least Concern; estimated
worldwide population 612,000–
640,000 individuals

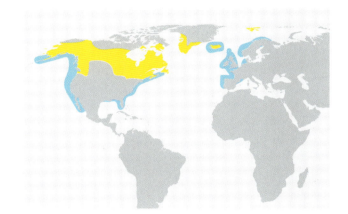

THE GREAT NORTHERN Diver perfectly illustrates the "split personality" of a migrant. During the breeding season, this bird is the living embodiment of the northern lakes, its haunting calls the subject of ancient folklore. In winter, however, it falls silent, sheds its spangled robes and disperses across the cold, gray coastal oceans—another anonymous traveler, until spring returns.

Loons move awkwardly on land, with their feet placed so far to the rear that they cannot walk properly. In the water, however, their deep dives and dagger-like bill enable them to capture the fastest fish. One of five diver species worldwide, this species is known in America as the Common Loon. In summer, it is beautifully patterned with white checks, spots and "necklaces" on its blue-black upperparts. In winter, it is a more subdued gray/brown above and pale below.

The breeding range of the Great Northern Diver covers much of the northern USA and Canada up to the Arctic Circle and also extends east to southern Greenland, Iceland, and Svalbard. Prime breeding habitat comprises forested freshwater lakes with enough room for taking off by running on the surface—a necessity for this heavy bird. A male often

claims a whole lake as its breeding territory, using various far-carrying nocturnal wailing calls to assert ownership and keep in contact with his mate. The female lays two eggs and incubation lasts twenty-eight days. The chicks can dive within days of hatching but are unable to fly for seven or eight weeks.

Soon after breeding, adults head south, while young birds depart a few weeks later. Their winter quarters comprise coasts, bays, and unfrozen inland water bodies; some 4,000 winter offshore in the UK. The species migrates alone or in small groups, traveling by day and flying at up to 8,860 ft (2,700 m) to stay above the more turbulent air. Reaching speeds of 75 mph (120 km/h), they cover impressive distances, with journeys from Winsconsin to Florida recorded. Pairs spend winter apart but are reunited in spring.

On the breeding grounds, adult divers face few threats and individuals can live for more than twenty-nine years. During migration, divers sometimes crash-land on wet runways or car parks, mistaking them for water, and become unable to get airborne again. Oil spills also take their toll. At present, the species is listed as Least Concern.

OPPOSITE An adult Common Loon parades its
striking monochrome breeding plumage.

MAGPIE GOOSE

Anseranas semipalmata

SIZE
L: 28–35 in (71–89 cm)
Wt: 4.4–6.6 lb (2–3 kg)
WS: 49–64 in (125–165 cm)

APPEARANCE
Large and long-necked; black head and neck; black-and-white body; pale orange legs; pink/orange bill with face shield.

LIFESTYLE
Breeds during rainy season in tropical wetlands, feeding on aquatic grass seeds; migrates during dry season to permanent water bodies, feeding on corms of aquatic plants; polygamous breeder, each female laying 8 eggs on average.

RANGE AND MIGRATION
Northern Australia and southern New Guinea; migrates from breeding grounds to permanent water sources during dry season.

STATUS
Least Concern; worldwide population estimated at 1 million.

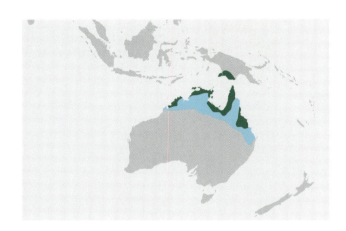

ON A JULY evening in Kakadu National Park, Australia, skeins of geese straggle across a sunset sky. The dusty air and drifting smoke of bushfires intensify the vivid colors and the birds' squeaky honking—like a chorus of children's toys—swells to a roar as the skeins coalesce into a single flock. They wheel around above the billabong where they'll be spending the night.

When we think of wild geese on migration, we generally imagine a journey that crosses latitudes, the birds fleeing the frozen conditions of the north for milder climes further south and returning in spring, once their breeding grounds have thawed. In the tropical climate of Australia's Northern Territory, however, it is fluctuations in rainfall rather than temperature that trigger the mass movement of the Magpie Goose. These movements may take any direction.

July marks the height of Kakadu's dry season, known to the local Kunwinjku people as *Wurrgeng*. At this time of year, the lush wetlands where the geese breed during the rains have dried up, the grasses withering and the waters receding. Now with fledglings in tow, the geese move en masse, traveling to the few reliable sources of permanent water across the region. There,

they crowd the shrinking pools in great numbers, alongside egrets, herons, ibises, and other water birds. Forsaking the wild rice and other grasses that sustained them during the rains, they now use their sharp, hooked bills to dig out the nutritious corms of water chestnuts, blue lilies, and other plants beneath the mud.

Come the summer season, known as *Gudjewg*, life is very different. The bush explodes with greenery, water flows everywhere, and the skies boil with regular thunderstorms. By November, the geese are back at their breeding colonies on the lush wetlands. Males pair up with two or more mates—the Magpie Goose is polygamous—and build their nests on floating platforms among the tall spear-grass. Each female lays around eight eggs, but with two birds involved, a nest may accommodate a combined total of up to fifteen. Incubation is shared and males take the lead in raising the young.

The Magpie Goose is an unusual bird—and not only for its breeding habits. Although the shape of its bill and its general build mark it out clearly as a member of the order Anseriformes (incoporating the ducks, geese, and swans), it differs from other members of this group in several ways. These include

OPPOSITE A female Magpie Goose with her newly hatched clutch in the tropical wetlands of Australia's Northern Territory.

the structure of its feet, which have strong claws and are only partially webbed (hence its scientific species name *semipalmata*), and also its moult pattern, which takes place gradually, unlike that of other ducks and geese, ensuring that the birds never lose their powers of flight. Fossils have revealed that the Magpie Goose is, in fact, the last living representative of a more ancient lineage of wildfowl that diverged from the ancestral form before today's other ducks, geese, and swans. Accordingly, taxonomists have placed it in a family all of its own: the Anseranatidae.

Whatever its taxonomy, the Magpie Goose and its migration are integral to the ecology of Australia's northern tropical wetlands—and also to its ancient human culture. Known as *manimunak* to the local Kunwinjku peoples, this abundant bird has long been an important seasonal source of protein. When flocks gather on the dry season billabongs, growing fat on water chestnuts, they become an important target for local hunters, whose traditional hunting methods include hurling sticks and even capturing the birds from below

the water using hollow reeds as snorkels (although today a shotgun will do just as well). During the summer breeding season, hunters also harvest the birds' eggs—although not in quantities sufficient to deplete the population.

Magpie Geese once ranged more widely across Australia, being common in the other wetlands of South Australia. Heavy hunting eradicated them in many areas, however, as did the drainage of the wetlands on which they depend. Today they are found only across the northern reaches of the continent, ranging from the Fitzroy River in Western Australia to Rockhampton in Queensland. They also occur in southern New Guinea. The largest population is in Kakadu National Park, where peak counts may exceed 500,000 birds. Traditional hunting by local communities is still permitted but greater threats to the species lie in the increased inundation by seawater of some of its floodplain habitat and the encroachment of invasive species such as para grass (*Brachiaria mutica*) and giant sensitive plant (*Mimosa pigra*).

OPPOSITE AND ABOVE After breeding, Magpie Geese gather in large flocks and migrate away from the drying wetlands with their fledglings to wherever they can find pools of more permanent water.

WILDFOWL AND DIVING BIRDS

02 | SEABIRDS

THE OCEANS COVER some 71 percent of the earth's surface so it is hardly surprising that many species of bird have adapted to a life at sea. Some, such as gulls, are largely coastal birds, seldom straying far from continental shelves. Others, such as albatrosses, are truly pelagic, breeding only on remote oceanic islands and spending much of their lives wandering over the waves, far from land.

Many seabirds, just like landbirds, are seasonal migrants. Unlike their land-based cousins, however, they are adapted to finding food at sea. The Arctic Tern, perhaps the best-known of all long-distance migrants, does not need to fuel up on its breeding grounds before departure but can meander south more slowly, catching fish along the way. Such birds cover some truly extraordinary distances—none more so than this species, with an annual migration between Arctic and Antarctic regularly exceeding 50,000 miles (80,000 km).

The ocean's surface is not homogeneous: Seasonal currents determine the distribution of resources, and many migration routes of birds have evolved to exploit these. The Short-tailed Shearwater, for example, completes a vast loop migration between its New Zealand breeding grounds and Alaskan wintering grounds which allows it to take in the most productive areas of the Pacific at peak season on its way.

Shearwaters, albatrosses and other pelagic seabirds are uniquely adapted to wander the oceans: high-aspect ratio wings allow them to glide great distances by harnessing the up-drafts of waves; glands next to their bills enable them to excrete excess salt; and a strong sense of smell helps them locate floating food from afar. These birds belong to the tubenose order Procellariiformes, all of which live long and mature slowly. Some may not breed until the age of twelve, having first circumnavigated the Southern Ocean many times. Some are huge: The Wandering Albatross's 11 feet (3.3 m) wingspan is the largest of any bird. But smaller ones such as the tiny Wilson's Storm-petrel are just as hardy. These sparrow-sized seabirds wander over more than two-thirds of the world's ocean surface, yet each year return to breed on a scattering of tiny islands around the edge of the Antarctic Circle.

Not all seabirds migrate by flying. Atlantic Puffins are among many auk species of the family Alcidae whose chicks leave the nest flightless and must swim away from their breeding colonies to spend their first winter out at sea. Penguins—the best avian swimmers—may migrate thousands of miles from the breeding colonies to their winter feeding grounds; for the Emperor Penguin, this starts with a trek over the Antarctic ice-sheet, walking and tobogganing on its belly to reach the open sea.

The tropics also have their long-distance travelers. Great Frigatebirds use their lightweight build to drift for months on end: One individual flew non-stop for 185 days, covering 34,000 miles (54,700 km) as it looped around the equator. Sooty Terns may spend years wandering the equatorial regions without ever touching down on land. Neither of these species has waterproof plumage so they pluck their food from the waves without risking waterlogging by landing.

Since the 1990s, satellite tracking has revolutionized our understanding of seabird migration, revealing not only the distances that many species cover but also the complex routes they follow. Data loggers pinpoint the location of birds thousands of miles from land by calculating co-ordinates from recorded light levels. Thus scientists have recently learned that British populations of the Red-necked Phalarope—a shorebird so adapted to ocean life that it sits comfortably in this chapter—migrate right across the Atlantic to winter off the Pacific coast of Central America, overturning previous assumptions that they joined other populations in the Indian Ocean.

Such discoveries are vital to seabird conservation. These feathered wanderers have evolved to withstand some of the most challenging conditions on the planet; indeed, for thousands of years, sailors have used their movements to navigate around bad weather or toward land. However, evolution has not equipped them to deal with anthropogenic damage to their environment, from long-line fishing and floating plastic waste to the depletion of precious fish stocks. Today, for example, all twenty-two of the world's albatross species are listed by the IUCN at some level of conservation concern, with three species Critically Endangered. All seabirds need our help.

OPPOSITE White-faced Storm-petrels, like all their kind, patter the ocean surface with their feet to stir up plankton and other food.

WANDERING ALBATROSS

Diomedea exulans

SIZE
L: 3 ft 6 in–4 ft 5 in (107–135 cm)
Wt: 13–28 lb (5.9–12.7 kg)
WS: 8 ft 3 in–11 ft 6 in (2.51–3.5 m)

APPEARANCE
Huge; on ground, resembles
outsized gull, with massive pink
bill; in flight, long narrow wings
have the widest span of any bird;
adult, white, with black markings
on wing edges; immature,
chocolate-brown with white
markings, progressively becoming
whiter with age.

LIFESTYLE
Feeds on squid, small fish, and
offal at or just below ocean surface;
breeds on oceanic islands; lays 1
egg every 2 years; fledgling takes
11–15 years to reach maturity; may
live 60 years or more.

RANGE AND MIGRATION
Breeds on South Georgia and other
outposts in the southern oceans;
circumpolar non-breeding
distribution at latitudes of
28–60°S.

STATUS
Vulnerable; worldwide breeding
population 26,000 pairs.

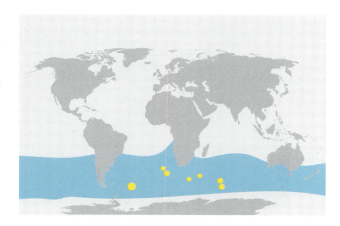

FEW MIGRANTS ARE more aptly named than the Wandering Albatross. Any vessel plying the vast expanses of the Southern Ocean can expect to meet this huge nomad sooner or later. Banking effortlessly on long, narrow wings, it glides low over the swell without so much as a flap—at times drifting away to the horizon, at others sweeping close to reveal its great size. This bird seems almost more of a hang-glider than a bird, its average wingspan of 10 feet (3 m) is much the largest of any flying creature and may sometimes top 12 ft (3.65 m).

Exactly where this albatross wanders is more difficult to ascertain. Its migration is not simply a return journey between two locations. Rather, its breeding quarters—which comprise a handful of islands in the Southern Ocean—offer only temporary residence. For the rest of its life, the bird is at sea, following the winds and currents to wherever the feeding is most bountiful. Given that it breeds only once every two years, taking a "sabbatical" year between, and that a youngster does not return to its breeding colony for at least six years after fledging, the open ocean is truly its home. In the course of this nomadic life, the Wandering Albatross covers astonishing distances: Individual birds may circumnavigate the Southern

Ocean three times in one year, covering more than 75,000 miles (120,000 km) in the process. Flying at an average speed of 25 mph (40 km/h), they may cover 590 miles (950 km) per day.

So how does it achieve these extraordinary feats? Like all albatrosses and other smaller members of the Procellariiformes ("tubenose") order of pelagic seabirds, the Wandering Albatross uses a technique known as "dynamic gliding." The high aspect ratio of its long, narrow wings allows it to harness the updraft from breaking waves, gaining lift by angling into the wind then turning diagonally to glide along the next wave. In this way, it can zigzag for countless miles across the ocean and remain in the air for hours, with no need to flap. An adaptation of the tendons at the base of its wings locks them into an extended position without exerting any muscular strain. Indeed, an albatross expends no more energy in flight than when sitting on its nest.

This albatross is the largest of six very similar species known as "great" albatrosses (the genus *Diomedea)*. It breeds only on the Southern Hemisphere outposts of South Georgia, Crozet Islands, Kerguelen Islands, Prince Edward Islands, and Macquarie Island, but its winter wanderings span the southern

OPPOSITE The Wandering Albatross makes its immense journeys on the longest wings of any bird, measuring up to 12 feet (3.65 m) across.

ABOVE A Wandering Albatross cruises past the icebergs of Antarctica.

oceans, ranging between latitudes of 28° and 60°S. Thus, its non-breeding range of 25 million square miles (65 million sq km) is more than 34,000 times its breeding range of 730 square miles (1,890 sq km).

Like other albatrosses, this species feeds on squid, small fish, crustaceans, and other food gleaned from the ocean's surface, largely at night. A key component of its diet is offal and by-catch, which is why it follows ships. An individual may gorge on 6 lb (2.7 kg), a quarter of its own bodyweight, at a sitting. A meal this big often prevents take-off and the bird may vomit up its stomach contents to get airborne.

Among the special adaptations that equip albatrosses for ocean life are tubular nostrils, which power a much stronger sense of smell than found in most birds and enable them to locate floating carrion from a great distance. They also have powerful stomach acids, for breaking down this food in their gut. As with most ocean-going seabirds, glands at the base of their bill absorb salt from their system and expel it in the form of a saline solution through a regular drip down the bill.

Wandering Albatrosses mate for life but breed only once every two years. Courtship starts at the colony in early November with noisy displays of bill clapping, head-waving, wing-spreading, and braying. The pair build a conical nest mound of mud and vegetation on an exposed ridge, where the breezes assist with take-off. The female lays a single egg in mid/late December and incubation lasts eleven weeks. When the chick hatches, the parents alternate roles: one sitting while the other forages, returning to feed their charge on regurgitated stomach oils. The hatchling remains in the nest longer than any other bird, not fledging for at least a year, after which it wanders the high seas.

These slow-growing birds do not return to their natal colony for six years, and even then don't breed for eleven to fifteen years. Indeed, with a lifespan that may reach sixty years, their life history is not so different from our own. Scientists using GPS transmitters have discovered that non-breeding foraging areas vary from one population to another and that prevailing wind direction is critical to migration routes and strategies. For example, birds from the Crozet Islands that winter off the coast of New Zealand will return via the Pacific, following strong circumpolar westerly winds; this makes a return journey of 13,000 miles (21,000 km) after their outward journey of 5,000 miles (8,000 km)—a "deviation" of 8,000 miles (13,000 km).

This bird's scientific species name *exulans* derives from the Greek for "exile." With its lifestyle of wandering and endurance on the world's wildest oceans, it is hardly surprising that it has long held a totemic significance for sailors. Indeed, in some cultures, its death was seen as an ill omen, as depicted in Coleridge's *The Rime of the Ancient Mariner*. Adult albatrosses encounter few natural dangers; unfortunately, recent times have seen them fall victim to a number of anthropogenic threats, from longline fishing—where birds drown when captured on the baited hooks—to the ingestion of plastic waste. Today, with some 26,000 breeding pairs, this species is listed as Vulnerable and is, like all albatrosses, the focus of concerted conservation efforts.

ABOVE A Wandering Albatross joins Cape Petrels and Southern Giant Petrels to feed off Kaikoura, New Zealand.

OPPOSITE A pair of Wandering Albatrosses perform their breeding display against the mountainous backdrop of South Georgia.

GRAY-HEADED ALBATROSS

Thalassarche chrysostoma

SIZE
L: 32 in (81 cm)
Wt: 6.2–9.7 lb (2.8–4.4 kg)
WS: 7.2 ft (2.2 m)

APPEARANCE
Large; ash-gray head, throat, and upper neck, with pale crescent behind eye; sooty brown upper wings, mantle, and tail; white belly and rump; bill black with bright yellow upper and lower ridges; in flight, long narrow wings show white underside with dark outline.

LIFESTYLE
Feeds on squid, crustaceans, fish, and other food from ocean surface; breeds on oceanic islands; lays 1 egg every 2 years; fledgling takes up to 10 years to reach breeding maturity.

RANGE AND MIGRATION
Breeds on oceanic islands in Southern Hemisphere, notably South Georgia; circumpolar non-breeding range across all southern oceans.

STATUS
Endangered; worldwide population of 250,000 in steep decline.

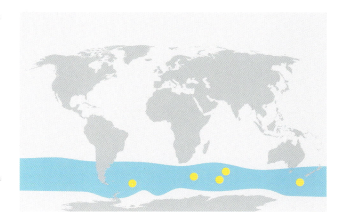

THIS WIDESPREAD AND attractive albatross belongs to the genus *Thalassarche*, whose members, also known as "mollymawks," are smaller than those of the genus *Diomedea*, such as the Wandering Albatross (see pages 64–69). Nonetheless, it is no less inclined to wander. Indeed, studies of this species have revealed migratory movements just as impressive as those of its enormous cousins.

Though modest in size by albatross standards, this is nonetheless a very large bird with an average wingspan greater than that of a Golden Eagle. Its scientific species name *chrysostoma* means "golden-mouthed" and refers to the bright yellow edges to the bill. Otherwise, it is identifiable by the soft blue-gray head and neck, and the white rump that contrasts with its dark upper wings and tail. Like all albatrosses, it has tubular structures on its bill called naricorns that amplify its olfactory powers—important when locating scattered food on the ocean surface—and salt glands that excrete excess salt from its system. It also produces stomach oils that provide vital sustenance for both growing adults and traveling adults, and which can be vomited up in self-defence at predators such as giant petrels, which target nestlings.

The Gray-headed Albatross breeds on a limited scattering of islands and spends its non-breeding time ranging the southern oceans in search of food. In the sixteen months between breeding seasons, individuals may travel up to 150,000 miles (240,000 km) and wander further south than any other in the mollymawk genus. What's more, they may do so at exceptionally high speeds: In a 2004 study, one individual was recorded traveling at an average speed of 78.9 mph (127 km/h) over eight hours while returning to its nest from a feeding trip, earning the species an entry in the *Guinness Book of World Records* as the world's fastest bird in level flight.

The principal nesting colonies of this species are on South Georgia. Smaller populations also breed on the Islas Diego Ramirez, the Kerguelen Islands, Crozet Islands, Prince Edward Islands, Marion Island, and Campbell Island. A pair nests once every two years, if their first attempt is successful. The female lays her single egg in mid-October. It is incubated, largely by the male, for seventy to seventy-two days until hatching in mid-December, whereupon the pair feed their voracious chick with up 21 oz (616 g) of food per day. After four and a half months, the youngster fledges. It then sets out,

OPPOSITE A Gray-headed Albatross broods its slow-growing chick at a breeding colony on the windswept slopes of South Georgia.

typically in mid-May, to wander the oceans, not returning for six or seven years to the island where it was raised, where it still won't breed for several years more.

Today, the Gray-headed Albatross is listed as Endangered by the IUCN, its numbers having fallen some 40 percent over the last ninety years. The South Georgia colonies, home to around half the breeding population, have seen the steepest declines. In an effort to address this problem, scientists have conducted intensive research into the species' movements outside the breeding season. In one 2018 study, they fitted tiny geolocators to the legs of sixteen fledglings on Bird Island, South Georgia, prior to their departure. The data these returned revealed that most birds headed straight to key Japanese fishing grounds, where the species is often reported caught as by-catch. This corroborated suspicions that the Gray-headed Albatross is especially vulnerable to the dangers of long-line fishing, its appetite for squid, crustaceans, lampreys, and other surface food causing it to become ensnared by the countless hooks that are dragged for miles behind fishing vessels.

Other studies have also produced further insights. They have revealed, for example, that male Gray-headed Albatrosses tend to venture further south than do females, perhaps because they can better withstand the rougher seas at those latitudes. They have also shown that birds from island colonies in the southern Indian Ocean fly directly past the foraging areas in the south Atlantic in order to avoid competition with birds from the breeding colonies in that area. With this increased understanding of the birds' movements, conservationists can better work with fishing fleets and governments on strategies that mitigate against the heavy toll of albatross by-catch. These strategies include new technology to make hooks and lines albatross-proof.

Meanwhile, back at the colonies, the birds face other problems. It is significant that seven of the tagged juveniles in the 2018 study didn't even make it off the island, falling prey to predatory giant petrels and skuas before they were strong enough for departure. Depleted breeding colonies are much more vulnerable to such opportunists and less able to offer a collective defence. Conservationists hope that greater protection for birds on their wanderings will enable them to rebuild their colonies to full strength and that the decline of this ocean wanderer can be arrested.

RIGHT The Gray-headed Albatross may wander 150,000 miles (240,000 km) between breeding seasons.

ARCTIC TERN

Sterna paradisaea

SIZE
L: 13–14 in (33–36 cm)
Wt: 3–4.5 oz (86–127 g)
WS: 30–33 in (76–85 cm)

APPEARANCE
Small and elegant with long wings and long, forked tail; pale gray, appearing largely white, with contrasting white cheeks and black crown and nape; appears white in flight; fine, red bill and short, red legs.

LIFESTYLE
Feeds on small fish and marine invertebrates at or just below surface, often plunge-diving; breeds in large coastal colonies; female lays 1–3 (average 2) eggs in shallow ground nest.

RANGE AND MIGRATION
Breeds around Arctic Circle, in Europe, Asia, and North America; winters around Antarctic Circle; migration routes follow Atlantic and extend east to staging areas in Indian Ocean.

STATUS
Least Concern; global population more than 2 million individuals.

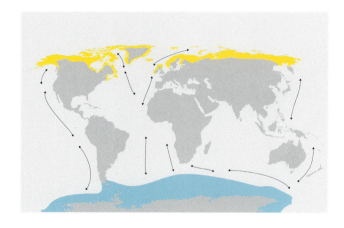

THE ARCTIC TERN is a bona fide "A-lister" among migratory animals: the poster bird for migration in countless children's books and encyclopedias. It is celebrated, above all, for the distance of its journeys, which may total the equivalent of three return trips to the moon over one bird's lifetime. Indeed, this species is a true record breaker: Other seabirds may clock up as many miles in their annual wanderings but no species migrates further between defined summer and winter quarters.

These seasonal quarters are at opposite ends of the earth. The bird breeds within and around the Arctic Circle, its range extending along the northern coastlines of North America, Europe, and Asia and reaching as far south as northern France and Massachusetts, but it winters around the Antarctic Circle, using key hotspots such as the Weddell Sea. Because it breeds during the northern summer and winters during the southern summer, this bird never experiences a winter. Indeed, it may see more daylight than any other animal on the planet.

Unlike the enormous albatrosses, the Arctic Tern appears a mere slip of a creature: too fragile, you might imagine, to complete such a monstrous journey. Yet this bird is built to travel. Long, slim wings power a buoyant flight, enabling it to spend days on the wing, gliding for long periods and even snatching brief naps, while its prowess as a fisher—plunge-diving from above to snatch small fish and marine invertebrates just below the surface—means that it is never short of food along the way.

It has long been known that the Arctic Tern travels vast distances. In 1928, an individual banded in July in Labrador, Canada, was retrieved in South Africa just four months later. However, the recent advent of satellite tracking via lightweight geolocators fixed to the bird's feet has revealed that previous estimates fell far short of the truth. A group of Arctic Terns thus tagged in the Netherlands in 2013 were found to have covered an average distance of 56,000 miles (90,000 km) in a single year.

These geolocators have also revealed that the routes the birds take are not as straightforward as you might imagine from a glance at the map. The Netherlands' study found that the birds traveled south down the west coast of Europe and Africa, but then—instead of continuing due south to Antarctica—rounded the Cape and diverted east, almost reaching Australia,

OPPOSITE A pair of Arctic Terns perform an elegant nuptial display, having recently arrived at their breeding grounds on Scotland's Shetland Islands after a mammoth journey from Antarctica.

LEFT Even migrating seabirds take a break. An Arctic Tern finds a temporary perch on floating sea ice off the coast of Svalbard.

before heading south to Wilkes Land in northeast Antarctica and then making their way back west around the Antarctic continent. This helps explain why, in 1982, a bird banded in the Farne Islands, northeast England, was retrieved three months later in Melbourne, Australia.

Not all the birds in one colony follow the same route. A 2007 study in northeast Greenland conducted by the Greenland Institute of Natural Resources tagged ten birds with geolocators. All departed their colony in late July and spent their first month in the North Atlantic, presumably at a feeding hotspot. In September, all headed south to the Equator—but at this point some continued east down Africa's western coast while others went west, crossing the Atlantic and continuing down the east coast of South America. By November, all had come together to spend winter in Antarctica's Weddell Sea. Leaving in April, they then took an "S"-shaped return route: first to Africa, then across the Atlantic, crossing the Equator in May and finally winding back up the North Atlantic to arrive on their Greenland colony by the end of the month. With the imperative of reclaiming their breeding territories, this return migration was much quicker than the outward one.

Such observations confirm that the Arctic Tern, like most pelagic migrants, does not simply follow the shortest route but navigates to take into account such variables as wind and food. Further studies of the Farne Islands colony in 2015 revealed that, after rounding the Cape of Good Hope, the birds spent October at a staging area in the southern Indian Ocean and then November at a second staging area off eastern Antarctica, not arriving in the Weddell Sea until February 2016. By the time they returned to their breeding grounds in May, some had covered 59,650 miles (96,000 km)—more than twice the circumference of the earth. Not only do such studies illuminate the lives of the terns, they also produce vital insights into broader ocean ecology, revealing seasonal hotspots on which many other species also depend for food.

Back on their breeding grounds, Arctic Terns form large colonies on open ground near the coast. Each pair renews its bonds with elaborate courtship displays that include offering gifts of fish. The nest is a simple scrape in the ground lined with a little plant material, in which the female lays an average of two eggs. Incubation lasts twenty-two to twenty-nine days and the chicks fledge twenty-one to twenty-four days after hatching. The parents are extremely aggressive in defending their nests, dive-bombing predators such as foxes, skuas, and even people—readily striking anybody who wanders too close and even drawing blood with their sharp bills. Sometimes a whole colony will arise en masse to drive off an intruder, filling the air with their shrill calls.

Once fledged, young Arctic Terns head off with their parents on the long journey south. They may go on to live thirty years or more. The species is listed by the IUCN as Least Concern, with an estimated population of more than two million individuals. However, breeding populations are in decline in some of the more southerly nesting grounds and scientists fear that the impact of global warming on fish stocks may be part of the cause.

LEFT An Arctic Tern chick peeks out from between its parent's primaries. If it survives its first year, this youngster may live to fly the equivalent of three return journeys to the moon.

RED-NECKED PHALAROPE

Phalaropus lobatus

SIZE
L: 6.5–8 in (17–20 cm)
Wt: 1.2 oz (35 g)
WS: 15 in (38 cm)

APPEARANCE
Small wader with lobed toes and needle-like bill that swims like waterbird; in breeding plumage, gray body with chestnut neck and breast, black face and white throat—female larger and brighter than male; in non-breeding, white below and gray above with dark face mask.

LIFESTYLE
Feeds on marine invertebrates in fresh and saline water, gleaned at the surface while swimming; breeds beside tundra pools; polygynous—female lays clutches of about 4 eggs with several males, who incubate eggs and rear young.

RANGE AND MIGRATION
Breeds around the Arctic Circle, in northern Europe, Asia, and North America; winters in tropical seas, including southeastern Pacific, Arabian Sea, and eastern Indian Ocean.

STATUS
Least Concern; global population estimated at 3.6–4.5 million individuals.

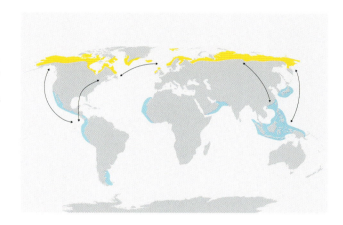

"WHEN I WAS eventually given the email, it nearly knocked me off my seat," recalls Malcolm Smith of the UK's Royal Society for the Protection of Birds. "We knew that the southeastern Pacific was an important wintering area for North American phalaropes, but we didn't expect our birds to be joining them."

Smith was responding to the results of a 2012–2013 study on the Shetland Islands, Scotland, that dramatically overturned long-held assumptions about the migration of a small wader called the Red-necked Phalarope. A male that he had tagged with a tiny 0.2 oz (6 g) geolocator on its breeding grounds in summer 2012 had returned on June 19, 2013. To his amazement, the data carried in the geo-locator revealed that, after leaving its breeding grounds, this individual had first crossed the Atlantic Ocean to the east coast of North America and had then journeyed south to the Gulf of Mexico. By mid-September, it had crossed Central America to the Pacific Coast of Costa Rica and by mid-October it had reached its wintering grounds off the coast of Ecuador, where it had remained until the following April, when it began its return journey. Now, in mid-summer, it was back on the Shetlands, ready to breed.

What was astounding about this information—quite apart from the distances involved—was that scientists had previously believed that all European Red-necked Phalaropes migrated *southeast* after breeding, crossing Europe and the Middle East to winter in the Arabian Sea. If this Shetland bird was typical of its population, it seemed that the scientists had got it wrong—by a factor of about 10,000 miles!

In fact, the scientists were not entirely wrong. Red-necked phalaropes from Scandinavia and western Russia *do* indeed travel overland to the Arabian Sea. However, this study revealed that the UK breeders, along with those from Iceland, use an entirely different and much longer flyway, crossing the Atlantic to join birds from North American breeding populations on their southward migration to the tropical Pacific—a journey that is, on average, some 2,500 miles (4,000 km) longer.

Further studies have since revealed that this divide in the migration routes of European Red-necked Phalaropes is reflected in other aspects of their biology. The birds heading west are comparatively longer-winged than those heading east to better handle the longer flight. They also make more autumn stop-overs, to fuel up for their longer journey—

OPPOSITE The Red-necked Phalarope, although a member of the sandpiper family, is adapted for swimming and spends the winter in flocks at sea.

FLIGHTS OF PASSAGE

ABOVE In Baja California, Red-necked Phalaropes scatter as the tail flukes of a Humpback Whale break the surface.

including in Atlantic Canada's Bay of Fundy, where birds from all over Arctic Canada congregate before heading south—and they return more quickly in spring. The Pacific birds seem to remain in a relatively small area all winter; those in the Arabian Sea, where food sources fluctuate, are constantly on the move.

These are not the only two flyways used by the Red-necked Phalarope. Like many shorebirds, it has a circumpolar breeding distribution in the high latitudes of the Arctic and sub-Arctic (the tiny Scottish population represents one of the species' most southerly outposts). Thus birds from western Canada migrate down the west coast to those same Pacific winter grounds and birds from Eastern Russia migrate down the western Pacific to Japan and Southeast Asia, as far as Indonesia and even northern New Guinea. Wintering areas are also known off West Africa and Argentina.

You may wonder why a shorebird spends its winters at sea. In fact, phalaropes are not typical waders: Aided by lobed webbing on their toes—hence this species' scientific name *lobatus*—they are adapted to life on the water, swimming with all the proficiency of a duck or grebe and finding their food on the surface rather than along the shoreline. Their diet comprises small aquatic invertebrates—ranging from insects on their freshwater breeding pools to crustaceans and small fish at sea—which they pick from the surface with needle-fine bills. On shallow pools, they have a diagnostic habit of spinning to create a small vortex that stirs up tiny food items from the bottom. At sea, they gather in large flocks—especially where converging currents produce food-laden upwellings.

As if to prove it does everything differently, the Red-necked Phalarope is also polyandrous. On the boggy tundra pools where this species breeds, it is the females—larger and more brightly colored than the males—that initiate mating behavior, battling other females as they pursue suitable males. Having mated with one male and laid her clutch of four eggs in a small grass-lined depression, a female will quickly move on to the next and another after that, in each case leaving her partner to incubate the clutch and then rear the brood. Incubation takes twenty days and fledging twenty more, by which time the females are long gone—already heading south along whichever migratory flyway their population uses.

LEFT Two Red-necked Phalaropes take flight on Scotland's Shetland Islands, one wearing a ring. Research has recently established that this population migrates to winter off the Pacific coast of South America.

ATLANTIC PUFFIN

Fratercula arctica

SIZE
L: 11–12 in (28–30 cm)
Wt: 14–23 oz (400–650 g)
WS: 19–25 in (47–63 cm)

APPEARANCE
Pigeon-sized, with big, parrot-like bill and upright posture on land; in breeding plumage, black above and white below, with pale gray face, pink legs, and bright red, yellow and blue-gray bill; in non-breeding plumage, dark above and white below, with darker face and smaller, darker bill.

LIFESTYLE
Feeds on small fish by diving from surface; breeds in burrows in large colonies on cliff slopes; female lays 1 egg, with both parents raising the single chick.

RANGE AND MIGRATION
Breeds around the North Atlantic, north into the Arctic Ocean: in Europe, from northern France to Svalbard; in North America, from Maine to Labrador. Winters at sea in North Atlantic and Arctic, south to the Mediterranean.

STATUS
Vulnerable; global population estimated at 12–14 million mature individuals, but declining.

A PIGEON-SIZED BIRD bobs in the cold, choppy waters of the North Atlantic. It's alone, hundreds of miles from land. Briefly cresting the swell, it reveals dark upperparts, pale underparts, and a grayish face: nothing especially striking. Preening diligently with a thick black bill, it works hard to coat its insulating plumage with water-resistant oils from its preen gland. Soon it has ducked out of sight beneath the waves.

This anonymous-looking bird, you might be surprised to discover, is an Atlantic Puffin. It may not resemble the dapper character beloved of book covers and children's toys—the one standing proudly beside its burrow, dressed in a smart tuxedo and colorful clown's face. But that's because this is mid-winter. The multi-colored bill, smart plumage, and comical expression will reappear in spring, when it pairs up with its mate back at the breeding colony. Right now, the bird is more concerned with finding enough to eat and riding out the winter storms. Indeed, given that the species spends only four months on its breeding grounds and the rest of its life at sea, this drab-looking, ocean-going puffin is perhaps the more representative version.

We have long been familiar with the Atlantic Puffin on its breeding grounds. This unmistakable bird forms busy, noisy colonies on islands and sea cliffs at various locations around the North Atlantic. Most are on the European side, from northwest France, the UK, and Ireland up to Iceland, the Faeroes, Norway, and Svalbard. There is also a smaller population on the other side of the Atlantic, from Maine up to the Gulf of St. Lawrence, Newfoundland, Labrador, and western Greenland.

The life of the puffin at sea is rather less known. We know that some remain in the far north of the Arctic Ocean, the North Sea, and the North Atlantic, while others head further south, reaching the central Mediterranean, the Canary Islands and continuing down the US coast as far as North Carolina. We also know that they disperse widely and are largely solitary—hence the difficulty in finding, let alone observing, them. It is only with the recent advent of geolocators that scientists have been able to learn something of their movements.

The Atlantic Puffin is the smallest of three puffin species in the genus *Fratercula*, a word that derives from the Medieval Latin for "friar." This genus belongs to the Alcidae family, otherwise known as auks. All are pelagic birds, adapted for

OPPOSITE Sand eels figure prominently in the diet of the Atlantic Puffin. Stocks of this and other small shoaling fish are crucial to the bird's breeding success and migratory movements.

life at sea. Their short legs and webbed feet propel them efficiently through the water, and their wings, which power a rapid, whirring flight, are equally effective as paddles, enabling the birds to pursue fish deep underwater with the speed and agility of penguins. While that extraordinary bill may catch the eye during courtship, its primary purpose is catching the small fish—including sand eels, capelin, and herring—on which the bird subsists. It can carry dozens at a time, holding them in place with its muscular, grooved tongue while it pursues even more.

Puffins arrive at their breeding grounds in April—or, further north, in May or June. They form colonies on steep grassy slopes, nesting in burrows that they dig themselves or take over from rabbits. Pairs mate for life and return to the same burrow year after year. Decked out in fresh breeding plumage, complete with multi-colored bill, they first perform head-wagging courtship displays. Then, after a spring clean of the burrow, the female lays a single large egg inside. Incubation lasts thirty-nine to forty-five days, with both parents sharing duties. Once it hatches, they take turns to provide for the growing chick, making daily commutes to fishing grounds that may be 50 miles (80 km) offshore.

The chick leaves the burrow after thirty-eight to forty-four days, alone. It cannot yet fly properly and is vulnerable to attack by gulls or skuas, so it leaves at night, flapping, walking, and tumbling its way down to the sea. Once it hits the waves it heads straight out from shore and may be more than a mile away by day-break. It now embarks on a life at sea, not returning to its colony—or indeed setting foot on land—for two to three years, and not reaching breeding maturity for another four or five. For much of this time it is joined by non-breeding adults, who are flightless for up to two months during their moult. The birds tend to forage solo, getting together only in spring, when they gather offshore of their breeding grounds, prior to reclaiming their burrows.

Recent studies have shed more light on the migratory movements of puffins outside the breeding season. In one 2010 study on Scotland's Isle of May, 75 percent of birds fitted with geolocators traveled from the North Sea west to the North Atlantic. In a 2016 study, in Maine, USA, tagged puffins were found first to head north to the Gulf of St. Lawrence and then south to winter off Cape Cod, where underwater mountains and canyons ensure a rich food supply. It is clear that, as with all pelagic birds, fluctuations in prey items and weather dictate migratory movements.

Adult puffins occasionally fall prey to predators such as Great Black-backed Gulls or seals. However, they are resilient birds and may live to twenty-nine years of age. Today the greatest threats they face are anthropogenic ones, including oil spills and climate change. The latter is especially significant: Warming seas causing shifts in the distribution of plankton, the small fish that feed upon it and, thus, the food supply for puffins. Today, the European population comprises 90 percent of the total and is estimated at 4.7–5.7 million pairs—more than half of those being in Iceland. However, recent steep declines in many breeding colonies has led the IUCN to upgrade the conservation status of this species from Least Concern to Vulnerable.

PREVIOUS An Atlantic Puffin beside its burrow in the Shetland Islands, Scotland.

RIGHT Atlantic Puffins disperse over the open ocean, the habitat in which they spend some three-quarters of their lives.

ABOVE Short-tailed Shearwaters form huge flocks on their wintering grounds in the northern Pacific.

SHORT-TAILED SHEARWATER

Ardenna tenuirostris

SIZE
L: 15.7–16.9 in (40–43 cm)
Wt: 1.1 lb (500 g)
WS: 35.5–39 in (91–100 cm)

APPEARANCE
Dark brown, long-winged seabird, the size of medium-sized gull; uniform dark brown, appearing black from a distance, with paler gray underwings.

LIFESTYLE
Feeds on small fish and marine crustaceans by diving from surface; breeds in burrows in large coastal colonies; female lays 1 egg, with both parents raising the single chick.

RANGE AND MIGRATION
Breeds around Tasmania and the Bass Strait, southeast Australia; winters at sea in the northern Pacific as far north as the Bering Sea.

STATUS
Least Concern; 23 million pairs estimated.

IT'S LATE AUGUST in the Bering Sea, off northeast Russia. The sea erupts as a Humpback Whale breaks the surface, its huge body scattering a swarm of black birds. The birds regroup, massing in their thousands around the feeding leviathan. Lines of them drop into the water while others continue their fast, low circling.

The birds are Short-tailed Shearwaters. Seen up close, they are sooty-brown and, like all shearwaters, glide on stiff, narrow wings, utilizing the updraft from the waves. They're after small fish and marine crustaceans, using their wings to dive down and capture prey under the surface. The whales have alerted the shearwaters to a feeding bonanza.

However, these northern waters are not where the Short-tailed Shearwater starts life. The species breeds during the southern summer at the opposite end of the Pacific Ocean, in Australia—in colonies around Tasmania and islands of the Bass Strait. The largest, Babel Island, is home to some 2.8 million pairs. After breeding, the birds head north to spend the boreal summer in the rich feeding grounds of the North Pacific, ranging from Japan as far north as the Bering Sea. This migration mirrors that of the Arctic Tern (see pages 74–79) up and down the Atlantic, but in reverse. The distances it involves are almost as great, with individuals clocking up 37,000 miles (60,000 km) every year.

Mated pairs of Short-tailed Shearwaters arrive every year at their breeding colonies in October—to the same burrow. The single egg, laid in late November, hatches in late January after a fifty-three-day incubation. The adults make long feeding trips of up to a week to provision their youngster. It gains weight rapidly, though, and by the time it leaves the burrow, it is heavier than its parents. In late April the parents are gone, leaving the chick to perfect its flying skills alone.

The Short-tailed Shearwater is Australia and New Zealand's most numerous seabird, with an estimated 23 million pairs. Youngsters, known as "Mutton Birds" due to their their fatty flesh, were once harvested in the thousands for food, oil, and feathers. Today, traditional aboriginal and Maori communities still conduct a small, sustainable harvest, but a greater threat lies in birds ingesting floating micro-plastics and larger plastic items, especially with their food stocks being potentially at risk from climate change. For now, the IUCN lists the species as Least Concern.

SOOTY TERN

Onychoprion fuscatus

SIZE
L: 13–14 in (33–36 cm)
Wt: 5.2–8.4 oz (120–240 g)
WS: 32.5–37 in (82–94 cm)

APPEARANCE
Elegant, medium-sized seabird with long wings and forked tail; dark brown above and white below; black cap with white forehead; immatures uniform scaly gray/brown.

LIFESTYLE
Feeds on small fish and marine crustaceans by diving from surface; breeds on tropical islands and atolls; both parents raise the single chick after a long incubation; young do not return to land for 5 years.

RANGE AND MIGRATION
Breeds on tropical islands in the Atlantic, Pacific and Indian Oceans; migrates to feeding zones throughout the tropical oceans.

STATUS
Least Concern; 60–80 million individuals.

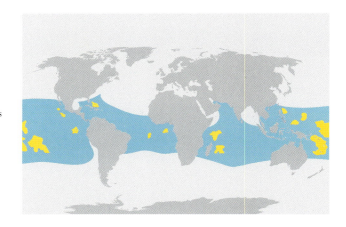

NO SEABIRD SPENDS longer in the air than the Sooty Tern. After leaving its nest as a youngster, an individual may not return to its breeding colony for five years. During this time, it will never touch down on land. What's more, the bird is not built for swimming and risks becoming waterlogged, so it hardly ever touches down on water, preferring to land on flotsam or even the backs of sleeping turtles. Studies have revealed that it sleeps on the wing, in short power naps of just a few seconds. The Sooty Tern is the seabird equivalent of the Common Swift (see pages 250–253).

This species is the most abundant seabird of the tropics, and plies the equatorial zones of the Atlantic, Pacific, and Indian Oceans. It forms colonies up to a million-strong on rocky or coral islands but, at other times, migrates to feeding zones across the open ocean.

The Sooty Tern shows the long wings, forked tail, and buoyant flight of all its kind and is easily identified by its sooty-brown upperparts. It feeds on small fish and crustaceans by plucking them from the surface waters and even catching fish in mid-air when they leap above the waves. Thousands forage together, often where whales are driving food to the surface.

Extensive studies of the large Sooty Tern colony on Bird Island in the Seychelles have shown that pairs arrive at the breeding colony in April to renew their permanent bonds by displaying. They then head south for a month or more to feed, before returning to breed in June and July. The nest is typically a small depression in the rocks. A female lays up to three eggs but the pair produces just a single chick. They share incubation for a month and feed their chick for two months until it fledges, traveling up to 296 miles (477 km) on their fishing trips. The youngster then heads out to sea and will not return until it reaches sexual maturity five to six years later.

With its delayed maturation, low productivity, long incubation and fledging rates, and pre-breeding foraging trips, the Sooty Tern has more in common with shearwaters than it does with other gulls and terns—as does the bird's longevity, which has been measured at thirty years or more.

The Sooty Tern is is known as "Wideawake Bird" in Pacific lore due to the incessant noise of its breeding colonies. In some areas, such as the Marquesas Islands, its eggs are important for food. Despite hurricanes, rats, and humans, the species remains abundant, with a worldwide population estimated at 60–80 million birds.

OPPOSITE The relentless round-the-clock noise of thousands of Sooty Terns at their Indian Ocean breeding colonies has earned them the nickname "Wide Awake Bird" among local islanders.

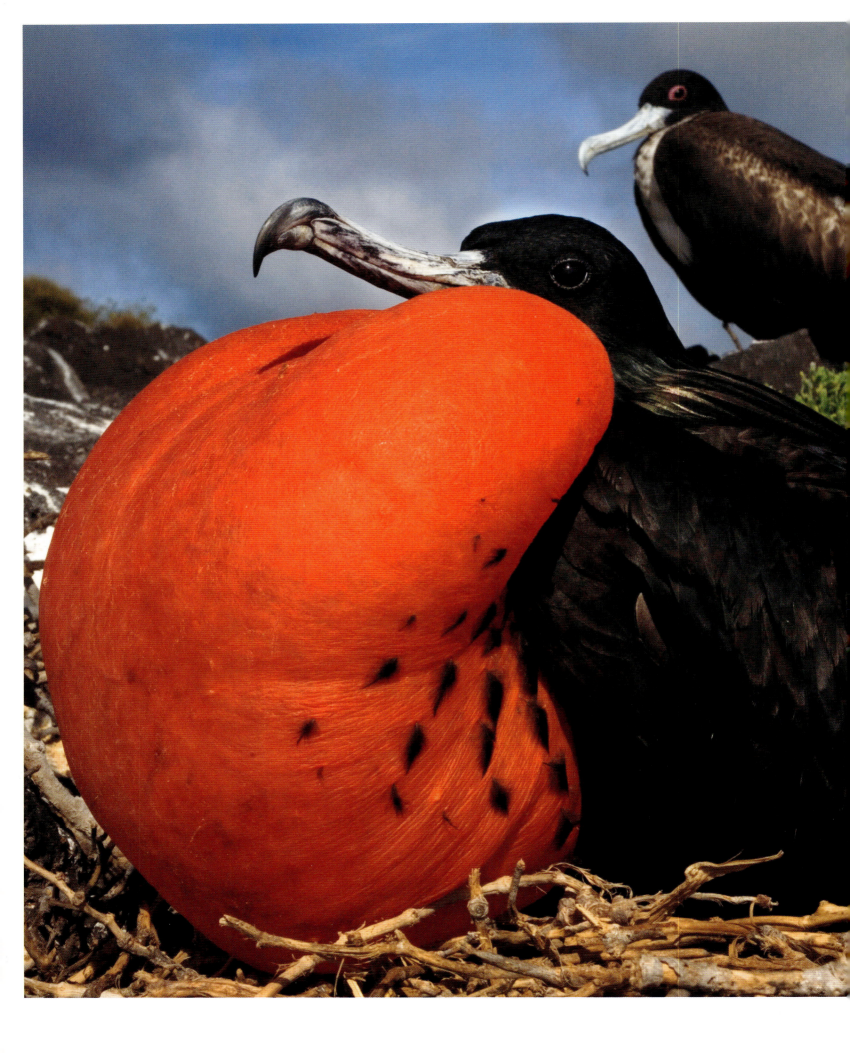

GREAT FRIGATEBIRD

Fregata minor

SIZE
L: 33–41 in (85–105 cm)
Wt: M: 2.2–3.2 lb (1–1.4 kg);
F: 2.6–3.5 lb (1.2–1.6 kg)
WS: 81–91 in (2–2.3 m)

APPEARANCE
Large seabird with long angular wings and forked tail; all black with red throat (male) or white throat (female); slow, buoyant flight.

LIFESTYLE
Feeds on fish and squid, plucked from surface in flight; may pirate food from other seabirds; breeds in coastal colonies; builds platform nest in low tree—typically mangroves; female lays 1 egg; fledgling may remain in parental care for 18 months.

RANGE AND MIGRATION
Breeds on oceanic islands and coasts in Indian, Pacific, and (marginally) South Atlantic Oceans; migrates to non-breeding feeding zones within tropical latitudes.

STATUS
Least Concern; population estimate 500,000–1 million individuals.

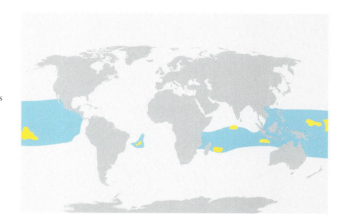

THERE IS NO mistaking a frigatebird. That long-winged, rakish silhouette hangs on its 7-foot (2.1-m) wingspan high above the ocean like a sinister-looking children's kite tethered on an invisible string. Indeed, no bird hangs in the air better than a frigatebird. With the largest wingspan-to-body weight ratio of any bird, their plumage weighing more than their skeleton, it's no surprise that these tropical seabirds are largely aerial operators and that in their wanderings they can cover thousands of kilometers with minimal effort.

The Great Frigatebird is one of five species in the family Fregatidae, which is evolutionarily allied to gannets and pelicans in the order Pelecaniformes—its big, hooked bill betraying this affinity. Like the others, it has long, angular wings, a forked tail and is largely black in plumage. Females may weigh some 10–20 percent more than males and have a white breast. Males have a glossier greenish iridescence and a patch of naked red skin on the throat that comes into its own during the breeding season.

Frigatebirds breed on tropical coasts and islands. The breeding range of this species lies between latitudes 25°N and 25°S, with colonies on the Galápagos Islands and Hawaii in the Pacific, as well as on the Seychelles, Aldabra, Christmas Island, and Mauritius in the Indian Ocean. Outside the breeding season it disperses widely, following weather patterns and prevailing currents to find the ocean's richest feeding areas, and occasionally stopping to roost on islands and atolls.

During this nomadic existence, the Great Frigatebird has little use for land, where its movements are clumsy. It is equally ill-equipped to land on the water, as its plumage lacks waterproofing oils and would quickly become waterlogged. It thus feeds entirely in the air, using its long bill to pluck its food—largely fish, squid, and other marine life—from the surface and often capturing flying fish as they leap from the water. Frigatebirds are known for their piratical pursuit of other seabirds such as boobies, harrying them until they abandon their catch. Studies suggest, however, that the Great Frigatebird probably obtains no more than 5 percent of its food in this way.

Frigatebirds are also well known for their courtship display. At the start of the breeding season, males line up at their colonies and inflate that red throat skin, known as the gular sac, into an outlandish scarlet balloon, while pointing their

OPPOSITE The male Great Frigatebird inflates his gular sac with air to form a bright red balloon, which he flaunts during a dramatic breeding display.

bills skyward. At the appearance of a female overhead, they quiver their wings and vibrate their bill against this balloon to produce a distinctive drumming sound.

Pairs are monogamous during the breeding season. They work together to build a large platform nest in a low tree. Incubation of the single egg lasts an exceptionally long fifty-five days, parents rotating three-to-six-day shifts and losing 20–30 percent of their bodyweight in the process. For the first three months, both parents feed the chick, after which the male departs and the female continues alone for another eight months. After fledging, the chick may remain under her watch for 150–248 days. This is the longest period of parental care of any bird, its length varying with food resources.

Female Great Frigatebirds do not reach breeding maturity for some eight years while males can take more than ten years before they're ready to mate; in the meantime, they wander the oceans. Studies with solar-powered geolocators have revealed that different populations follow very different patterns. Birds tagged on Europa Island, off Mozambique, made a long-distance migration across the Indian Ocean to the Seychelles. One individual flew non-stop for 185 days, making huge loops around the Equator and covering 34,000 miles (54,700 km) in the process. Youngsters from this colony departed after adults and it emerged that the immatures, non-breeding adults, and breeding adults all used separate foraging areas. Birds tagged in New Caledonia made shorter journeys to wintering areas in the southwest Pacific, and birds tagged on the Galápagos Islands remained resident within the archipelago all year round. These geographical variations may partly reflect the availability of roosting islands.

During their non-breeding wanderings, frigatebirds have no use for land other than for the occasional brief touch-down on an oceanic rock or atoll. Their lightweight build gives them the lowest wind-loading of any bird and they use this anatomy to exploit prevailing oceanic weather conditions. Thermals of warm air rising off the warmed ocean surface on the Equator give them lift and they are known to rise on cumulus clouds to heights of 5,249 feet (1,600 m). From this height, they can glide 40 miles (64 km) without flapping, before hitching a lift skyward on the next column of warming air. The bird's ability to ride oncoming weather fronts has long helped alert sailors to changing weather patterns.

Great Frigatebirds live a long time. In one 2002 study in Hawaii, ten of thirty-five banded birds recaptured were more than thirty-seven years old and one was at least forty-four. They face few natural threats in the wild. Breeding colonies have been damaged by human activity, however—including the introduction of rats and other invasive predators, and the bird has disappeared from the island of St. Helena as a result, but populations remain healthy and the bird is listed as Least Concern by the IUCN.

RIGHT Great Frigatebirds will exploit the feeding behavior of other oceanic hunters to find food. Here, they hover above the surface to pick off the fleeing bait fish being pursued by predatory sailfish.

WILSON'S STORM-PETREL

Oceanites oceanicus

SIZE
L: 6.3–7.3 in (16–18.5 cm)
Wt: 1.4 oz (40 g)
WS: 15–16.5 in (38–42 cm)

APPEARANCE
Tiny seabird with distinctive low, fluttering flight; sooty brown with white rump and belly; short bill, square tail, and comparatively long legs that dangle while foraging over waves and project beyond end of tail in flight.

LIFESTYLE
Feeds on plankton, small fish, and crustaceans plucked from surface in low flight; breeds in burrows in colonies, returning to nest after dark; female lays 1 egg.

RANGE AND MIGRATION
Breeds on remote islands in Southern Hemisphere, from Tiera del Fuego to edge of Antarctica; circumpolar non-breeding distribution in tropics and Northern Hemisphere.

STATUS
Least Concern; population estimated at up to 20 million.

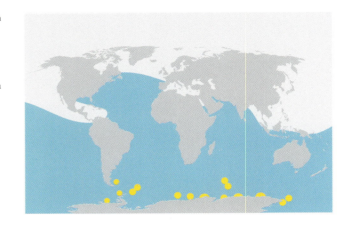

WILSON'S STORM-PETREL SEEMS something of a paradox. This is one of the world's most numerous species of bird, yet few people other than ornithologists have heard of it and even fewer have laid eyes on one. This anonymity is explained by the bird's lifestyle and, perhaps, size. Like all storm-petrels, it is a true pelagic species, nesting in far southern latitudes and spending the rest of its life wandering the world's oceans. It is also tiny—no larger than a sparrow—so it is much harder to spot out at sea than the likes of albatrosses.

The genus *Oceanites* derives its name from the Oceanids, the mythical 3,000 daughters of the Greek goddess Tethys. This species is the most numerous and widespread of the world's twenty-five storm-petrels and is sooty brown in color, with a white rump and belly, and a pale band across the upper wing.

Wilson's Storm-petrel breeds on remote islands in the Southern Hemisphere, from the southern Chilean fjords to the South Shetlands, where they are the smallest warm-blooded creature to breed within the Antarctic Circle. After arriving at their breeding colonies in November, females fatten up for ten days, returning by the first week of December to lay their single egg in a small burrow; incubation lasts for forty-four to forty-eight and a half days. Both parents feed their single chick, visiting the nest after dark in order to avoid predators. Fledging lasts from forty-eight days in the southernmost breeding colonies to seventy-eight days at the most northerly, this disparity reflecting the difference in day length.

After breeding, from late April the birds head out across the world's oceans. They reach their northernmost extent in the North Atlantic, even reaching the Arctic, where they make the most of summer while their breeding grounds are in the grip of the southern winter. Elsewhere they head for the Tropics, from the Persian Gulf to Indonesia, although they are less numerous in the Pacific. As with most pelagic birds, these wanderings reflect fluctuations in food, weather, and other factors.

This species has been recorded living for ten years, although banding recoveries of other storm-petrel species suggest it may live much longer. Threats are greatest on the breeding grounds, where gulls, sheathbills, and other predatory birds may target chicks and returning adults, and breeding colonies around the Antarctic are sometimes swamped by snow. However, with a population estimated at some 20 million, it is listed by the IUCN as Least Concern.

ABOVE Wilson's Storm-petrel uses the up-drafts of waves to flutter just above the ocean surface, picking off plankton and other small prey in the swell.

EMPEROR PENGUIN

Aptenodytes forsteri

SIZE
L: 4 ft (1.2 m)
Wt: 49–99 lb (22–45 kg)

APPEARANCE
Largest penguin, heavily built and stands 4 ft (1.2 m) tall; black upperparts and white underparts, with pale yellow breast and bright yellow ear patch; bill black above and orange-pink below.

LIFESTYLE
Flightless; feeds on fish and squid, diving to depths of more than 1,640 ft (500 m) to capture prey; breeds in colonies on pack ice during Antarctic winter; male incubates single egg on feet while female makes feeding trip to ocean; male and female co-ordinate care of fledgling.

RANGE AND MIGRATION
Breeds only in Antarctica, migrating to breeding colony on foot over ice; outside breeding season migrates to feeding zones in Southern Ocean.

STATUS
Near Threatened; population of about 450,000 adults, now in decline.

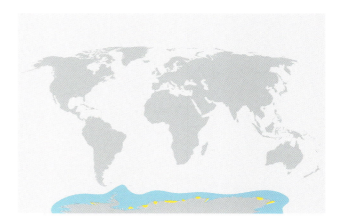

"I DO NOT believe anybody on earth has a worse time than an Emperor Penguin," wrote legendary Antarctic explorer Apsley Cherry-Garrard (1886–1959). He had a point. Not only does this bird live in the coldest place on the planet: It also chooses the dark, frozen depths of winter as its breeding season and starves itself for three months while it gets the job done. What's more, to reach these forbidding breeding grounds, it must migrate over ice for up to 75 miles (120 km)—on foot.

This is the largest of the world's penguins and the fifth heaviest bird in the world—though the weight of the larger males may fall by nearly half during their long winter fast. It breeds only in Antarctica at 66–77°S, forming large colonies on pack ice near the coast. Outside the breeding season, it leaves these colonies and heads out into the Southern Ocean, dispersing far from the colony. Vagrants have turned up as far away as New Zealand and South Georgia.

Few birds boast more extreme survival adaptations than the Emperor Penguin. Flightless, like all penguins, its streamlined body moves with great agility through the water, powered by stiffened, paddle-like wings. It often hunts by diving below its prey—largely fish, plus krill and squid—to spot them against the ice above, whereupon it powers up and seizes them with sharp bill and barbed tongue. It also feeds nearer the bottom, and can descend to more than 1,640 feet (500 m), staying down for eighteen minutes at a time. Solid bones help it withstand the pressure and its blood is adapted to transport oxygen at low concentrations. Meanwhile it shuts down non-essential metabolic functions and slows its heart to just 15 bpm.

Out of the water, the challenges are just as daunting. Temperatures in the Antarctic winter regularly fall below −58°F (−50°C) and winds of 93 mph (150 km/h) batter the icy terrain. Nonetheless, this penguin maintains a constant body temperature of 102°F (39°C). Its tiny, blade-like outer feathers are packed more closely together than on any other bird and by holding them erect it can trap an insulating layer of air in the soft down underneath, which keeps body heat in and water out. A thick layer of fat beneath the skin adds extra insulation.

Emperor Penguins reach breeding maturity from their third year. This bird is the only species to breed during the Antarctic winter. In March, as winter starts to bite and day length decreases, the adults trek from the ocean to their

OPPOSITE A pair of Emperor Penguins tend to their growing chick on the sea-ice of Antarctica.

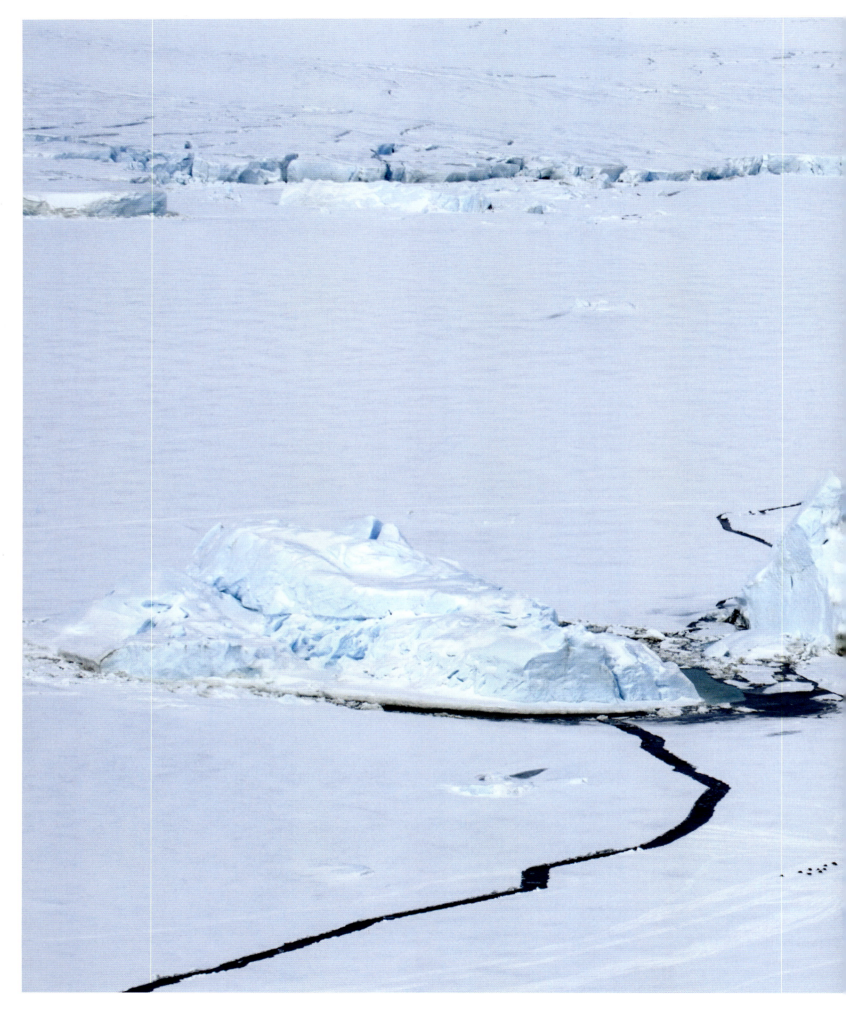

ABOVE A small convoy of Emperor Penguins seen mid-migration, as they cross the Antarctic wilderness between their breeding grounds and the open ocean.

colonies, some 30–75 miles (50–120 km) away across the pack ice, tobogganing on their bellies where the gradient allows. Males perform their "ecstatic" display to attract a mate, the two then bowing and parading in a formal ceremony that pairs them up for the season. The female lays a single egg that at just 2.3 percent of her weight is proportionally the smallest of any bird. She then carefully transfers it onto the male's feet: a dropped egg will not survive any contact with the freezing ground. Her mate immediately snuggles it into his brood pouch—a thick fold of warm belly skin.

Now, her reserves exhausted by egg laying, the female heads back to sea to feed, leaving the male to incubate the egg alone. He stays at his post for two months, the egg not once leaving his feet while he endures the very worst of the world's hardest climate. He does all of this without food; by the time the egg hatches he will not have eaten for over three months. Warm company helps: Emperor Penguins huddle together in their colonies to shelter from the elements. This dense mass of birds is in constant slow circulation, with individuals on the windward side moving to the leeward side and working their way into the center, so that all share the benefit of the warmth of the crowd.

The egg hatches just as the females return in mid-July to early August. Each locates her mate by his call. She immediately takes over, feeding the chick by regurgitating food from her stomach, while the male heads for the sea to feed. He's back after three weeks and both parents now tend to their growing chick together. Youngsters are covered in silver-gray down and have a black face with a white mask. At seven weeks, they huddle into crèches for warmth, but the parents continue to feed them. At the beginning of the Antarctic summer (from December to January), parents and young migrate en masse to the sea. This time the trek is shorter, as the melting pack ice has brought the sea nearer.

Studies have shed some light on where Emperor Penguins travel after leaving the breeding colony. In one 2006 study, the Australia Antarctic Division mounted satellite trackers on the back of ten fledged youngsters. These headed straight for the Southern Ocean, crossing 155 miles (250 km) of pack ice, before dispersing at sea up to 1,430 miles (2,300 km) from the colony. In the six months before the trackers gave out, one individual traveled 4,350 miles (700 km). Much still remains to discover about the birds' movement over the years that follow.

Emperor Penguins may live to twenty years or more, although only 19 percent survive their first year. Southern Giant Petrels prey on chicks, while Leopard Seals and Orcas lurk around the ice edge ready to snatch youngsters entering the water. Today there are 400,000–450,000 spread across forty separate colonies. However, recent decades have seen notable declines and the loss of some key colonies. The Halley Bay colony, for example, experienced almost complete breeding failure for three years from 2015, with thousands of chicks dying. Scientists are concerned that climate change poses a significant threat, causing the loss of the sea ice on which the species depends and the depletion of its key food stocks. Some have predicted its extinction by 2100. In 2012, the IUCN upgraded the Emperor Penguin to Near Threatened.

LEFT Emperor Penguins are among the few birds that migrate on foot—or even on their bellies, where the ice allows them to toboggan.

03 | SHOREBIRDS AND WADERS

IN SUMMER, THE wetlands of the Northern Hemisphere host numerous long-legged wading birds. Cranes and storks stride through grasslands and marshes, foraging for food at their feet. Smaller shorebirds, such as sandpipers, forage around bogs and pools. For many, summer offers only a brief breeding window. As the northern winter closes in, they head south to warmer coasts and waters, where food is easier to find.

The White Stork is one of the best-known European migrants, long celebrated as a bringer of spring and, according to ancient myth, deliverer of babies. The first proof of where this bird traveled came in 1822, when an individual turned up near Klütz in Germany with an African arrow through its neck. Since then, the species' habit of nesting alongside people—pairs returning year after year to the same nest on a church tower or castle wall—has made it one of the best studied of all migrant birds.

Storks migrate in flocks, flying in "V" formation along time-honored flyways. Heavy-bodied and broad-winged, they rely upon thermals—columns of warm air rising from the sun-heated ground—for lift, and do not have the flapping power for long sea crossings. Large numbers thus gather at narrow sea straits such as Gibraltar, spiraling high into the sky before gliding down to the other side.

Formation flying is also a strategy for cranes, which offer some of the best-known migration spectacles—both in their bugling migratory flights and in their exuberant courtship dances en route back to their breeding grounds. In North America, Sandhill Cranes visit wetland staging posts in huge numbers during their journeys. In Europe, Common Cranes do the same, while in Asia, Demoiselle Cranes, having overflown the Himalayas, find a warm welcome in Rajasthan, northern India, where locals await their arrival with hand-outs of grain. Along many such flyways, cranes figure prominently in local culture—from ancient Hindu epic poetry to today's crane festival in Bosque del Apache, New Mexico.

Most migratory shorebirds—"waders" to European ornithologists—breed in the far north, on the boggy Arctic tundra. During the brief summer breeding season, they feed largely on freshwater invertebrates. When breeding is over, they move to the coast and head south. Many make for estuaries, mangroves, and other tidal habitats, where they band together in huge numbers, probing the mud for marine worms and molluscs, and forming swirling tight-knit flocks as they move to and from their high-tide roosts. Among them are some impressive travelers: Red Knot, for example, will fly up to 400,000 miles (643,000 km) in a lifetime, each year doubling their weight before leaving the Arctic. A special place is reserved in the record books for the Bar-tailed Godwit: This long-billed species has been recorded flying from Alaska to New Zealand in a non-stop trans-Pacific flight of nine days—the longest known migratory journey of any animal without stopping to feed.

Not all shorebirds migrate to the coast. The Common Sandpiper winters mostly inland, fanning out across the wetlands of tropical Africa and southern Asia to find suitable ponds and waterholes. The Eurasian Woodcock has no interest in wetlands: An anomalous wader that uses its long bill to probe woodland leaf litter rather than coastal mud, it is a partial migrant—populations from eastern regions heading southwest to temperate climes when their native woodlands are snowed in.

While most migrant wading birds breed in the north, Africa's Lesser Flamingo offers a tropical alternative. A specialist of soda lakes, where it breeds in caustic conditions few other animals could survive, this bizarre-looking bird migrates outside the breeding season to other lakes across east and southern Africa, forming enormous flocks that turn the lakeshore pink.

Migratory wading birds are dependent upon the traditional staging areas where they gather in huge numbers to recharge their batteries before completing their journeys. For cranes, these may be low-lying inland wetlands, such as Nebraska's Platte Valley. For shorebirds, they are generally expansive tidal mudflats, such as China's Yellow Sea. Today, conservationists around the globe are working to secure these vital havens against the threats of development and destruction. The survival of millions of birds depends upon it.

OPPOSITE A flock of European Golden Plovers passes in front of a crescent moon. Most waders migrate by night.

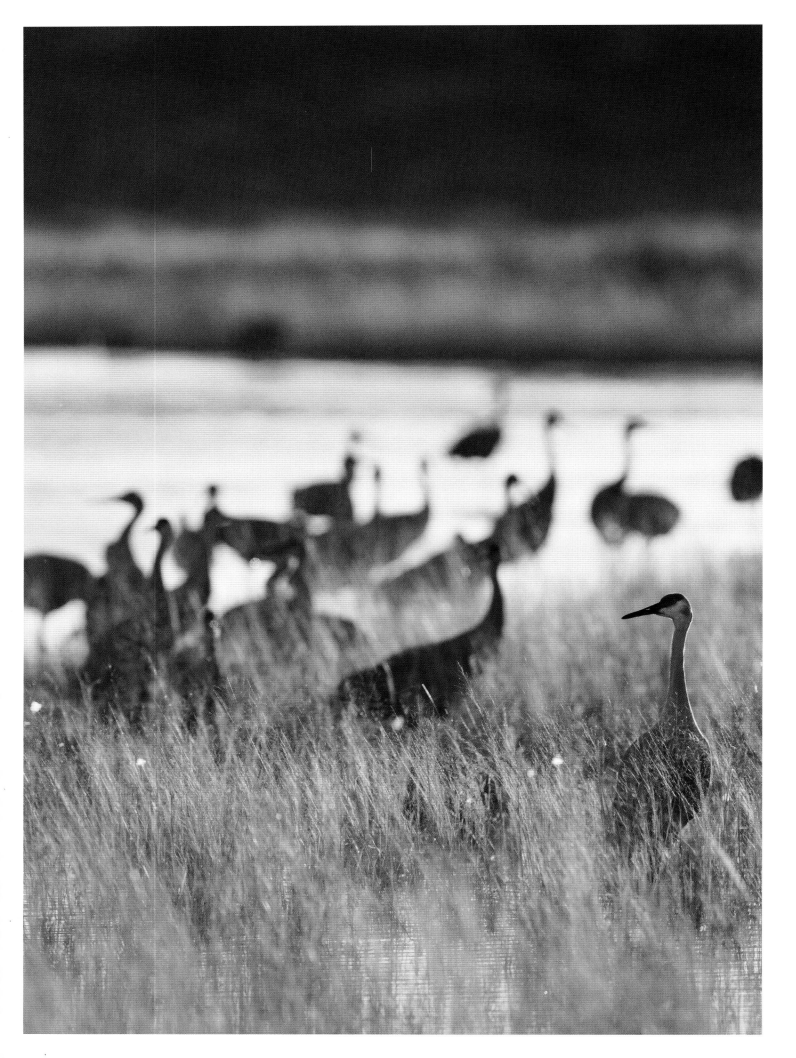

SANDHILL CRANE

Antigone canadensis

SIZE
L: 2 ft 7 in–4 ft 6 in (80–136 cm)
Wt: 6–14.8 lb (2.7–6.7 kg)
WS: 5 ft 5 in–7 ft 7 in (165–230 cm)

APPEARANCE
Tall, with long neck, long legs, and a sharp bill; shows broad wings in flight; plumage gray, with red forehead and white cheeks; upperparts tinged ochre.

LIFESTYLE
Inhabits grasslands, meadows and shallow wetlands; forages on ground for plant materials, cereal grains, insects, and small vertebrates; mates for life, pairs performing elaborate breeding displays; lays 2 eggs in raised nest on ground; fledgling stays with parents for 10–12 months.

RANGE AND MIGRATION
Migratory population breeds in northern USA, Canada, Alaska, and far-eastern Siberia, and winters in southern USA and northern Mexico; isolated non-migratory populations occur in Florida, Mississippi, and Cuba.

STATUS
Least Concern; population estimated at 650,000.

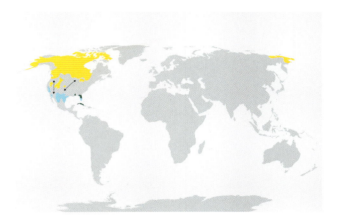

IN THE PRE-DAWN half-light of a February morning, large birds are packed by the thousand onto a wide sandbar in a shallow river. Long necks tucked away, rounded contours glazed with the night's frost, they appear more boulders than birds. Around the next bend, another sandbar is packed with thousands more. Further on, there are more still. In total, along just 75 miles (120 km) of the Platte Valley, half a million Sandhill Cranes are gathered: three-quarters of the world's population.

The first birds begin to stir: Long necks appear; a murmur of trumpeting calls rises into the chilly air. Soon the murmur has swelled to a chorus. The birds are awake and restless, shifting on their sandbar. One takes flight and, as though at a starting gun, others follow. Hundreds, thousands, lifting off in waves until the sky is thick with their wings and the chorus a deafening clamor.

The Platte River winds eastward across Nebraska through the heart of America's Great Plains. It is neither a breeding nor a wintering ground for the cranes but rather a staging post where, for a few weeks every February, they congregate in this precious ribbon of habitat. They have flown up from wintering grounds in Texas, New Mexico, and northern Mexico. Now they are fattening up before the final push to their breeding grounds up in the northern USA, Canada, Alaska, and eastern Siberia. The birds arrive in waves between mid-February and mid-April, each from different wintering populations and each spending four to five weeks in the valley. During their stay, they will gain at least 10 percent in body weight.

The sight of these birds on the move is one of the world's great migration spectacles. Every morning they head out en masse from their roosts and move out from the valley to the surrounding fields. Here they feed largely on waste grain left over from last year's harvest, picking their food from the ground with long sharp bills. Every evening, they return to the same shallow, braided channels along the river, where they roost on sandbanks until morning.

On the journey north, the birds travel in family groups— mated pairs accompanied by their fledged young from the previous year. They fly in loose formation, keeping in contact with calls. On warm days, broad wings allow them to use thermals, gaining height with a minimum of flapping then gliding toward their destination. In this way, they may cover 400 miles (640 km) per day. By now, courtship is already under

OPPOSITE Sandhill Cranes at dawn on their wintering grounds in Bosque del Apache, New Mexico.

SHOREBIRDS AND WADERS

Like all cranes, Sandhill Cranes migrate in family groups and keep in contact on the wing with constant bugling calls.

way and, once they reach the breeding grounds, it goes into overdrive, with the elegant leaping and bowing performances common to all cranes, accompanied by loud "unison" calls— each pair vocalizing in synchronized duet, their bugling amplified by an exceptionally long trachea.

The Sandhill Crane is best distinguished from other tall American wading birds by its uniform gray-brown plumage and striking red forehead. It is also one of the oldest bird species known, with fossils dating back 2.5 million years. Scientists recognize several subspecies and there is considerable variation in size, with the northernmost breeding birds being up to 50 percent heavier on average than those from more southerly breeding populations.

Sandhill Cranes mate for life. Back on their breeding grounds by early May, pairs work together to build a nest mound, using plant material to elevate it above the surrounding marsh. A female lays on average two eggs, and both parents share the thirty-day incubation. The downy chicks leave the nest within a few days and can quickly feed themselves, although for another three weeks they are brooded by their parents, who are aggressive in defending their charges, using kicks and sharp pecks to repel predators such as Red Foxes and Northern Raccoons.

Young cranes remain with their parents long after fledging, heading south with them in autumn and not reaching independence until just before the next year's breeding season, whereupon they band together with other young birds in non-breeding flocks. They reach sexual maturity at two years but may not breed for five years or more. This species has an impressive longevity: one individual banded in Wyoming in 1973 was retrieved in New Mexico in 2010, and was at least thirty-six years and seven months old.

In Bosque del Apache, New Mexico, a Sandhill Crane festival is held every November to celebrate the birds' arrival. At such wintering sites, and at migratory staging posts, the cranes join large numbers of other wintering birds, including Snow Geese (see pages 26–31), which, like the cranes, have adapted to feed on left-over grain in the surrounding fields and have increased their population as a result.

Offering a complete contrast to the migratory wanderings of most Sandhill Cranes are a number of smaller breeding populations in the south—notably in Florida, but also in smaller numbers in Cuba and Mississippi. These birds do not migrate, but reside year-round in these warmer wetlands, where they supplement their plant diet with more animal matter—insects, snails, small reptiles, and mammals—than their relatives up north.

The Sandhill Crane is the world's most numerous crane species, with an estimated population of 650,000; it is listed by the IUCN as Least Concern.

ABOVE An early spring evening in the Platte Valley sees thousands of Sandhill Cranes gather on sandbanks, preparing to complete their journey north.
OPPOSITE The loud bugling call of a Sandhill Crane may be heard from more than a mile away.

DEMOISELLE CRANE

Grus virgo

SIZE
L: 33.5–39.5 in (85–100 cm)
Wt: 4.4–6.6 lb (2–3 kg)
WS: 61–71 in (155–180 cm)

APPEARANCE
Smallest crane species; pale blue-gray above; black neck and black breast with long plumes; white stripe extends from eye into plume on back of head.

LIFESTYLE
Forages on open plains and steppes for plant materials, cereal grains, insects, and small vertebrates; mates for life, pairs performing elaborate breeding displays; nests on bare ground and lays 2 eggs.

RANGE AND MIGRATION
Breeds in Central Asia from Black Sea to Mongolia and northeast China, and far eastern Europe; winters in Indian subcontinent and sub-Saharan Africa; isolated sedentary populations occur in Turkey and the Atlas Mountains of North Africa.

STATUS
Least Concern; world population estimated at 230,000–261,000 individuals.

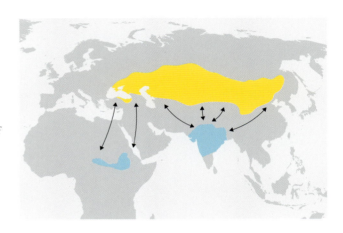

LEGEND HOLDS THAT the Demoiselle Crane acquired its common name from Marie Antoinette, who, upon seeing a captive bird from Russia, remarked on the maiden-like elegance of its slender build. Appearances can be deceptive, however. This species may look delicate but twice a year it undertakes one of the toughest migratory journeys of any bird. From late August to early September, flocks gather on their breeding grounds in Central Asia in preparation for their flight south to India. Between them and their destination lie the Himalayas, the highest mountain range on earth.

The migratory flocks that make this journey number up to 400 individuals. As with all cranes, these flocks comprise smaller family groups—pairs migrating with their newly fledged young. The birds make a distinctive shape in flight, their head and neck projecting forward and feet and legs behind, and use their broad wings to ride thermals and soar to altitudes of 16,000–26,000 ft (4,900–7,900 m). This allows them to cross the high ranges, using mountain passes where possible to circumvent the peaks. As well as contending with the cold and hypoxic air at these altitudes, they must also evade the attacks of Golden Eagles, for whom the cranes' annual migration represents an important seasonal food resource. The great raptors target the youngest and weakest birds, diving upon them in breathtaking aerial pursuits.

Significant numbers of Demoiselle Cranes winter in Rajasthan, northwest India, on the edge of the Thar desert. Here the species has become the subject of a remarkable conservation story. Near the small hamlet of Khichan, some 87 miles (140 km) west of the "Blue City" of Jodhpur, the birds arrive in great numbers to take advantage of the sacks of grain provided for them by the local community. Numbers have built up from fewer than 100 some fifty years ago, to more than 9,000 today. This custom springs from the efforts of a local farmer, Ratanlal Maloo, who believed it was his duty as a devout Jain to help these birds, which are revered in local folklore. Knowledge of this dependable food source has spread through the local crane population, which now throngs the village from October to March every year.

Each day, the birds arrive to feed around Khichan in the early morning and then congregate on the sand dunes before departing in impressive formations. The spectacle has become a major tourist attraction. Up to 5.5 tons (5,000 kg) of bird seed is consumed every day by the birds, the cost allayed by revenue

OPPOSITE Migrating Demoiselle Cranes fly in tight formation and stay together for the length of their journey.

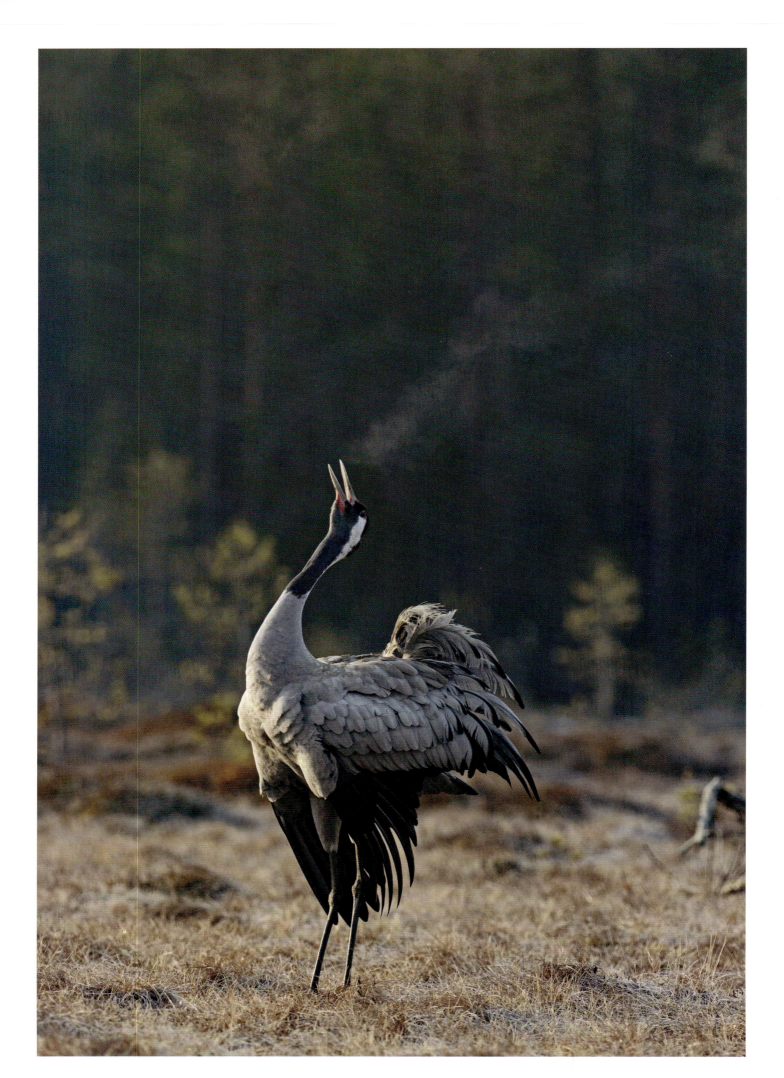

COMMON CRANE

Grus grus

SIZE
L: 39–51 in (100–130 cm)
Wt: 6.6–13.4 lb (3–6.1 kg)
WS: 71–94 in (180–240 cm)

APPEARANCE
Tall, with long wings, long legs, sharp bill, and broad wings in flight; ash-gray plumage, black head with red crown and white streak from eye to back; upper tail coverts form long plumes usually raised in a loose fan; upperparts tinged brown during breeding season.

LIFESTYLE
Frequents boggy wetlands and meadows in and around boreal forest and, outside breeding season, open farmland and savannah; forages on ground for plant and animal food; mates for life, pairs performing elaborate breeding displays; lays 2 eggs in raised nest beside pool.

RANGE AND MIGRATION
Breeds in northern and eastern Europe and Russia; winters in southern Europe, North Africa, Middle East, East Africa, northern Indian subcontinent, and eastern China.

STATUS
Least Concern; population estimated at 491,000–503,000 individuals.

A LATE EVENING in late September, somewhere in Central Europe. From high overhead comes the clamor of distant voices—a sharp, irregular chorus, rising and falling. Clearly birds, they sound at first like geese. As they draw closer, however, the sound takes on a more musical, trumpeting quality. A glance upward reveals nothing visible against the dark sky.

The chorus of Common Cranes on the move is a sure sign of autumn across much of Europe, by day and night. The birds are heading south toward their wintering grounds, following time-honored flyways. Like all cranes, their unusually long trachea, fused to the sternum, helps amplify their calls, allowing both for highly vociferous courtship displays and far-carrying communication when on the move.

This is the only crane species you will see across most of Europe. In general coloration it is similar to the Demoiselle Crane (see pages 116–119), with a pale ash-gray body and a black and white head and neck. But it is taller, with a longer bill and a bare red crown. What's more, the long plumes of its tail coverts stick up like a Victorian bustle, rather than trailing elegantly like those of a Demoiselle Crane, and its soft gray plumage becomes smeared with brown during the breeding season, the bird using mud and rotting vegetation to help camouflage itself near the nest.

This species breeds widely across northern Europe, notably in Scandinavia and the Baltic, but also through central and eastern Europe south to Greece and Romania, and west to the UK and Ireland. Further east, it ranges across Russia to Chukotka in the far east. Each population has its own wintering grounds: Most from Scandinavia and northern Europe winter in Spain and North Africa. Others from further east winter in Turkey, Israel, and Iran, some continuing to East Africa (Sudan, Ethiopia, and Eritrea). Some also winter in northern India and Pakistan, while the eastern Russian populations winter in eastern China. Vagrants occasionally reach western North America.

Typical habitat for the Common Crane is open meadows in and around boreal forest, where their omnivorous diet comprises a wide variety of plant and animal matter, from insects and amphibians to seeds and berries; indeed, cranberries may derive their name from this bird. A breeding pair will claim a territory in a boggy forest clearing where they will renew their lifelong monogamous bond through a ritual courtship dance, in which

OPPOSITE A Common Crane in Finland greets the dawn with its clamorous courtship cry.

LEFT Common Cranes mass on their migratory staging area in Israel's Hula Valley.

they bob, bow, leap, and pirouette while using that trumpet voice in synchronized "unison calls." Their nest is built near shallow water and may be used for several years. The female lays two eggs (on average) in May and shares the thirty-day incubation with the male. Both parents defend the nest aggressively, using kicking feet and stabbing bills against predators such as Red Foxes and Wild Boars. The hatchlings are brown, for camouflage, and can run with their parents within twenty-four hours and fly within about nine weeks, but don't reach breeding maturity for three to six years.

Autumn migration starts from late August, after the adults have completed their post-breeding moult. Family groups head out together, along with their non-offspring from previous years, forming groups of up to 400 that fly in loose "V" formation. Different populations follow different flyways. The majority of cranes from northern Europe and Scandinavia head southwest across France and Germany to the southwestern Iberian Peninsula, where up to 220,000—around 40 percent of the world population—spend winter. Their route takes them over the Pyrenees to Lake Gallacanta in central Spain. From here, they disperse to different sites around the southwest, with around 53 percent ending up in the province of Extramadura. Cranes from further east follow the Syrian–African flyway south via Israel and Turkey to East Africa. The great plain of Hortobágy in central Hungary is a crane migration nexus, with some continuing west or south from there.

All these flyways hold important staging points: Lakes or wetlands where the travelers put down to refuel for a few days or even weeks, smaller flocks coalescing into much larger ones. In recent decades, some crane populations have taken to spending the entire winter at key staging posts, curtailing the rest of their migration. This is generally because they find plentiful food nearby, especially where the fields are still littered with spilt grain from the previous year's harvest. Up to 60,000 cranes now overwinter at Lac du Chantecoq in northeast France, for example, while 40,000 remain in Israel's Hula Valley, where the government provides up to 8.8 tons (8,000 kg) of supplementary grain per day.

Common Cranes may live up to forty years in the wild and have few natural predators as adults. Anthropogenic threats are more significant, including the loss of habitat to dams, wetland drainage and urbanization. Nonetheless, the species is doing well across much of its range, with a population of around 500,000 listed as Least Concern by the IUCN. The bird has recently returned to the UK, where it was once common (and was served at a banquet for the Archbishop of York in 1465), but was extirpated by the end of the seventeenth century. Through natural recolonization in East Anglia and a reintroduction scheme on the Somerset Levels—where fledglings have even been hand-reared by conservationists dressed in crane costumes—the UK population had risen to fifty-four breeding pairs by 2018.

ABOVE The broad wings of a Common Crane power its take-off and also allow it to make use of thermals during its long migratory journeys.

SHOREBIRDS AND WADERS

EURASIAN WOODCOCK

Scolopax rusticola

SIZE
L: 13–15 in (33–38 cm)
Wt: 8.4–14.8 oz (240–420 g)
WS: 22–26 in (55–65 cm)

APPEARANCE
Plump, pigeon-sized shorebird; long, straight bill, relatively short legs, and rounded wings; plumage russet above and buff below with complex, cryptic camouflage markings, and black barring on crown.

LIFESTYLE
Adapted to woodland habitat, where it probes ground for earthworms and other invertebrate food; crepuscular, performing "roding" display flights at dusk during breeding season; lays 2 eggs in camouflaged ground nest.

RANGE AND MIGRATION
Breeds across central Russia and Europe, south to the Canary Islands; northern and eastern populations are migratory, wintering in western Europe, the Indian subcontinent, and Southeast Asia.

STATUS
Least Concern; population estimated at 15–16 million individuals.

WOODCOCK ARE AN avian anomaly: shorebirds that never go near the shore. Though related to snipe, sandpipers, curlews, and other members of the Scolopacidae family that live largely around water, these secretive birds have eschewed a life of paddling in favor of pottering around the woodland floor. Here they use their long, straight bills to probe for earthworms and other invertebrate food beneath the soil.

The Eurasian Woodcock is one of seven woodcock species worldwide. Like its relatives, it has cryptically patterned plumage with spots, bars, and fine vermiculations in earthy tones that provides excellent camouflage on the forest floor. Consequently, it is a very difficult bird to observe, especially since it is largely crepuscular—that is, mostly active at dusk and dawn. Eyes positioned high on its head allow it 360° all-round vision, so it is able quickly to spot danger and lie low.

This species inhabits broadleaf and mixed woodland, requiring a dense understory—typically of bramble, bracken, or hazel—and damp areas in which to feed. Its breeding range extends across central Russia through Central Europe and south to the Canary Islands. Across much of this range, it cannot survive the winter, with the frozen or snow-covered ground making feeding impossible. Thus, in autumn, woodcock from eastern and northern regions migrate to milder wintering quarters where they'll find food to last them until spring. Those from western Russia and Scandinavia head into western Europe. Those from further east in Russia head south to Southeast Asia and the Indian subcontinent. Only in the far west of the range, in countries such as the UK, are the birds sedentary, remaining on or near their breeding grounds all year.

Eurasian Woodcock are known for their erratic, twisting flight when flushed from the forest floor, a habit that has long made them a favorite quarry of hunters. On migration, however, they fly fast and direct, generally traveling alone and reaching speeds of 58 mph (93 km/h). The distances they travel are impressive: Studies of one satellite-tagged bird named Navarre wintering in northern Spain revealed that she completed a 2,361-mile (3,800-km) spring journey from Cantabria to Russia in just ten weeks and returned the next autumn to within 6.8 miles (11 km) of where she was first tagged.

In the UK, a breeding population of some 55,000 birds may rise to 1.4 million during winter. Extensive studies conducted by the Game and Wildlife Conservation Trust, using stable-isotope

OPPOSITE The natural habitat of the Eurasian Woodcock is the forest floor, where its cryptic plumage provides excellent camouflage.

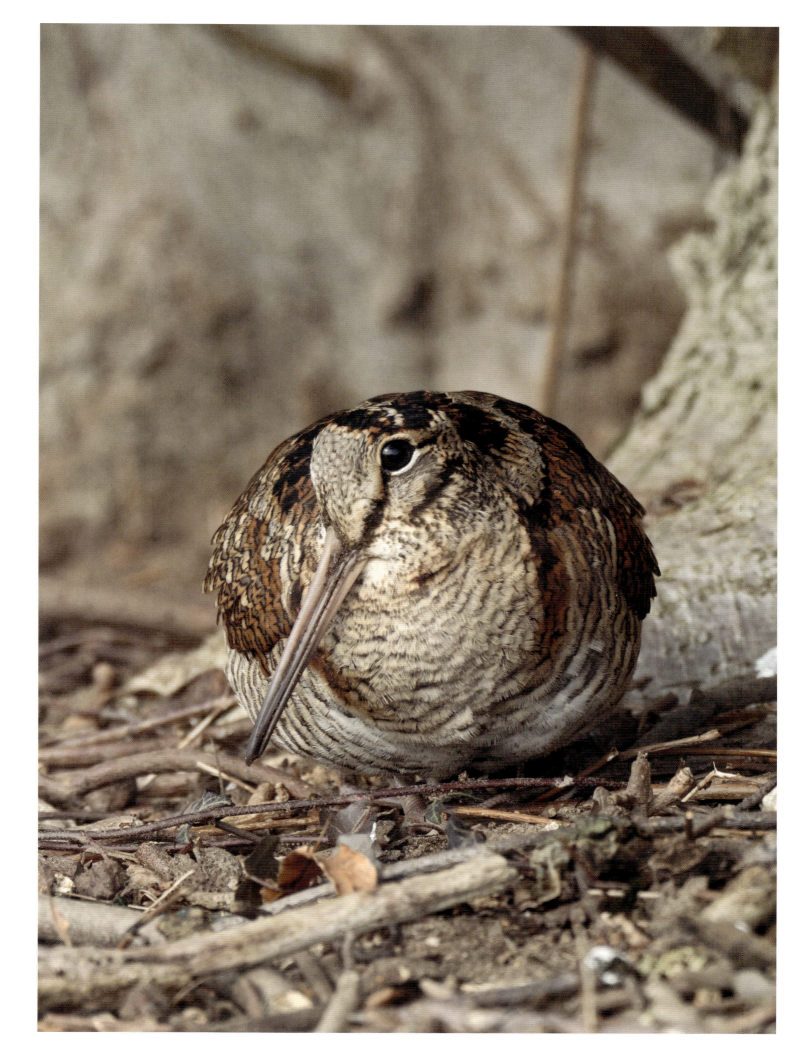

analysis suggests 51 percent of Eurasian Woodcocks wintering in Britain and Ireland come from northwestern Russia and the Baltic States, 39 percent from Scandinavia and Finland, and just 10 percent from Central Europe, Britain, and Ireland. In a study in which twenty-four satellite tags were fitted to woodcock at six wintering locations during March 2012 and March 2013, birds were tracked returning to seven countries to breed: Norway, Sweden, Finland, Poland, Latvia, Belarus, and Russia. The total distance that these birds traveled ranged from just over 620 miles (1,000 km) for migrants between Scotland and Norway to around 4,440 miles (7,100 km) for those breeding in central Siberia.

Such studies have also shown that birds wintering in the same location may make very different migration journeys. In February 2009, two birds were satellite-tagged on the Scottish island of Islay. One left on March 22, crossed Scotland in five days and was on its breeding grounds in southern Norway by April 4. The other flew south, reaching Humberside in northeastern England on March 25; it then traveled to Russia via Germany, eastern Sweden, and Latvia, arriving on May 27, two months and 2,553 miles (4,110 km) after its departure.

Back on their breeding grounds in spring, male Eurasian Woodcock perform a territorial display known as "roding," in which they fly back and forth at dusk over a woodland clearing, making a methodical grunting call interspersed with high whistles. A female lays one or two eggs in a nest made in low ground cover and lined with dead plant material. She incubates for twenty-one to twenty-four days and the young, which leave the nest within hours, fledge after fifteen to twenty days. Unusually among birds, a female woodcock may transport its young away from danger in flight, carrying them tucked under her legs and tail.

The Eurasian Woodcock occupies a prominent place in British culture, having long been popular with hunters—which continues to this day, the birds being hunted outside the breeding season using dogs. The early arrival of migrants on the east coast in autumn is traditionally seen as a portent of a good harvest, and the first full moon of November was once heralded as a "woodcock moon." In certain years, when the weather is especially hard, woodcock may arrive from their eastern breeding grounds in exceptional numbers, often turning up in urban environments, far from their usual habitats, in a desperate search for food.

Though classified by the IUCN as Least Concern, the Eurasian Woodcock is declining in many areas, facing such threats as forest fragmentation and insecticides. In the UK, it is Red-listed as a conservation priority, its breeding population having declined by more than 50 percent in the last twenty-five years.

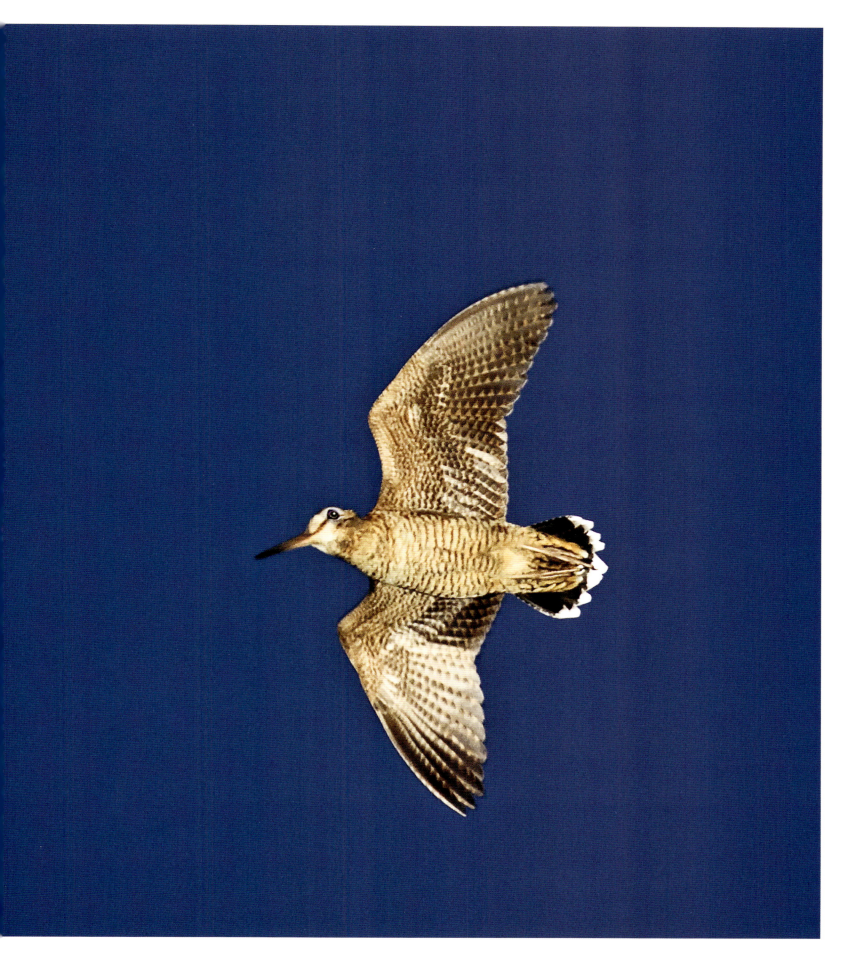

ABOVE Eurasian Woodcocks migrate by night
and may travel more than 2,500 miles (4,023 km)

RED KNOT

Calidris canutus

SIZE
L: 9.1–10.2 in (23–26 cm)
Wt: 3.5–7.1 oz (100–200 g)
WS: 19–21 in (47–53 cm)

APPEARANCE
Small, stocky shorebird with medium-length short bill and relatively short legs; breeding plumage, brick-red below and mottled gray above; non-breeding, pale gray above and white below.

LIFESTYLE
Breeds on Arctic tundra, nesting beside small pools; winters in large flocks on estuaries and muddy shorelines; lays 4 eggs in ground nest; feeds on insects and larvae on breeding grounds and marine molluscs on winter quarters.

RANGE AND MIGRATION
Circumpolar breeding distribution around Arctic Circle, including Russia, Canada, and Alaska; migrates south to winter along temperate coastlines, as far south as Argentina, South Africa, and New Zealand.

STATUS
Least Concern; population estimated at 1.1 million individuals; some subspecies in decline.

A SWARM OF birds rises from the mudflats in a crescent wave, thousands of dark bodies moving in perfect synchronization. They wheel back, changing direction like a shoal of fish, their pale undersides flashing brilliant white in the late-afternoon sun. The birds are Red Knot. Two months ago, they were breeding on the Arctic tundra but now they are massing at a high-tide roost on a windswept estuary, thousands of miles to the south.

The Red Knot is stockier and shorter-legged than most *Calidris* waders. In summer, it sports handsome brick-red underparts; in winter, this is replaced by a drab pale gray plumage, offering better camouflage against the mudflats. This species breeds all around the Arctic Circle and can be divided into a number of subspecies, each with a different migration route. The nominate form breeds in northern Russia and migrates via western Europe and the west coast of Africa to the Cape. A more easterly subspecies breeds further east in Russia and migrates to eastern Australia and New Zealand. In the New World, one form breeds in northwest Alaska and migrates south to Panama and Venezuela, while another breeds in Canada and migrates down the Atlantic coast to Tierra del Fuego, Argentina—a return trip of up to 18,000 miles (29,000 km).

In May, the female lays an average of four eggs in a ground nest on the tundra and incubation lasts around twenty-two days. Once the chicks hatch, the females migrate, followed by the males after fledging; the young are the last to leave. One Red Knot, first banded in 1995 at the age of two, was last seen in New Jersey in February 2014 and must have lived for at least twenty-one years, clocking up at least 398,000 miles (640,000 km)—almost as far as a return journey to the Moon (no wonder it was nicknamed the "Moonbird"!). The species doubles its body weight prior to departure, switching from insects to hard-shelled molluscs on its non-breeding grounds.

Studies of the Red Knot have helped inform conservation strategies for long-distance migrants. Today the species is listed as Least Concern by the IUCN. However, some populations are struggling—notably the *rufa* subspecies of the western Atlantic, which has declined from 82,000 in the 1980s to fewer than 30,000 today. Its decline reflects the overharvesting of Horseshoe Crab larvae by fishermen in Delaware Bay on the east coast of the United States, a resource on which the birds depend during their autumn journey south.

OPPOSITE A flock of Red Knot in breeding plumage reveal their brick-red underparts.

ABOVE Red Knot on their high-tide roost at Snettisham, Norfolk, eastern England. Such gatherings may number many thousands and form dramatic spectacles in their tight, synchronized flight.

BAR-TAILED GODWIT

Limosa lapponica

SIZE
L: 15–16 in (37–41 cm)
Wt: 6.7–22.2 oz (190–630 g)
WS: 28–31 in (70–80 cm)

APPEARANCE
Medium-sized wader with long bill; in summer, brick-red head, neck, and chest and gray-brown upperparts; in winter, pale gray above and white below.

LIFESTYLE
Breeds on Arctic tundra; lays 4 eggs in ground nest; winters on both temperate and tropical regions; flocks feed on mudflats, probing for worms and other aquatic food beneath mud.

RANGE AND MIGRATION
Breeds around Arctic Circle, from Scandinavia across Russia to western Alaska; migrates south to winter along coastlines of Europe, Africa, Asia, and Australasia.

STATUS
Near Threatened; worldwide population estimated at 1.1 million individuals.

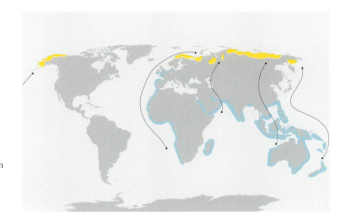

AMONG MANY IMPRESSIVE statistics associated with bird migration, few top those of the Bar-tailed Godwit. This long-billed shorebird may not have the wingspan of an albatross or speed of a swift, but its non-stop journey from Alaska to New Zealand in just nine days is the longest recorded single flight of any winged migrant. Indeed, it is the longest known journey undertaken by any animal without pausing to feed.

In 2009, several Bar-tailed Godwits wintering in New Zealand were satellite-tagged by researchers. Just six to eight days after departing in mid-March, they had reached the shores of the Yellow Sea, off China, 5,950 miles (9,575 km) to the north. Pausing a few weeks to refuel, they then traveled a further 3,000 miles (5,000 km) to western Alaska. In August, after breeding, they headed south, straight down the middle of the Pacific. One female named E7 flew non-stop 7,258 miles (11,680 km) from Alaska's Avinof Peninsula to the Piako River Estuary in New Zealand in just nine days, covering the distance at an average speed of 35 mph (56 km/h).

For such an astonishing feat of endurance, a Bar-tailed Godwit must lay down heavy fat reserves in a feeding binge before departure, almost doubling its body weight. At the same time, its digestive organs and gizzard shrink to almost nothing, further conserving energy by reducing its metabolic activity. On the push south, tail winds also help it along.

The Bar-tailed Godwit breeds on the Arctic tundra, its range extending from Scandinavia, around northern Russia to western Alaska. On its breeding grounds, its drab gray and white winter plumage is replaced by a handsome brick-red head, neck, and breast. Here, the female lays around four eggs in a shallow scrape. Incubation lasts twenty-two to twenty-four days. Both parents look after the chicks, which fledge at nineteen to twenty-one days.

In winter, Bar-tailed Godwits leave for the coast, where they use their long bills to probe mudflats for food at low tide. Winter quarters differ by subspecies: The nominate form breeds in western Russia and Scandinavia, and winters in western Europe; the west Siberian subspecies *L. l. taymyrensis* winters in Africa and the Persian Gulf; the central Siberian form *L. l. menzbieri* winters in Southeast Asia and Australasia; and the easternmost *L. l. baueri* breeds in far eastern Russia and western Alaska and winters in Australia and New Zealand.

Today the Bar-tailed Godwit is listed as Near Threatened due to the steep decline of the two subspecies that use the East Asian–Australasian Flyway. Land reclamation, pollution, and hunting around the Yellow Sea coastline have all had an impact on this species and the many others that depend upon this vital staging post.

OPPOSITE The Bar-tailed Godwit holds the record for the longest non-stop journey without feeding known in the animal kingdom, having been recorded migrating from Alaska to New Zealand in just nine days.

WHITE STORK

Ciconia ciconia

SIZE
L: 39–45 in (100–115 cm)
Wt: 5.1–9.9 lb (2.3–4.5 kg)
WS: 61–85 in (155–215 cm)

APPEARANCE
Tall and upright, with long red bill and long red legs; plumage white with black flight feathers; flies on broad wings with head and legs extended; immatures duller, with black beak that grows progressively more red.

LIFESTYLE
Forages for animal food in fields, meadows, and wetlands; builds large stick nest atop trees or buildings; female lays 4 eggs on average; winters largely on tropical and subtropical fields and savannahs.

RANGE AND MIGRATION
Breeds in scattered populations across Europe, east to western Russia, with largest populations in Spain, Poland, and Ukraine; also in Turkestan; migrates south to winter in sub-Saharan Africa and southern Asia.

STATUS
Least Concern; worldwide population estimated at 700,000 individuals, including 447,000–495,000 in Europe.

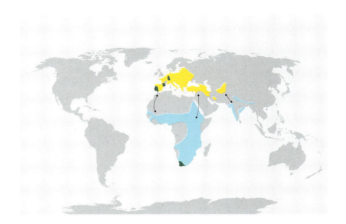

IN THE SPRING of 1822, a White Stork appeared in the German town of Klütz with an arrow through its neck. The bird appeared to be perfectly healthy, or at least it was feeding alongside its companions without any obvious difficulty. To the astonishment of the locals, however, the arrow turned out to be of African origin. Where on earth had this stork been?

The White Stork has featured prominently in culture since ancient times: whether in *Aesop's Fables*, as mythical pilgrim to Mecca, or as deliverer of babies, it has long attracted our attention and affection. Perhaps less known, however, is its importance in the history of ornithology. The Klütz bird, now preserved in the University of Rostok, was living proof that when White Storks departed every autumn from the German villages in which they'd nested, their destination was thousands of miles away on another continent. This revelation occurred decades before banding allowed scientists to establish beyond doubt the truth of bird migration.

Amazingly, another twenty-five such storks—known in German as *Pfeilstorche* (arrow storks)—have since been documented. Thankfully, science has not relied upon these gruesome accidents to study the species' migration. The conspicuous appearance of the White Stork and its propensity to live alongside us have long made its seasonal comings and goings among the easiest of any bird to observe. Indeed, this species was the subject one of the first and longest banding projects, conducted at the Rossitten Bird Observatory in Germany from 1906 until World War II. As technology moved on, White Storks remained at the forefront of research. They were among the first birds to be kitted out with satellite transmitters and GPS tracking has since revealed much more about their migration routes and strategies.

The White Stork's large size, conspicuous black-and-white plumage, and long red legs and bill render it unmistakable. A carnivorous forager, snapping up insects, frogs, fish, and small mammals from the ground, it has long found a home alongside people—feeding in grassy meadows and farmland, and often constructing its nests on human structures, from church towers to telegraph poles. Today, the nominate subspecies (*C. c. ciconia*) has a fragmented breeding range across Europe, with concentrations in Iberia, North Africa, central and eastern Europe, and western Russia. A small breeding population, founded by wintering birds, has also colonized South Africa's

OPPOSITE White Storks mass on a thermal over Beit She'an in northern Israel as they head south towards their African wintering grounds.

LEFT White Storks at their nests on the San Miguel Collegiate Church in Alfaro, northern Spain, the world's largest breeding colony of this species on a single building.

Cape. A separate subspecies (*C. c. asiatica*) breeds in Asia, largely in Turkestan.

On its breeding grounds this is a noisy bird, its bill-clattering greeting displays rattling out like machine-gun fire from its elevated nests. Monogamous pairs construct large stick platforms that, when used over several years, may reach 550 lb (250 kg) in weight. A female lays an average of four eggs which the pair incubates for thirty-three to thirty-four days, thereafter feeding the chicks until they fledge fifty-eight to sixty-four days later and then for two or three weeks after that. The youngsters don't usually breed for at least four years and a lifespan of thirty-nine years has been recorded for this species in the wild.

European White Storks winter in sub-Saharan Africa, from the Equator to the Cape. They set out from August in large, loose flocks, using thermals to spiral skyward—reaching 4,900 ft (1,500 m)— then soaring in order to conserve energy. To avoid long ocean crossings where thermals are unavailable, they converge on narrow sea straits, mingling with pelicans, raptors, and other large-bodied, soaring migrants heading in the same direction. From Central Europe, two principal routes have evolved: Some birds head west over Gibraltar, then continue south around the western fringes of the Sahara; others head east via the Bosphorus and continue south down the Nile Valley. Both routes take about twenty-six days to reach the wintering grounds. The spring return journey takes much longer: up to forty-nine days before the birds reach their nests in late March and April. Birds of the *asiatica* subspecies have it easier, not crossing any oceans and wintering in India and Iran.

On their African wintering grounds, White Storks use similar open terrain, often finding food around the hooves of grazing herds or pursuing savannah grass fires to pick off the exodus of small animals fleeing the flames. Youngsters may remain in Africa for a second year, not returning to their European breeding grounds until the following year and not breeding for a year or two after that.

The fortunes of the White Stork have long been tied to human activities. Forest clearance across Europe during the Middle Ages benefitted the species by expanding its breeding habitat but subsequent industrialization and modern agriculture sent it into decline. Uncontrolled hunting along some flyways—notably in Lebanon's Beqaa Valley—still claims thousands of storks every year, while power lines and other obstacles also take their toll. A recent concern is the increasing tendency of storks in some regions to curtail their migrations—especially in southern Spain and Morocco, where the birds have taken to feeding on large exposed garbage dumps and, with no need to move on after breeding, remaining there all winter. Ongoing studies aim to establish the long-term implications of this trend and how it affects the birds' ecology. Meanwhile, re-introduction projects have re-established the bird in the Netherlands, Belgium, Switzerland, and Sweden and now aim to do the same in the UK.

ABOVE White Storks flock to grass fires on their African wintering grounds to capture small prey driven out of cover by the flames.

SHOREBIRDS AND WADERS

LESSER FLAMINGO

Phoenicoparrus minor

SIZE
L: 35–41 in (90–105 cm)
Wt: 2.6–6 lb (1.2–2.7 kg)
WS: 35–41 in (90–105 cm)

APPEARANCE
Tall, with small, round body and very long neck and legs, white or pinkish plumage and black-tipped, blood-red bill, held inverted when feeding; red and black markings on wings best visible in flight, when flies with head and legs extended.

LIFESTYLE
Breeds only on alkaline soda lakes; winters on freshwater lakes and coastal wetlands; filter-feeds on aquatic algae using inverted bill; nests on elevated mud platforms, producing 1 chick every 3 years.

RANGE AND MIGRATION
Occupies just 6 principal breeding sites, 4 in east and southern Africa and two in Rajasthan, northwest India. Winters on nearby lakes and along coastline of Indian Ocean.

STATUS
Near Threatened; worldwide population 2.2–3.2 million individuals.

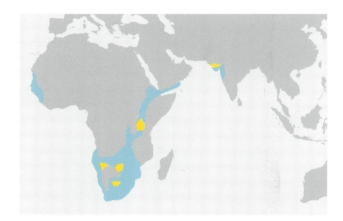

FROM A DISTANCE, Kenya's Lake Nakuru appears ringed with a lurid pink wash. Only through binoculars does this bizarre apparition resolve into feathered solidity: Lesser Flamingos, crammed by the thousand into every contour of the lake shore. Up close, the true scale of the spectacle unfolds, with massed ranks paddling in the shallows, upending in the deeps and winging over the water in gangly squadrons.

Kenya's Rift Valley soda lakes host the largest gathering of flamingos on earth. Numbers fluctuate as the birds move around: If they are not at Nakuru, they might be on Lake Bogoria or Magadi. However, none of these lakes are where the birds breed. Only at Lake Natron, just south of the border with Tanzania, do they find the extreme conditions to which they are uniquely adapted. In peak years, more than two million pairs breed here—at least half the world's population.

Some 1,400 miles (2,250 km) to the south, on the fringes of the Kalahari Desert, are three other breeding sites: one at Etosha Pan in Namibia; one at Sua Pan in Botswana; and one—a recent addition, courtesy of a conservation project—at Kamfers Dam, in South Africa. About the same distance to the northeast, across the Indian Ocean, there are also two breeding sites in northwest India. This means that virtually the entire breeding population of the Lesser Flamingo is restricted to these six principal sites.

Ornithologists have long known that Lesser Flamingos move around, causing great seasonal fluctuations on the Rift Valley lakes. Less known, however, is how far they move and which routes they follow. At Etosha Pan in Namibia, for example, the birds breed on average only once every seven years or so. When conditions are right for nesting, however, the small resident population may swell by tens of thousands almost overnight. Where do all these new arrivals come from?

This species is the smallest of the world's flamingos, distinguished from the Greater Flamingo—the only other Old World species—by its smaller size, shorter neck, and deeper red bill. Like all flamingos, it feeds exclusively in alkaline waters, where it uses its boomerang-shaped bill to filter food from the salty shallows—notably the blue-green *Spirulina* algae on which the species is heavily dependent.

The Lesser Flamingo's breeding requirements are very exacting, hence the paucity of breeding sites. It uses only highly caustic soda lakes, their alkaline waters—reaching 140°F (60°C)

OPPOSITE Lesser Flamingos on their breeding grounds wave their bills in synchronised "head flag" breeding displays.

04 | SONGBIRDS

SONGBIRD IS A common name for the bird order Passeriformes, also known as passerines or "perching birds." This order accounts for more than half the world's bird species and includes such familiar families as robins, thrushes, finches, wrens, and swallows. Most are small and many are celebrated for their songs, made possible by an adaptation of the vocal apparatus absent in other animals. Many of these songs have become synonymous with bird migration, bringing life to the landscape as the birds arrive in spring to claim breeding territories.

Songbird migration comes down to diet. In the northern hemisphere, most insect-eating species are long-distance migrants. With their food supply turned off in winter they travel south, many heading for the tropics. Some complete enormous journeys that belie their modest size. The Willow Warbler, for example, weighs just 0.2 oz (12 g) but may travel up to 8,000 miles (12,870 km) each way between East Africa and Siberia. In the Americas, the similar-sized Blackpoll Warbler journeys between central Canada and Brazil, its southbound route including a non-stop 1,500-mile (2,400-km), 80-hour flight over the Atlantic, from New England to the Caribbean.

To meet the extreme energetic demands of such epic journeys, most songbirds binge-feed before departure, some almost doubling their body weight in extra fat reserves, which speed them toward their direction as rapidly as possible. Most fly by night, when the air is cooler and more stable and predators less active, and generally on a broad front—only meeting up at regular pit-stops. Some aerial insectivores, such as swallows, fly by day, able to feed in flight as they travel. Their journeys are typically slower.

Songbird migration seldom follows a straight line. The routes of many species feature diversions around barriers such as mountain ranges or involve long sea crossings. Populations of some species divide: From northern and Central Europe, some Spotted Flycatchers pass to the west of the Alps and some to the east, the two routes crossing the Mediterranean into Africa at different points. A few species that have expanded their ranges preserve an inherited migration route that now appears illogical: Northern Wheatears in Canada migrate across the Atlantic to follow the Afro-Palearctic highway to East Africa rather than joining other American species on the much shorter journey south to Central America.

Birds that do not feed entirely upon insects may have other options. Species such as the American Robin switch to a mostly berry-based diet during winter. They can then remain on their breeding grounds, while others—typically populations further north, where conditions are tougher—migrate south, even leapfrogging their sedentary companions. Such species are known as partial migrants and their migratory patterns vary from year to year with weather conditions. Some seed-eaters, such as finches and buntings, also make smaller movements. Snow Buntings breed further north than any other passerine and, in winter, leave their Arctic breeding quarters for coasts and steppes. There, they replace their black-and-white summer plumage with a patchwork of brown, white, and black that better camouflages them against the new terrain.

A few songbird species move according to the fluctuation of their food resources. The Red Crossbill feeds almost entirely on pine seeds and birds may move en masse at any time of year in order to exploit these crops, sometimes remaining to breed in their new quarters. Such unpredictable mass movements, known as irruptions, are also typical of some migrant passerines in tropical arid zones. Africa's Red-billed Quelea, a small weaver that is the most abundant bird in the world, forms flocks of millions that move to wherever rainfall produces grass seeds, sometimes stripping crops like a swarm of locusts.

Migratory songbirds have earned a special place in our culture. In Europe, the Barn Swallow is celebrated as an emissary of summer, while the evocative nocturnal refrain of the Common Nightingale has inspired poets from Shakespeare to Keats. Today, however, these birds face multiple threats, from hunting to habitat loss, causing significant declines in many species. A few receive help: In North America, Purple Martins are now almost entirely reliant on artificial nest boxes. But many require conservation work on a landscape scale, safeguarding or restoring their migratory flyways to shore up their future.

OPPOSITE An Ovenbird, newly arrived in Cape May, New Jersey, from its winter quarters in Central America, bursts into territorial song.

PURPLE MARTIN

Progne subis

SIZE
L: 7.5–7.9 in (19–20 cm)
Wt: 1.6–2.1 oz (45–60 g)
WS: 15.3–16.1 in (39–41 cm)

APPEARANCE
Small (though large for a swallow), with slightly forked tail; breeding male uniform black with glossy blue sheen; non-breeding male and female browner above and pale below; immature like female, with blotchier underparts.

LIFESTYLE
Inhabits open country where it feeds on insects captured in flight; a natural cavity breeder, now it mostly breeds in purpose-built nest boxes around human habitation, in which lays 3–6 eggs in mud and grass nest.

RANGE AND MIGRATION
Breeds in North America as far north as central Canada, mostly east of the Rockies. Migrates through Caribbean to overwinter in South America, south to Brazil.

STATUS
Least Concern; population estimated at 7 million but declined during the twentieth century; eastern population now dependent upon artificial nestboxes.

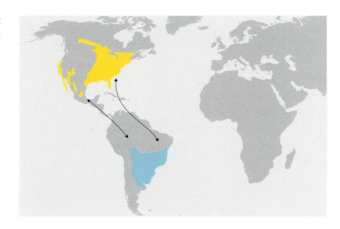

FEW BIRDS DEPEND more upon people than the Purple Martin. Across North America, this chunky member of the swallow family breeds in purpose-built nestboxes—often combined into complete nesting apartment blocks, fixed to people's roofs or mounted on poles in front yards. Furthermore, across most of eastern and central United States and Canada, these nestboxes have in recent years become the *only* places in which the species breeds. The natural holes and cavities on which it once depended have been taken over by House Sparrows and Common Starlings, invasive species from Europe that have usurped the martins.

Nest boxes for Purple Martins are not a modern innovation. Native American communities, including the Cherokees, first provided similar homes hundreds of years ago using hollowed-out gourds, possibly even before the first Europeans arrived. For these traditional societies, the birds not only provided a cheerful twittering song around the home—their aggressive mobbing also helped deter any passing hawk that might be eyeing up the chickens.

A few thousand miles to the south, people have a rather different view on Purple Martins as neighbors. On their winter quarters in Brazil, these birds are also attracted to human structures and habitations—even choosing power stations in the middle of the Amazon rainforest. Indeed, they roost in such vast numbers on roofs and power lines in streets and public parks that, in some towns, the accumulation of droppings and feathers has become a public health hazard. Large post-breeding roosts also form in North America, prior to migration, but these are more transient, lasting just a week or two. Those in South America last many months and are a genuine source of concern for some local authorities.

The Purple Martin is one of the larger members of the swallow family (Hirundinidae), identified by its largely dark plumage—all-black with an iridescent blue sheen in breeding males—and slightly forked tail. Females and non-breeding males are browner, with pale underparts, while immature birds have blotchy markings below. Like all swallows, it feeds on insects caught in flight—generally foraging at greater heights than other swallow species. It does not prey habitually on mosquitoes, as has been claimed by those trying to sell nest boxes, but is one of the higher-flying swallows and tends to target bigger species such as dragonflies, moths, beetles, and larger flies, often hunting over water. It is also known to prey on fire ants—thus performing a useful control service for what can be a very destructive invasive pest.

The breeding range of the Purple Martin spans eastern and

OPPOSITE The Purple Martin, like other members of the swallow family, feeds on the wing during its migration flight.

LEFT In eastern North America, the Purple Martin is entirely reliant on artificial nest boxes for its breeding success—as seen here at Cape May, New Jersey.

central North America, from northern Mexico to southern Canada, with separate populations in the western USA. Taxonomists recognize four subspecies, with the eastern form *P. s. subis* being the most numerous. The first returning migrants arrive early, reaching breeding colonies in Texas and Florida from late January, while the latest reach northern USA and Canada in May. Males arrive first to claim territories and investigate nest sites before the females make their choice of mate. In eastern populations, this invariably means competing with other members of a colony for the best chambers in a purpose-built block. Pairs in western populations may nest individually, however, and still use natural sites such as holes in saguaro cactuses or those excavated by woodpeckers.

Together a pair of martins builds a three-layered structure inside the nestbox with a base layer largely of mud and twigs, overlaid by smaller twigs and grasses, and topped with a leaf-lined depression. The female lays three to six eggs which she incubates for fifteen to eighteen days. Both parents feed the nestlings, which fledge about twenty-six to thirty-one days after hatching. After breeding, Purple Martins gather in large flocks, often mixing with other species, typically on bridges or powerlines, feeding and roosting together as they prepare for the journey south. They depart en masse, the earliest in July and the latest in October, sometimes forming flocks so large that they show up on radar.

Purple Martin migration has been studied for many years: The oldest individual on record was aged at least thirteen years and nine months, having first been banded in Illinois in 1933 and subsequently recovered in 1947. Until relatively recently, however, the migration routes were poorly known. In 2007, the Purple Martin Conservation Association used geolocators to track birds from their winter quarters near Sao Paulo in Brazil to the Association's headquarters in Erie, Pennsylvania. Their results revealed that birds made this roughly 5,000-mile (8,000-km) journey along one of two main flyways: Some headed north via Colombia and through Central America, crossing the Gulf of Mexico from Yucatán to make landfall somewhere between the Florida Panhandle and eastern Texas, while others took a more easterly route via Venezuela, island-hopping north through the Caribbean and crossing from Cuba to eastern Florida. Spring migration was considerably faster than autumn migration.

Other studies have tracked birds of the western subspecies traveling up overland through Mexico. As with all migrants, individuals can veer off course, often due to poor weather conditions. 2004 saw Purple Martins recorded in Europe, both in the Azores and on the Scottish Island of Lewis.

The Purple Martin is listed by the IUCN as Least Concern. However, populations crashed during the twentieth century due to competition with the more aggressive Common Starlings and House Sparrows for nest sites.

LEFT Few migratory birds receive a warmer welcome in American households than the Purple Martin.

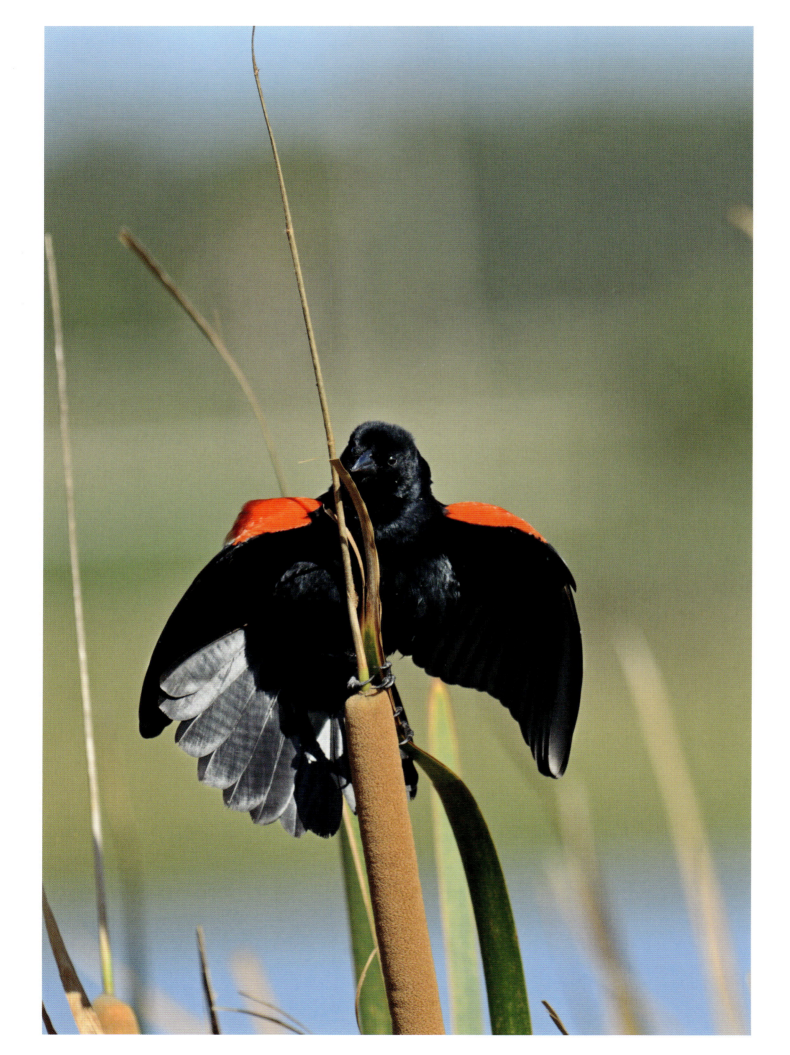

RED-WINGED BLACKBIRD

Agelaius phoeniceus

SIZE
L: male 8.7–9.4 in (22–24 cm); female 6.7–7.1 in (17–18 cm) Wt: male average 2.3 oz (64 g); female average 1.46 oz (41.5 g) WS: 12–16 in (30.5–40.5 cm)

APPEARANCE
Common Starling sized, with short, sharp bill; breeding male uniform black with red shoulder coverts banded with yellow bar; non-breeding male, female, and immatures streaky brown.

LIFESTYLE
Inhabits meadows, prairies, and wetlands, where it forages largely on the ground for seeds and insects; breeds among reeds and vegetation near water; polygynous: male may have more than 10 females, each laying 2–3 broods per season, comprising 3–4 eggs.

RANGE AND MIGRATION
Breeds across North America and northern Central America from Alaska and Canada to northern Costa Rica; partial migrant: northern populations travel to southern US and northern Mexico, overwintering in huge flocks on farmland and marshes.

STATUS
Least Concern; population may reach 250 million in peak years.

AN INDIVIDUAL RED-WINGED Blackbird seems to demand attention during the breeding season: Clad in its smart, jet-black plumage, emblazoned with bright red-and-yellow epaulettes, it calls out its familiar crackly three-note refrain from conspicuous perches all over North America. After breeding, however, this bird seems to become a different creature entirely. Each individual is subsumed into vast flocks that turn the skies dark as they swarm to their roost over the fields and prairies of the Midwest. Combined with other wandering seed-eaters, including cowbirds, Common Starlings, and grackles, these flocks can be millions strong.

The Red-winged Blackbird is probably the most numerous bird in the USA, with a population estimated at over 250 million in peak years. Its breeding grounds range across most of North America, north to Canada and southern Alaska and south to Florida, Mexico, and northern parts of Central America, including northern Honduras and northern Costa Rica. It even occurs on islands in the Bahamas and Florida Keys.

The Red-winged Blackbird is a partial migrant. The more southerly populations are resident, staying put on or around their breeding grounds all year. More northerly populations head south after breeding, however, traveling to the southern and central USA and northern Mexico. In their wintering quarters and during their return migratory journeys, they form some of the largest non-breeding aggregations of any bird. The huge flocks descend on fields to feed on grain and have long been blamed by farmers for causing serious crop damage—so much so that control measures, both legal and illegal, have often seen the birds eradicated in the tens and even hundreds of thousands.

The Red-winged Blackbird belongs to the Icteridae, an American family of songbirds that includes cowbirds, grackles, caciques, and New World orioles. It is not related to the Common Blackbird (*Turdus merula*) of Europe, which belongs to the thrush family. However, like its European namesake, this species is sexually dimorphic, with the breeding finery of the larger male being in marked contrast with the streaky brown anonymity of the smaller female.

This versatile bird inhabits meadows, prairies, and fresh and salt-water marshes, where it uses its short, sharp bill to feed on a variety of seeds, weeds, and—especially in the breeding season—insects and other small animals. Outside the breeding

OPPOSITE A male Red-winged Blackbird flaunts striking colors during its breeding display.

season it flocks on farmland, including feed lots and pastures, banding together with other seed-eaters in search of waste grain.

On their breeding grounds, Red-winged Blackbirds form loose colonies, typically among rushes, sedges, and cattails. Males set up territory with conspicuous breeding displays, in which they sing repetitively from a raised perch while flashing their striking shoulder markings. This is a polygynous species, one male sometimes defending more than ten females. The nest is a woven basket, lined with mud and attached to vegetation which usually overhangs water. It is constructed over three to six days by the female, who may lay two or three clutches per season, each comprising three to four eggs. She incubates the clutch for eleven to twelve days, with the chicks fledging after a further eleven to fourteen days.

The prolific breeding productivity of this species means that it is very much on the menu for many predators—both at the nest, where everything from Northern Raccoons and rat snakes to herons and even Marsh Wrens can target the eggs and chicks, and as an adult, when it may fall victim to raptors such as the Short-tailed Hawk. This is a feisty bird, however, and adults will put up a spirited defence of their nests, driving away predators such as crows, hawks, and even humans. It has been known to live up to 15.8 years in the wild.

The migratory movements of the Red-winged Blackbird have long been the subject of research, primarily in order to investigate the impact that this species has on crops. Some 700,000 birds were banded from 1924–1974, with 11,000 recoveries. The species migrates in flocks, traveling during the day, with females tending to travel further than males, which arrive on the breeding grounds earlier but depart later in the autumn. The peak southward movement is during October and early November, when the huge roosting flocks may gather along key flyways in the central Great Plains region. Some populations may cover considerable distances: Birds from the Great Lakes migrate nearly 745 miles (1,200 km).

The Red-winged Blackbird is extremely abundant and listed by the IUCN as Least Concern. Conflict with people continues. In 2009, the United States Department of Agriculture euthanized 950,000 Red-winged Blackbirds in the states of Texas and Louisiana, using poisons. While numbers remain high, these control measures may have wider ecological consequences. They have been implicated in the decline of the closely related Rusty Blackbird (*Euphagus carolinus*), the numbers of which have dropped by an estimated 90 percent since the 1960s—it is now IUCN-listed as Vulnerable.

ABOVE Red-winged Blackbirds form some of the largest non-breeding flocks of any North American bird and can have a significant impact on agriculture.

OPPOSITE During the breeding season, Red-winged Blackbirds are generally found close to water.

EASTERN BLUEBIRD

Sialia sialis

SIZE
L: 6.3–8.3 in (16–21 cm)
Wt: 0.95–1.2 oz (27–34 g)
WS: 9.8–12.6 in (25–32 cm)

APPEARANCE
Small songbird with fine bill; breeding male has blue upperparts and orange throat and breast; female duller; immature speckled below, blue coloration intensifies with age.

LIFESTYLE
Inhabits woodland edges and open country with scattered trees, including parkland and residential areas; feeds largely on insects, captured on ground from perch— also some berries; builds small cup-shaped nest in tree-hole; female produces 2 annual clutches of 3–7 eggs on average.

RANGE AND MIGRATION
Breeds in North America east of the Rockies, north to central Canada and south to Florida, Mexico and Nicaragua; northern populations migrate south in winter; southern populations remain in breeding quarters.

STATUS
Least Concern; population estimated at 22 million; currently rising after decline during first half of the twentieth century.

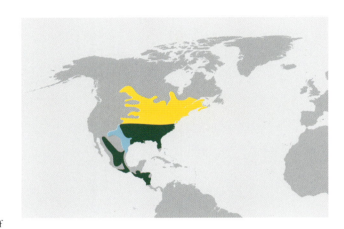

DESPITE THE INSPIRING words of Vera Lynn in the popular World War II song, there are unlikely ever to be "blue birds over the White Cliffs of Dover." These North American birds are not known to have ever found their way across the Atlantic. Nonetheless, they can certainly fly considerable distances across their own continent.

Three species of bluebird make up the thrush genus *Sialia* and are identifiable by their bright blue coloration. The Eastern Bluebird is the only one to occur in eastern North America, breeding from eastern and central Canada south into Mexico and Nicaragua. In breeding plumage, the male sports blue upperparts and a bright orange breast and throat, with the female being similar but dowdier.

Eastern Bluebirds inhabit woodland clearings and open country with trees, often taking up residence in parkland and residential areas. A pair build a neat cup-shaped nest in a cavity— such as an abandoned woodpecker hole—and the female lays a clutch of from three to seven eggs, producing two broods a year. Incubation last thirteen to sixteen days and the chicks fledge after a further fifteen to twenty days. Immature birds have speckled underparts, the blue coloration intensifying as they mature.

Bluebirds feed primarily on insects, flying down from a perch to capture prey on the ground. In winter, it will take berries and fruits from hawthorn, wild grape, sumac, and hackberry. A partial migrant, its reliance on insects means that northern populations migrate in winter. Birds from Canada and northern USA head south in autumn to winter in the southeastern USA and Mexico. In doing so, they fly over resident southern populations that remain on their breeding grounds all winter.

Eastern Bluebirds may migrate in flocks of hundreds, though generally travel in smaller groups. Immature birds migrate independently of adults and may stay in contact on their winter quarters and return together the following year. In spring, males reach breeding grounds before females. Nonetheless, banding studies have shown that individuals from Manitoba, Canada, may travel more than 1,300 miles (2,100 km) to winter in southern Texas.

The Eastern Bluebird is listed as Least Concern. After declines in the early twentieth century, the species is thought to have benefitted through afforestation across the central USA. Populations across much of its range rose on average by 1.5 percent annually from 1966 to 2015.

OPPOSITE Eastern Bluebirds typically take up a prominent perch from which to search for prey on the ground.

BLACKPOLL WARBLER

Setophaga striata

SIZE
L: 4.9–5.9 in (12.5–15 cm)
Wt: 0.42–0.53 oz (12–15 g)
WS: 7.9–9.8 in (20–25 cm)

APPEARANCE
Small and fine-billed; in breeding plumage, has streaky dark brown back, streaked white underparts, and black cap and mustache; in non-breeding plumage, greenish and streaky; double pale wing-bar; pinkish orange legs and feet.

LIFESTYLE
Inhabits coniferous and deciduous forests in mountainous and northern areas, feeding on flies, gnats, spiders, and other invertebrates in canopy; builds small cup nest low in branches of conifer, female typically producing 2 annual clutches of 3–5 eggs.

RANGE AND MIGRATION
Breeds across northern North America, from New York State and New England across Canada to Alaska; migrates via east coast and over Atlantic to winter in Lesser Antilles and northern South America.

STATUS
Near Threatened; population estimated at 59 million but has declined heavily since 1970.

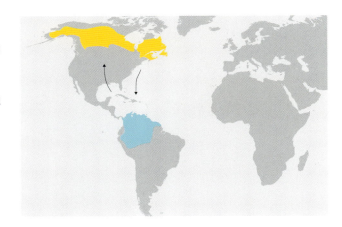

THIS UNASSUMING SONGBIRD makes a spectacular migratory journey. Summer finds it in the north of the American continent, from New England across Canada to Alaska, where it breeds in mountainous and boreal forests. Come autumn, these forests are no place for insect-eaters, so the entire population heads south to northern South America, some covering more than 6,500 miles (10,460 km). In the process, they make one of the longest known sea crossings of any landbird.

The Blackpoll Warbler is one of the less colorful of the New World warblers, and its streaky black-and-white plumage can be hard to see as it flits around the tree canopy, seeking out aphids, spiders, and other small invertebrates. It nests largely in spruces and other conifers. The female lays a clutch of three to five eggs, which she incubates for twelve days. Once the young have fledged at around ten days, she leaves them in the care of the male and moves on to start a second brood elsewhere.

Recent satellite tracking using light-sensitive geolocators has shown that all breeding Blackpoll Warblers from across North America converge on the northeast coast from mid-August. Alaskan breeders must, therefore, travel completely across the continent before they even begin their journey south.

When the birds head south over the Atlantic Ocean, many do not make landfall until the coast of northern South America or the Lesser Antilles. This means an average journey of 1,578 miles (2,540 km) in 72–88 hours, non-stop.

Studies have shown that this tiny bird achieves this astonishing feat by almost doubling its body mass from 0.4 oz (12 g) to 0.7 oz (20 g) during a pre-departure feeding binge. Over the Atlantic, it burns 0.003 oz (0.08 g) of fat per hour, traveling at an average 27 mph (43 km/h) and losing up to 0.1 oz (4 g) during the journey. Birds without enough body fat fail to make it. Only the Ruby-throated Hummingbird (see pages 262–265) is known to travel for more kilometers per gram.

Individuals tracked from breeding grounds in Nome, Alaska, take eighteen days to travel some 6,650 miles (10,700 km) to the Atlantic coast of the Carolinas, where they spend a month fattening up, before a 2.5-day flight of up to 2,113 miles (3,400 km) to the coast of Colombia, Venezuela, or northern Brazil—an annual round-trip of about 12,400 miles (20,000 km).

The Blackpoll Warbler has an estimated 59 million mature individuals but recent declines (with a fall of 92 percent between 1970 and 2014) have led the IUCN to list it as Near Threatened.

OPPOSITE The vigorous breeding song of the male Blackpoll Warbler follows one of the most impressive migrations of any small passerine.

COMMON NIGHTINGALE

Luscinia megarhynchos

SIZE
L: 5.9–6.5 in (15–16.5 cm)
Wt: 0.6–0.84 oz (17–24 g)
WS: 9–10.2 in (23–26 cm)

APPEARANCE
Medium small, with robin-like bill; warm brown upperparts, buff to white underparts and reddish-brown tail.

LIFESTYLE
Inhabits open deciduous woodland, hedgerows and scrub up to 1,300 ft (400 m) above sea level; frequents understory, feeding on insects, including ants, beetles, and larvae, in low foliage or on the ground; builds nest low in thicket, female producing typically 1 clutch of 4–5 eggs.

RANGE AND MIGRATION
Breeds across western and Central Europe east to west-central Asia, from Britain to Kazakhstan; migrates to winter in broad east-west band across Central Africa, from Kenya to Senegal.

STATUS
Least Concern; breeding population estimated at 3.2–7 million pairs; locally threatened, including in Britain.

THE MELODIOUS SONG of the Common Nightingale has inspired some of Europe's greatest poets, from Homer and Virgil to Shakespeare and Keats. Yet the bird itself remains surprisingly little known. In the UK, where it remains a cultural icon, few people other than dedicated birdwatchers have ever seen one. Perhaps even fewer know that this bird departs every winter for the warmer climes of Africa.

One reason for this unfamiliarity is the bird's retiring habits. Common Nightingales skulk among thick scrub in open woodland, where they forage near the ground for invertebrates. When they are seen, they are nothing special: medium-small brown chats, their only distinctive feature being a reddish tail.

Common Nightingales breed from western Europe to western and Central Asia. Males arrive first on the breeding grounds and use that legendary song—a mixture of numerous phases, both sweet and explosive—to proclaim a territory and attract a mate. Their unusual habit of singing by night when most other birds have fallen silent explains the romantic associations they inspire—although only unpaired males pursue this energy-costly strategy. Females build a nest of grass and twigs low down in a thicket. The clutch of four to five eggs is incubated for thirteen to fourteen days and the young fledge eleven to thirteen days later, whereupon both parents feed and care for them.

After breeding, nightingales from across their breeding range head south to spend winter in a band of tropical bush and savannah across Central Africa, from Senegal in the west to Kenya in the east. Birds from eastern breeding regions follow a largely eastern route down the Nile Valley. Those from further west head down through western Europe, skirting the west of the Sahara to West Africa.

The use of geolocators has helped fill in the gaps. In 2009, a British Trust for Ornithology-tagged nightingale revealed that this bird left Norfolk, England, on July 25 and by the end of July was in northern France. It then traveled through France and Spain and by late August was in northern Morocco. There it paused to refuel, and headed through Western Sahara in October, reaching Senegal in November. December and January were spent in Guinea-Bissau. It set off back north in February, being recaptured in April within 164 feet (50 m) of where it was tagged.

The Common Nightingale is numerous in its main range, with an estimated 3.2–7 million pairs meaning that it is listed as Least Concern.

OPPOSITE The male Common Nightingale sings from deep cover, both by night and day.

WILLOW WARBLER

Phylloscopus trochilus

SIZE
L: 4.3–4.9 in (11–12.5 cm)
Wt: 0.24–0.42 oz (7–12 g)
WS: 6.2–8.6 in (16–22 cm)

APPEARANCE
Very small, slight bird, with fine bill; upperparts greenish-olive, with pale eyebrow; underparts pale yellowish.

LIFESTYLE
Inhabits broadleaved and mixed woodland, especially birch, willow, and alder, feeding on insects and their larvae in the canopy; nest low in understory; female lays 4–8 eggs.

RANGE AND MIGRATION
Breeds from western Europe and Scandinavia east across northern Asia to far-eastern Siberia; migrates to winter across sub-Saharan Africa, from Senegal to Kenya in north and south to the South African Cape.

STATUS
Least Concern; worldwide population estimated at 414–647 million mature individuals.

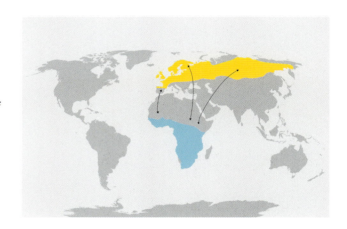

EVERY SPRING, THE lilting cadence of the Willow Warbler is the dominant sound across vast swathes of northern Europe and Asia. This sound is the perfect expression for such a delicate bird, which weighs no more than a pencil. Yet the annual journey this bird completes—sometimes more than 8,000 miles (12,870 km) each way—suggests extraordinary endurance.

The Willow Warbler is the commonest member of the leaf warbler genus *Phylloscopus*. It is slight with a short, fine bill, and its olive-green and yellowish plumage blends into the tree canopy, where it forages largely for small insects and their larvae. Its song distinguishes it from other leaf warblers such as the Common Chiffchaff (*Phylloscopus collybita*) where their ranges overlap. It also has slightly longer wings—an adaptation for its exceptionally long migration.

The Willow Warbler breeds from western Europe and Scandinavia, east across Russia and northern Asia to far-eastern Siberia. Across this range it is a bird of mixed and broadleaved woodland, notably birch, alder, and willow, preferring damp habitats with a dense understory of similar low-growing plants where it builds its nest.

In winter, the entire population funnels south down into sub-Saharan Africa. Different populations follow different routes. The nominate subspecies—*P. t. trochilus* from western Europe—takes a westerly route around the Sahara to winter in West Africa. The northern Scandinavian and Russian form, *P. t. acredula*, takes a more easterly route down the Nile Valley to eastern and southern Africa.

The longest migration is undertaken by the East Siberian subspecies *P. t. yakutensis*. A 2018 Swedish study used geolocators to track its autumn migration from Chukotka, showing that the birds first flew northwest across Siberia, then southwest, reaching stop-over sites in southwest Asia during the autumn equinox, and continuing south to winter quarters in southern Tanzania and Mozambique 93 to 118 days after departure. Some may even continue south to join *acredula* birds in eastern South Africa.

Willow Warblers are among the earliest migrants to return to breed. Females lay four to eight eggs in a neat domed nest low down in the understory, and both parents feed and raise the chicks. An estimated 62–97 million pairs breed across Europe; in parts of Scandinavia, there may be 1,000 pairs per square kilometer. In some areas, however, the species is in decline, threatened by habitat loss on its breeding and wintering grounds: In the UK, the population has fallen by 44 percent since 1970.

OPPOSITE Willow Warblers are among the northernmost breeders of Eurasia's passerines, and complete one of the longest migrations.

SPOTTED FLYCATCHER

Muscicapa striata

SIZE
L: 5.7 in (14.5 cm)
Wt: 0.49–0.71 oz (14–20 g)
WS: 9.4 in (24 cm)

APPEARANCE
Small bird with fine, broad bill; upperparts brown; underparts white with fine streaking; juvenile has spotted upperparts.

LIFESTYLE
Inhabits open deciduous woodland, parks, and gardens, with clearings and perches conducive to foraging for aerial insects; nests in cover, against wall or tree trunk; producing up to 2 clutches per season, with 4–6 eggs in the first.

RANGE AND MIGRATION
Breeds from western Europe and Scandinavia east to central and southwest Asia; migrates to winter in sub-Saharan Africa, from Senegal to Kenya in north, and south to the Cape.

STATUS
Least Concern; worldwide population estimated at 54–83 million mature individuals.

IN THE UK, this small, unobtrusive species has become something of a poster bird for the alarming decline in migratory bird populations. Like many insect-eating species of northern Europe, it migrates south after breeding to overwinter in sub-Saharan Africa. However, populations have been in free-fall since the second half of the twentieth century, with a decline of 87 percent since 1970 in the number of UK breeding pairs.

As its name suggests, the Spotted Flycatcher subsists largely on a diet of flying insects. Rather drab in appearance, with brownish upperparts and pale, streaked underparts (the "spots" are restricted to juveniles), it is most easily identified by its behavior: in particular, a distinctive habit of flying out from a perch in short sallies to catch moths, flies, and insects in mid-air, then returning with its catch to the same perch. As an adaptation for this aerial agility—as well as its long-distance flights—this species has longer wings that many similar-sized passerines. During inclement weather, when fewer insects take to the air, it will also forage among leaves.

Spotted Flycatchers are among the later European migrants to reach their breeding grounds, most arriving in late April and early May. They range across Europe, north to Lapland and south to Morocco, and east into southwest and Central Asia. Their preferred habitat is open deciduous woodland, parks, and gardens, with clearings among trees in which to practice their aerial pursuit of insects. A pair constructs its cup nest in an opening in dense cover—typically a recess in a wall covered by a climbing plant. The female lays a first brood of four to five eggs, generally followed by a smaller brood later in the summer. Eurasian Jays (*Garrulus glandarius*) are significant predators of both eggs and chicks.

Autumn migration starts from late July, with departures peaking in mid-to-late August. There are several subspecies, ranged geographically from east to west, with each choosing a different route south. Westernmost populations, including those from the UK, head southwest through Iberia into North Africa, crossing Western Sahara and ending up on wintering quarters along the West African coast, from Ghana to the Democratic Republic of Congo. Eastern populations take a more easterly route south, reaching as far as South Africa.

With a global population estimated at 54–83 million individuals, this species is currently considered Least Concern. However, there have been significant recent declines across parts of its European range. Key factors are thought to include habitat loss in the Sahel savannah belt—a critical staging post on the way to West Africa—and agricultural intensification in Britain, where insect supplies are extremely depleted.

OPPOSITE A reliance on a diet of winged insects, such as this wasp, obliges the Spotted Flycatcher to migrate to tropical climes outside the breeding season.

A Barn Swallow recently arrived at Minsmere
Nature Reserve on the east coast of England.

PUBLIC
FOOTPA

SPOTTED FLYCATCHER

Muscicapa striata

SIZE
L: 5.7 in (14.5 cm)
Wt: 0.49–0.71 oz (14–20 g)
WS: 9.4 in (24 cm)

APPEARANCE
Small bird with fine, broad bill; upperparts brown; underparts white with fine streaking; juvenile has spotted upperparts.

LIFESTYLE
Inhabits open deciduous woodland, parks, and gardens, with clearings and perches conducive to foraging for aerial insects; nests in cover, against wall or tree trunk; producing up to 2 clutches per season, with 4–6 eggs in the first.

RANGE AND MIGRATION
Breeds from western Europe and Scandinavia east to central and southwest Asia; migrates to winter in sub-Saharan Africa, from Senegal to Kenya in north, and south to the Cape.

STATUS
Least Concern; worldwide population estimated at 54–83 million mature individuals.

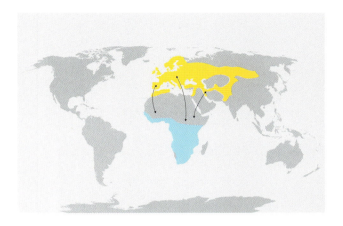

IN THE UK, this small, unobtrusive species has become something of a poster bird for the alarming decline in migratory bird populations. Like many insect-eating species of northern Europe, it migrates south after breeding to overwinter in sub-Saharan Africa. However, populations have been in free-fall since the second half of the twentieth century, with a decline of 87 percent since 1970 in the number of UK breeding pairs.

As its name suggests, the Spotted Flycatcher subsists largely on a diet of flying insects. Rather drab in appearance, with brownish upperparts and pale, streaked underparts (the "spots" are restricted to juveniles), it is most easily identified by its behavior: in particular, a distinctive habit of flying out from a perch in short sallies to catch moths, flies, and insects in mid-air, then returning with its catch to the same perch. As an adaptation for this aerial agility—as well as its long-distance flights—this species has longer wings that many similar-sized passerines. During inclement weather, when fewer insects take to the air, it will also forage among leaves.

Spotted Flycatchers are among the later European migrants to reach their breeding grounds, most arriving in late April and early May. They range across Europe, north to Lapland and south to Morocco, and east into southwest and Central Asia. Their preferred habitat is open deciduous woodland, parks, and gardens, with clearings among trees in which to practice their aerial pursuit of insects. A pair constructs its cup nest in an opening in dense cover—typically a recess in a wall covered by a climbing plant. The female lays a first brood of four to five eggs, generally followed by a smaller brood later in the summer. Eurasian Jays (*Garrulus glandarius*) are significant predators of both eggs and chicks.

Autumn migration starts from late July, with departures peaking in mid-to-late August. There are several subspecies, ranged geographically from east to west, with each choosing a different route south. Westernmost populations, including those from the UK, head southwest through Iberia into North Africa, crossing Western Sahara and ending up on wintering quarters along the West African coast, from Ghana to the Democratic Republic of Congo. Eastern populations take a more easterly route south, reaching as far as South Africa.

With a global population estimated at 54–83 million individuals, this species is currently considered Least Concern. However, there have been significant recent declines across parts of its European range. Key factors are thought to include habitat loss in the Sahel savannah belt—a critical staging post on the way to West Africa—and agricultural intensification in Britain, where insect supplies are extremely depleted.

OPPOSITE A reliance on a diet of winged insects, such as this wasp, obliges the Spotted Flycatcher to migrate to tropical climes outside the breeding season.

BARN SWALLOW

Hirundo rustica

SIZE
L: 6.7–7.5 in (17–19 cm)
Wt: 0.56–0.78 oz (16–22 g)
WS: 12.6–13.6 in (32–34.5 cm)

APPEARANCE
Small and aerodynamic, with
streamlined body, short head, short
bill, and long wings; glossy dark
blue upperparts, whitish underparts
and a red forehead and throat
trimmed with navy-blue breast
band; long outer tail streamers.

LIFESTYLE
Feeds on aerial insects; nests in
cup-shaped nest of mud, typically

inside farm building; lays 3–8 eggs;
may raise 2 broods a year.

RANGE AND MIGRATION
Breeds in Northern Hemisphere: in
North America, from Canada to
northern Mexico; in Eurasia, from
Ireland to Japan. Winters in
Southern Hemisphere: New World
birds winter in South America and
Old World birds in sub-Saharan
Africa and Indian subcontinent.

STATUS
Least Concern; worldwide
population estimated at 290–499
million individuals.

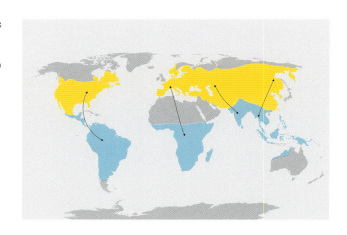

THE BARN SWALLOW is the most well-known and most widespread of the world's eighty-three swallow species. For many, it's also emblematic of bird migration—perhaps because its confiding and conspicuous life alongside our own has long made its appearance the most celebrated and its disappearance the most lamented: When swallows arrive, it seems, they bring the summer; when they leave, they take it away. The bird's name comes from its predilection for living around barns and other farm buildings, and its scientific species descriptor *rustica* suggests its rural associations in many cultures.

Like all swallows, this species has an aerodynamic shape, with a streamlined body, plus a short head, short bill, and long wings—all adaptations for catching small flying insects on the wing. The rudimentary legs and feet allow it to perch on wires and branches, but it is barely able to walk on the ground as it just shuffles around when collecting mud for its nest.

This conspicuous bird lives in any open country that offers an abundant supply of insects and the space in which to catch them, avoids heavily forested or built-up areas, and is often seen feeding above or near water. Cattle pasture is particularly popular, as cows leave large piles of insect-attracting dung and

churn up the best mud for nest-building without cropping the grass too low and allowing invertebrate life to flourish.

Barn Swallows breed across the Northern Hemisphere and winter in the Southern Hemisphere. Scientists recognize several different subspecies, including the nominate *Hirundo rustica rustica*, found from Europe east to Central Asia, and the North American form *H. r. erythrogaster*. Each heads to different winter quarters. The nominate form winters mostly in sub-Saharan Africa, with some 80–90 million arriving every year from Europe alone to spread out across the continent. Those from eastern Europe and Asia winter in eastern regions, as far south as South Africa's KwaZulu-Natal, while those from western Europe winter in western regions south to South Africa's Cape. Other subspecies commute elsewhere: Those that breed further east winter in southern and Southeast Asia, from India through Indonesia to northern Australia. The North American form winters in South America south to northern Argentina.

Early studies of Barn Swallow journeys were pivotal to today's understanding of bird migration. Conclusive evidence first arrived in 1912, when a swallow ringed the previous year in Staffordshire, England, was retrieved in KwaZulu-Natal, South

ABOVE Unlike many songbirds, Barn Swallows migrate by day,
using great aerial agility to capture insect prey on the wing.

A Barn Swallow recently arrived at Minsmere
Nature Reserve on the east coast of England.

PUBLIC
FOOTPA

Africa. Most British Barn Swallows start heading south during September. Before departure they gather in large numbers, often around wetlands, which offer plentiful food and safe roosts among the reedbeds. Large flocks can be seen lining up on overhead wires.

They feed energetically, building up fat reserves for migration. Then, once the weather conditions are in their favor, they set off, heading down through France and Spain, crossing the English Channel and the Mediterranean, and skirting around the Sahara. En route, they gather at traditional pit-stops, sometimes in the hundreds of thousands. By late October, most have reached their winter quarters where they spread out, finding suitable habitats to sustain them until the following February, when it is time to head north again to breed.

The return journey may start as early as late January. Spring migration is quicker and more direct, with the birds in a hurry to reach their breeding grounds. By late February, the main movement of British birds is already under way, with most reaching Mediterranean shores by March and arriving back by early April. Males tend to arrive before females, with the earliest generally being the oldest. They head straight to their breeding colonies to prepare for courtship and breeding.

Barn Swallows generally migrate in small, loose groups but they may come together in larger streams of tens or hundreds of thousands, both in flight and at roosts. They fly at lower altitudes than most small birds, often just meters above the ground, in order to hunt for insects along the way. Individuals are known to have traveled more than 250 miles (400 km) in a day. Ringing records illustrate this: For example, one bird made it from Paris, France, to Ghana in twenty-seven days, thus covering an average of 116 miles (188 km) per day; another traveled 1,881 miles (3,028 km) from Italy to Niger in just seven days at an impressive average of 269 miles (433 km) per day.

Swallows are socially monogamous: Pairs tend to stay together for successive years. Once a pair has re-established its bonds on the breeding site, they attend to their nest by either repairing last year's or building a new one, using grass cemented in place with mud. Human structures generally provide the nest sites: Barn Swallows have been nesting on human artefacts since at least the time of the Ancient Egyptians, and the availability of such structures has allowed them to colonize areas they might not otherwise inhabit—for example, by breeding in log cabins in the northern tundra. A female lays a first brood of five to seven eggs (on average), generally followed by a second, smaller, brood later in the summer.; incubation usually lasts from thirteen to fifteen days. Youngsters leave the nest at eighteen to twenty-three days and spend another five to seven days in their parents' care until they leave to roost with other immature birds. For their next challenge—migrating to Africa—they will be on their own. It will not be easy: although the fledgling survival rate in swallows is 70–90 percent, only 20–30 percent of birds survive their first year.

Despite these challenges, the Barn Swallow remains one of the world's most widely distributed and numerous birds with a global population that may number half a billion individuals, and is listed by the IUCN as Least Concern. In recent decades, it has extended its breeding range, notably across North America, but climate change and changing agricultural patterns remain potential threats.

LEFT Adult Barn Swallows continue to feed their chicks after they have left the nest. Soon these young birds will be striking out on their first southbound migration.

NORTHERN WHEATEAR

Oenanthe oenanthe

SIZE
L: 5.7–6.3 in (14.5–16 cm)
Wt: 0.6–1 oz (17–30 g)
WS: 10.2–12.6 in (26–32 cm)

APPEARANCE
Small, with upright stance, shortish tail, and fine bill; breeding male has pale gray upperparts, pinkish-buff breast, black wings, and black face mask; female and non-breeding male more pinkish-brown overall; in all plumages has bold white rump and white tail with black "T" bar on tip.

LIFESTYLE
Forages on the ground for insects in open and rocky country; pairs nest in recess in rock or wall; female lays 3–7 eggs.

RANGE AND MIGRATION
Breeds in Northern Hemisphere; across Europe and northern Asia to far-eastern Russia; discontinuous distribution in North America, in Alaska and western Canada, and in Greenland and eastern Canada; winters in Africa, in broad band just south of the Sahara.

STATUS
Least Concern; worldwide population estimated at 2.9 million individuals.

BIRDS ACQUIRE THEIR names in many different ways. "Wheatear" has nothing to with either "wheat" or "ears," but is thought to be a corruption of an Old English word that meant "white arse" and referred to the signature white rump that this bird shows in flight. A little less crude is the etymology of the scientific name *Oenanthe*. Derived from the Ancient Greek *ainos* (wine) and *anthus* (flower), it refers to the bird's return in spring just when the grape vines are blossoming. It also highlights another truth: This bird is a traveler—in fact, relative to its size, it may be the greatest bird migrant of all.

Wheatears are small insect-eating birds that are related to robins and chats in the Muscicapidae family of Old World flycatchers. The Northern Wheatear is the most widespread and most northerly occurring of some twenty-eight *Oenanthe* species, and is identified by its combination of pale gray back, pinkish-buff breast, and black face mask. Like all its kind, this long-legged, upright little bird frequents open country, where it hops along the ground in search of beetles, ants, and other small invertebrates, often popping up onto a prominent vantage point such as a rock or wall.

The Northern Wheatear breeds across almost the entire Northern Hemisphere. In Europe, it occurs from the Mediterranean to Scandinavia and east across Russia to the far northeastern corner of Siberia. From there, it has spread across the Bering Strait east into Alaska and Arctic Canada. From western Europe, it has also made an extension of its range into the New World, spreading northwest to colonize Iceland, Greenland, and the eastern shores of Arctic Canada. North America thus has two breeding populations, one in the northwest and one in the northeast, each separated by almost 2,000 miles (3,200 km). Each also represents two separate subspecies with very different migration routes.

Looking at this vast breeding distribution, you might expect that different wheatear populations across its east–west extent would choose different winter quarters. Perhaps those from Siberia and Alaska would join the Pacific Flyway and head south into Southeast Asia, along with the many shorebirds that use this route; perhaps the birds from Greenland and eastern Canada would head south through the Americas along with countless other North American migrants. However, this is not the case: all the world's Northern Wheatears spend winter

OPPOSITE Northern Wheatears are among the earliest European migrants to arrive on their breeding quarters and thus sometimes encounter adverse weather conditions. This individual must survive a late snowfall at Forsinard, northern Scotland.

in Africa. There, they occupy a broad central band just south of the Sahara that extends from Mauritania in the west to the Red Sea coast in the east, and southward through East Africa as far as Zimbabwe.

This funneling of the entire species from breeding quarters across the globe into one southern wintering area necessitates some extraordinary journeys. Indeed, some Northern Wheatear populations are the furthest traveled of all migrant landbirds. Birds migrating from Alaska travel up to 9,000 miles (14,480 km) one way, covering 180 miles (290 km) per day. Along the way they cross oceans, ice caps, and the Arabian Desert. Populations from Eastern Canada and Greenland—which belong to a separate subspecies, known as the "Greenland Wheatear" (*O. o. leucorhoa*)—must cross the North Atlantic via Iceland and Britain and Ireland to reach western Europe and continue into North Africa. Some even fly directly from Greenland to southwest Europe, their flight of up to 2,200 miles (3,540 km) being the longest known sea crossing of any songbird.

Such extreme journeys—which seem to contradict geographical logic—result from genetically inherited behavior in a species that has expanded its range faster than it has evolved migratory adaptations. Different populations prepare for their journey in different ways. Greenland Wheatears, which face a long sea crossing, almost double their body weight before the journey, putting on enough fat reserves to see them through. Alaskan and Russian birds, which travel more slowly

and can feed at many staging posts en route, have no need for such preparation and do not weigh nearly as much when they depart, flying largely by night. In the UK, each spring sees the arrival of birds of both the nominate form (*O. o. oenanthe*) which has come to breed and, a little later, a brief influx of the larger Greenland Wheatear, which is in transit for a few days en route to its breeding quarters on the other side of the Atlantic.

In western Europe, Northern Wheatears are among the earliest of migrants to return from Africa, arriving on their breeding grounds sometimes as early as late February. They set up territory in suitable habitat, generally in either coastal or upland regions, with very little tree cover and plenty of bare ground for foraging.

Males stake their claim with a scratchy territorial song often accompanied by a brief fluttering song flight, while females make their nests in rock crevices, rabbit burrows or other recesses near to the ground. The three to seven eggs are incubated for thirteen days. Both parents feed the chicks, which are independent within twenty-eight to thirty-two days of hatching, and by mid-August they are already preparing, alone, for their first flight to Africa.

ABOVE A female Northern Wheatear leaves its nest, hidden in a dry stone wall.
OPPOSITE A newly fledged Northern Wheatear ready for its first migration to Africa.

BALTIMORE ORIOLE

Icterus galbula

SIZE
L: 6.7–8.7 in (17–22 cm)
Wt: 0.79–1.48 oz (22.3–42 g)
WS: 9.1–12.6 in (23–32 cm)

APPEARANCE
Small-medium songbird; breeding male has black head and back, white wing-bar, and bright orange underparts, rump, and shoulders; female is yellow-brown above and orange-yellow below.

LIFESTYLE
Inhabits deciduous woodland and parkland where it forages in tree canopy for insects, fruit, and nectar; builds woven nest hanging from end of branch; female lays 3–7 eggs, generally raising 2 broods.

RANGE AND MIGRATION
Breeds in northeastern and central North America from Montana to Atlantic Canada, New England and south to Georgia; winters in Florida, Cuba, Mexico, Central America, and northern South America.

STATUS
Least Concern; worldwide population estimated at 6 million individuals.

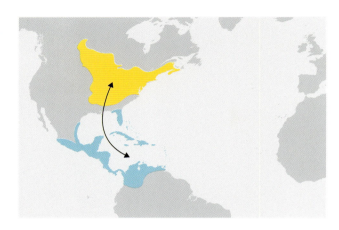

THIS NORTH AMERICAN songbird owes its name to the gorgeous black-and-orange livery of the breeding male, which recalls the coat-of-arms of English nobleman Lord Baltimore (1605–1675), first proprietor of the Province of Maryland. It has since acquired more celebrity as the name and emblem of Maryland's premier baseball team. It was US songwriter Hoagy Carmichael who perhaps first drew popular attention to the bird's migratory habitats, noting in his song "Baltimore Oriole" that it was "no life for a lady, to be draggin' her feathers around in the snow."

The Baltimore Oriole is unrelated to the true orioles of the Old World but sits alongside meadowlarks, grackles, cowbirds, and others in the New World Icteridae family. As in its Old-World namesakes, however, the male sports a striking plumage of black and yellow or orange, while fruit features prominently in its diet, along with insects and nectar, which it obtains by clambering around acrobatically in the tree canopy. This species reputedly has a particular liking for the ripest fruit, seeking out the darkest mulberries and reddest cherries. It pierces the flesh of larger fruits with its sturdy but sharp bill, then opens them to lap up the juice with its tongue.

This species has a largely northeastern breeding range in North America, from central Canada and Montana east to New Brunswick and New England and south to northern Georgia. Its typical habitat comprises leafy deciduous forest, open woodland, orchards, and wooded wetlands. It has taken readily to parks and gardens and is a common visitor to backyard feeders, where it is especially fond of orange halves. However, it is—as Hoagy Carmichael observed—long gone by the time the snows arrive, heading south to Florida, Cuba, southern Mexico, and Central America south to northern Colombia. On its wintering grounds, it gathers in small mixed feeding flocks, often visiting flowering and shade trees on coffee plantations.

In spring, Baltimore Orioles return north through Central America, many gathering in Panama during February and arriving along the Gulf Coast of Texas in early April. On their breeding grounds, the birds pair up, males performing vigorous hopping and bowing displays with their distinctive chattering song. The female builds a neat woven nest hanging from the end of a branch, in which she lays an average of four eggs, producing one clutch per season. Both adults feed the chicks, which hatch after an incubation of twelve to fourteen days.

With an estimated population of some six million, the Baltimore Oriole is considered Least Concern. The provision of artificial feeders may be affecting its migratory habits, with some southern populations electing to remain all winter.

OPPOSITE Baltimore Orioles in the south of their North American breeding range may overwinter wherever they find fruit provided at garden feeders.

SNOW BUNTING

Plectrophenax nivalis

SIZE
L: 6.2–6.6 in (16–17 cm)
Wt: 1–1.7 oz (28–50 g)
WS: 12.6–14.9 in (32–38 cm)

APPEARANCE
Sparrow-sized with relatively long wings and short, thick, bunting-like bill (though more closely related to longspurs); breeding male white, with black back, tail, and wingtips; female and non-breeding male browner and streakier, with rufous on crown, back and breast; all plumages show striking white wings in flight.

LIFESTYLE
Feeds on seeds and invertebrates in open country; breeds on Arctic tundra; lays 2–6 eggs in crevice nest among rocks and lichen.

RANGE AND MIGRATION
Circumpolar Arctic breeding distribution; also on mountain ranges in sub-Arctic, including in Scotland and Canada; in winter migrates south to southern Canada and the northern USA and, in the Old World, to northern and eastern Europe and in a broad band across Central Asia to the Pacific coast.

STATUS
Least Concern; population estimated at 30 million individuals; southerly populations vulnerable to habitat loss through global warming.

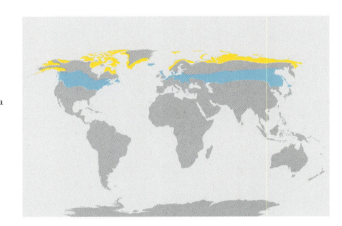

FOR COMMUNITIES AROUND the Arctic Circle, the annual arrival of Snow Buntings heralds the end of the long, dark, cold winter. These sparrow-like songbirds are among the earliest of the summer migrants to return. Males show up by mid-April, when snow still covers the ground and temperatures may be as low as −22°F (−30°C), with their twittering songs and display flights announcing the coming of spring.

Snow Buntings occur further north than other passerines. Breeding males are largely white with a black back and wingtips; females and non-breeding males are browner but also have bold white wings. The abundance of white in their plumage is an adaptation to tundra terrain, which can retain patches of snow. Their feathered tarsi (essentially, their lower hind limbs), unique among passerines, help to keep their legs warm.

The breeding range of this species extends from Alaska across Arctic Canada and Greenland to Scandinavia and Arctic Russia. It also breeds in a few more southerly locations such as Scotland's Cairngorm Mountains and Canada's Cape Breton, where the high altitude preserves Arctic-like conditions.

In winter, it migrates south. In the New World, to southern Canada and the northern USA and, in the Old World, to northern and eastern Europe as well as in a broad band across Central Asia to the Pacific.

The early arrival of male Snow Buntings allows them to secure favorable territories. Females arrive four to five weeks later, when the snow starts to melt. Pairs nest largely in small crevices among rock outcrops on the tundra, which afford protection from predators. A female lays her clutch of between two and six eggs as soon as the ambient temperature rises above freezing. To keep them warm, she stays sitting throughout the entire twelve-day-or-so incubation period as her mate brings her a variety of berries and invertebrates. The chicks fledge after twelve to fourteen days. Soon after breeding, Snow Buntings migrate south, the females leaving earliest. They travel by night and form small flocks on their wintering quarters, where they forage on open ground for the seeds of grasses and other low-growing plants.

Natural threats to the Snow Bunting include predators such as Arctic Foxes, raptors and skuas, while unseasonal storms early in the breeding season can take a heavy toll. Nonetheless, this is an exceptionally resilient species, adapted to withstand extreme conditions. It is listed by the IUCN as Least Concern, with an estimated 30 million individuals worldwide.

OPPOSITE The non-breeding plumage of Snow Buntings offers effective camouflage against the patchwork of snow, rock, and shingle where they spend winter.

RED-BILLED QUELEA

Quelea quelea

SIZE
L: 4.7 in (12 cm)
Wt: 0.53–0.92 oz (15–26 g)
WS: 5.5 in (14 cm)

APPEARANCE
Small, sparrow-like bird with streaky brown plumage and black face mask in breeding male; short conical bill, bright red in male, yellow in breeding female.

LIFESTYLE
Feeds largely on grass seeds, and crops where wild seeds not available; also takes insects during breeding season; feeds in huge synchronized flocks, sometimes millions strong; breeds in huge colonies in dense thickets, each pair producing an average of 3 eggs in an oval, woven nest.

RANGE AND MIGRATION
Breeds across sub-Saharan Africa, from Mauritania in west to Somalia in east and south to northeast South Africa; migrates in response to rainfall to areas where grass seed available, different populations favoring traditional areas.

STATUS
Least Concern; population estimated at a post-breeding peak of 1.5 billion individuals.

THE FLOCK RISES like a cloud, massing, splitting then reforming as it rolls over the savannah. More like an insect swarm than a gathering of birds, the sound of its countless, perfectly synchronized, tiny beating wings breaks like a wave. Who knows how many birds make up this extraordinary mass—flocks of millions have been recorded, sometimes taking several hours to pass overhead.

"Biblical" is little exaggeration when describing the movements of the Red-billed Quelea. This small, nomadic, seed-eating member of the weaver family (Ploceidae) is known as the "feathered locust"—not only for the numbers in which it gathers but also for the devastation that such gatherings can cause. Indeed, despite being entirely confined to the continent of Africa, this species is the most numerous wild bird on Earth, with peak post-breeding populations estimated at 1.5 billion.

Seen individually, Red-billed Quelea are nothing special. Resembling a small sparrow, they are streaky brown, with a stout conical bill that is coral red in the male and yellow in the breeding female. Breeding males have a black face mask surrounded by a brighter wash that varies regionally from pink to yellow. However, these birds are rarely seen individually: The ultimate social birds, they breed in vast colonies and migrate in massive non-breeding flocks across the grasslands of sub-Saharan Africa.

Red-billed Quelea naturally inhabit open terrain, from acacia woodland to semi-arid savannah, roaming wherever they can find enough grass seeds to sustain them. Where their natural habitat is replaced by farmland, they feed readily on crops, taking seeds from the likes of wheat, rice, sorghum, and millet. They seldom travel more than 19 miles (30 km) from water and are absent from forest, desert, and mountain ranges. Three main populations occur, each represented by a different subspecies: the nominate race, *Q. q. quelea*, ranges across western and Central Africa, from Mauritania to Chad; an eastern race, *Q. q. aethiopica*, is found from Sudan to Somalia and Tanzania; and a southern race, *Q. q. lathamii*, ranges from the southern Congo south to northeastern South Africa.

Migration for the Red-billed Quelea is not simply an annual return journey from A to B. Populations lead an itinerant life and are forever tuned to respond to rainfall. They arrive on feeding grounds a few weeks after the first rains have fallen,

OPPOSITE Red-billed Queleas gather around a waterhole, occupying every available perch.

SONGBIRDS

COMMON STARLING

Sturnus vulgaris

SIZE
L: 7.5–9.1 in (19–23 cm)
Wt: 2–3.6 oz (58–101 g)
WS: 12–17 in (31–44 cm)

APPEARANCE
Medium-sized passerine; glossy black with metallic sheen, pale spotted outside breeding season; sharp bill black in winter and yellow in summer; immature brown; walks and runs on ground; fast, direct flight on diagnostic triangular wings.

LIFESTYLE
Omnivorous, feeding in towns and farmland on a variety of invertebrates, seeds, and fruit; nests in holes, females laying 4–5 eggs in untidy cup nest; produces up to 3 clutches per year.

RANGE AND MIGRATION
Breeds naturally across Eurasia; widely introduced to North America, Australia, South Africa, Brazil, and Argentina; partial migrant in Eurasia, eastern breeding populations migrating south and west; some western populations remain on breeding grounds.

STATUS
Least Concern; population estimated at 310 million individuals.

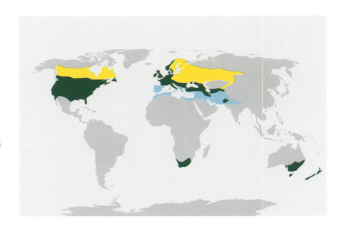

A COLD JANUARY evening along the Brighton, East Sussex, seafront in southern England, and as the lights of the Palace Pier twinkle into life, an arresting spectacle plays out overhead. Common Starlings swirl above the waves, the huge flock twisting and billowing like windblown smoke. Smaller flocks dart in over the sea front, each subsumed into the throng. As darkness falls, the pattern in the sky gradually dissolves, the birds dropping to their crowded roosts below the pier. But the chorus of twittering—the celebrated "murmuration"—continues, as the starlings jostle into position for the night.

Winter gatherings of Common Starlings offer spellbinding spectacles in many European cities. The Brighton gathering is far from the UK's largest, with flocks on the Somerset Levels often reaching a million, while peak December gatherings above the ancient cityscape of Rome may be up to five times that figure. These flocks tend to comprise winter visitors that have arrived from the north or east. Their swirling aerobatics, which may persist for half an hour before the birds finally settle, help bamboozle any lurking raptors, and in their gatherings the birds are thought to communicate information about where the best feeding grounds are for the morning.

The European Starling is a partial migrant. In Eurasia, its breeding range extends from northern Spain north to Scandinavia, south to Iran, and west to Central Asia.

Birds from northern and eastern regions migrate south and west in autumn to more temperate winter quarters, reaching North Africa, the Middle East, and the northern Indian subcontinent. However, many westerly populations stay put on their breeding grounds. This creates a complex situation in countries such as the UK, where in winter some breeding birds head south to the Iberian Peninsula but many remain behind, to be joined by a much larger influx of birds arriving from eastern Europe and Scandinavia. Birds banded in the Merseyside region of northwest England have been tracked back to breeding grounds in Finland, Russia, Poland, Germany, and Ukraine.

You needn't be a scientist to study Common Starling migration, however—large flocks moving by daylight make this one of the easier migrant species to track with the naked eye. Counts can be impressive: On October 16, 1997, 87,000 starlings were counted flying over the town of Hunstanton, Norfolk, in eastern England, as they arrived from their migration over the North Sea.

Today, such numbers are no longer confined to Eurasia. The deliberate import of sixty birds to New York's Central Park in 1890—reputedly by a misguided philanthropist who

OPPOSITE The Common Starling is a highly successful European colonist of the New World, and has taken its migratory habits with it.

wanted to see all bird species mentioned in Shakespeare in the New World—established the nucleus of a breeding population that has since colonized much of North America. Today, this population numbers some 150 million and accounts for 45 percent of the global total. The species has also been introduced to Australia and New Zealand, as well as to South Africa, Argentina, Brazil, Polynesia, and the West Indies. Some such populations have already established new migration routes: In North America, breeding birds from Canada and the northern USA head south in winter to the southern states; in Australia, some head north to New Guinea and Indonesia.

Today the Common Starling is one of the world's most widespread songbirds and occurs in twelve different geographical subspecies. Its success comes down to its versatility: With a broad omnivorous diet, comprising seeds, fruits, and invertebrates such as insect larvae and worms, it finds food across a range of habitats, and has adapted well to human environments, both urban and agricultural. It also deploys many feeding techniques, from probing the ground with open bill to capturing insects in flight, hanging from bird feeders, and even hawking from the backs of animals.

In spring, back on their breeding grounds, male Common Starlings sing vigorously in order to establish territories. Their long refrains comprise numerous different phrases, both mechanical and melodious, and the birds are accomplished mimics, a skill which has been celebrated by such varied and notable artists as Shakespeare and Mozart, the latter having kept a pet starling which he credited as inspiration for his Piano Concerto No. 17 in G major. Pairs build a scruffy nest in a cavity, the male sometimes even incorporating flowers in order to lure a mate with their color and fragrance. A female lays on average four to five eggs. Incubation lasts two weeks and the chicks fledge after another three weeks.

The abundance of starlings and their easy habituation to human environments has long made them popular subjects of study; as laboratory birds they are second only to the domestic pigeon in frequency. Experiments with captive starlings were pivotal in establishing that birds use the sun to orient themselves on migration. By using mirrors to alter the direction of sunlight, the birds could be persuaded to change course. Scientists have also studied the mechanics of murmuration flocks, establishing that each individual takes its bearings from up to seven birds in its immediate surroundings, enabling an entire flock to split-second synchronize its twists and turns without any leader.

Common Starlings have long had an ambiguous relationship with people. Their mass urban gatherings, however impressive to watch, can constitute a public health hazard, their droppings fouling streets and buildings and killing trees. In 1949, the weight of starlings roosting on the arms of Big Ben even brought Britain's most famous clock to a standstill. In cities such as Rome, the authorities employ various measures including trained falcons to deter the birds from roost sites.

In the USA, Common Starlings feeding on crops are estimated to cause $800 million of agricultural damage annually. As an alien invader, the species also has an impact on indigenous ecosystems, competing aggressively for nest sites with native birds such as sapsuckers. Such issues have led to significant control measures: 2008 saw some 1.7 million Common Starlings shot, poisoned, or trapped in the USA, and concerted culling has prevented the species from becoming established in Western Australia. However, starlings can also offer significant benefits through their predation on agricultural pests: The former Soviet Union even provided farmers with starling nestboxes to improve productivity.

Today, the conservation status of the Common Starling is mixed. The agricultural intensification of western Europe resulting in declining populations of grassland invertebrates has led to a heavy drop in breeding numbers in some regions, including the UK and the Baltic states. Elsewhere, however, there have been expansions and the bird is listed as Least Concern worldwide, with an estimated population of 310 million individuals.

ABOVE Windfall fruit is an important food source for wintering populations of the Common Starling.

FLIGHTS OF PASSAGE

ABOVE Common Starlings swarm around Brighton's Palace Pier before settling at their roost
for the night. Most of these birds will be winter visitors to Britain from mainland Europe.

SONGBIRDS

RED (COMMON) CROSSBILL

Loxia curvirostra

SIZE
L: 6.2 in (16 cm)
Wt: 1.5 oz (43 g)
WS: 11.4 in (29 cm)

APPEARANCE
Sparrow-sized finch with unique bill, in which tips of mandibles cross; male reddish to orange; females greenish with yellow rump (color varying across several regional subspecies)

LIFESTYLE
Feeds almost entirely on pine cones, using specialized bill to extract seeds; also takes some other seeds and buds; forages high in

trees, clambering acrobatically around cones; pairs build deep cup nest on high horizontal conifer branch; females lays 3–5 eggs, often during late winter.

RANGE AND MIGRATION
Breeds across North America and Eurasia, south to Mexico, North Africa and northern India, wherever extensive pine forests grow; migrates in search of new pine crops when resources are exhausted.

STATUS
Least Concern; population estimated at 15 million individuals.

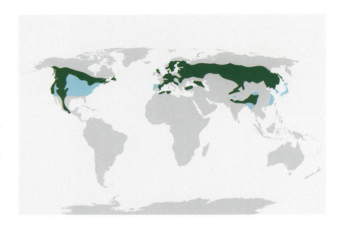

THE CLUE TO the nomadic habits of the Red Crossbill (known in Europe as the Common Crossbill) lies in its bizarre and eponymous beak, in which the tip of the upper mandible crosses the lower. This adaptation has evolved for extracting the seeds in pine cones and the bird is so dependent upon this diet that, in years when cone crops fail or are exhausted, it is forced to move on. Consequently, the species is an "irruptive" migrant—this means that it doesn't make regular migratory journeys between two locations, but "irrupts" irregularly into new areas, according to the availability of its staple diet.

Red Crossbills are sexually dimorphic finches, colored orange-red in males and greenish-yellow in females. They can be inconspicuous when feeding high in pines, clambering acrobatically between the cones, but reveal themselves when flying in small parties between stands of trees, uttering their distinctive flight call. Ornithologists have identified numerous regional subspecies which differ by call and bill dimensions, and studies to determine which of these may constitute entirely separate species is ongoing.

Crossbills feed by opening their crossed mandibles into pine cones, forcing the scales apart and prising out the seeds with their tongue. They may also take buds and other seeds, but their dependence on cones ties them to large forests of spruce

and, further south, pine. In western Europe, their fragmented distribution extends from Spain and North Africa to Scandinavia and Russia, and stretches across Central Asia, with separate populations in China and India. In North America, they breed across much of the continent.

This species is a very early nester among passerines, often having chicks as early as February—the pine crop is at its peak in winter. In North America and India, it can breed at any time in response to the pine crop. The nest consists of grasses and pine twigs on a horizontal branch. The sitting female is fed by the male while incubating three to five eggs, and the young fledge within eighteen to twenty days.

Red Crossbill irruption years can be major natural events. One was recorded in the chronicles of Benedictine monk Matthew Paris in the UK as early as 1254. Birds arrive in late summer after the spruce crop on continental Europe has been exhausted. Ringing studies show that most movement through Europe is southerly and that individuals ringed in one location may subsequently breed in widely separated localities.

Recorded regional declines of this species are due to the increased logging of old growth forests. With a population estimated at 15 million individuals worldwide, however, the species is listed as Least Concern.

OPPOSITE Red Crossbills often alight to drink from puddles, affording a close-up view of their extraordinary bill.

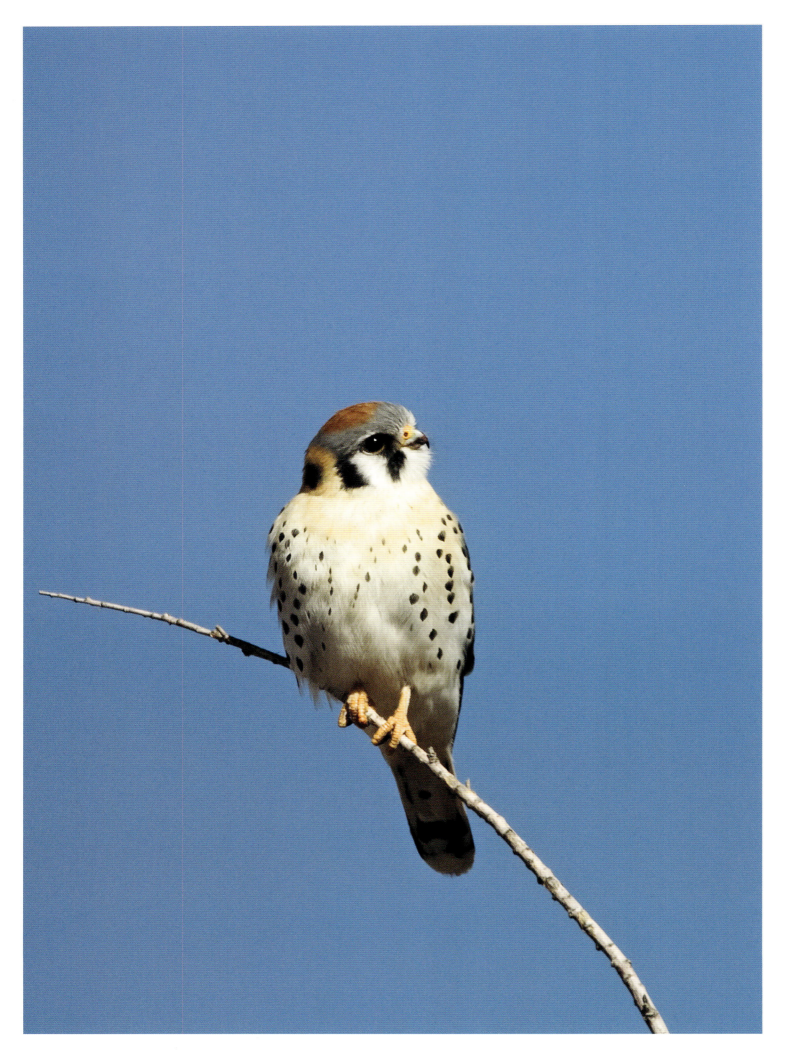

05 | R A P T O R S A N D O W L S

BIRDS OF PREY, just like other birds, migrate when their food becomes harder to find. Many eat small mammals, reptiles, amphibians, and large insects, most of which become scarce, die off, or hibernate during winter. Others also feed on birds, large numbers of which migrate far away. The majority of migratory raptors are those that breed in northern latitudes, which experience much greater climatic variations and food fluctuations than the tropics.

Many raptors are very large birds with broad wings adapted to soaring flight. Their migratory routes typically follow narrow corridors, often along ridges that generate helpful up-drafts. Flocks form at bottlenecks such as mountain passes or water crossings, where the birds wait for the thermals (or warm air currents) that will help whisk them over. In Eurasia, such locations include Gibraltar and the Bosphorus, at the western and eastern ends of the Mediterranean. In peak migration season, these areas see thousands of raptors, such as European Honey Buzzards and Short-toed Snake Eagles, spiraling high into the sky before gliding on, toward their destinations. However, even the biggest Mediterranean gatherings are dwarfed by those at Vera Cruz on the Gulf coast of Mexico, where peak autumn counts have been recorded of up to six million North American raptors in just a few days. *Buteo* species such as the Broad-winged Hawk dominate these gatherings, while Turkey Vultures also pass through in huge numbers.

Some raptors have a more slim-line build and are capable of longer unbroken flights. Swallow-tailed Kites are supremely aerial, able to stay aloft for long periods, and birds migrating from Florida to South America may cross the Gulf of Mexico non-stop. Some falcons fly even further: The Eleonora's Falcon completes a loop migration between the Mediterranean and Madagascar, its southbound leg taking it right over the central Sahara while its northbound return crosses the Indian Ocean directly to Kenya. This species is also remarkable for another reason: It's a specialist predator on songbirds, breeding on Mediterranean islands and delaying its own reproductive cycle to be able to feed its chicks on migrants heading south.

The Osprey is a partial migrant, with different geographical populations showing very different habitats. Birds from Canada migrate to South America, but in the process will overfly resident populations in the Caribbean. A specialist fish-eater, the Osprey follow coastlines and stop regularly to feed, making it one of the slower long-distance migrants. Nonetheless, individuals that nest in Quebec and overwinter in Brazil may cover more than 124,000 miles (200,000 km) during a fifteen-to-twenty-year lifespan.

The tropics offer most raptors richer pickings than they generally encounter on their more northern breeding grounds. On their African wintering quarters, birds such as Montagu's Harriers fan out across the savannah to exploit the prolific variety of reptiles, insects, birds, and small mammals in the long grass. However, the tropics bring competition from other predators and a higher parasite load, which is why these intrepid voyagers return north to raise their young. Many stop over at favorite staging areas, with Steppe Eagles, for example, congregating with other raptors at refuse tips on the Arabian Peninsula.

By contrast, the lifecycles of certain northern species can revolve around a single food source. Rough-legged Buzzards in the Arctic, for example, eat almost nothing but voles and lemmings, with their migratory movements reflecting this prey's availability. In poor rodent years, the birds head south in great numbers. This irruptive pattern is also typical of several owl species: the Short-eared Owl is a great wanderer, its long wings even enabling it to complete significant sea crossings, and even the Snowy Owl—that symbol of the Arctic—may wander as far south as Florida when the lemmings run out.

The hefty size of raptors has been the subject of pioneering studies, with the satellite tracking of Ospreys between Scandinavia and Senegal among the first of their kind. Such information is crucial to conservation initiatives, as raptors continue to be persecuted along their flyways. The Mediterranean remains a death trap, while the annual slaughter of thousands of Amur Falcons at their stop-over roosts in Nagaland, northeast India, came to light in 2012. Conservation aims to educate communities about the birds, which—as apex predators—are key indicators of a healthy environment.

OPPOSITE The American Kestrel is a partial migrant. Birds from Canada and the northern USA migrate south in winter, reaching as far as Central America and the Caribbean.

OSPREY

Pandion haliaetus

SIZE
L: 20–26 in (50–66 cm)
Wt: 2–4.6 lb (0.9–2.1 kg)
WS: 50–71 in (127–180 cm)

APPEARANCE
Large raptor with long wings and short crest; dark brown above, with dark face mask; white below, with brown breast band; glides on crooked wings.

LIFESTYLE
Preys almost entirely on fish, sighted from the air and captured in shallow water; occasionally takes other small vertebrates; monogamous pairs build large stick nest on raised vantage point near water; female lays 2–3 eggs.

RANGE AND MIGRATION
Always found near water, on coast or inland; breeds across Northern Hemisphere from North America to northern Europe and eastern Asia; migrates south to South America, Africa, and southern Asia; localized non-migratory populations resident in Caribbean, Central America, Middle East, Mediterranean, and Australasia.

STATUS
Least Concern; population estimated at 460,000 individuals, recovering after declines during the twentieth century; one of world's most cosmopolitan landbirds.

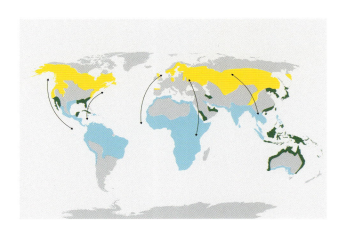

FISHERMEN UNLOAD THE night's catch as day breaks over a coastal lagoon in Senegal. Suddenly, an explosion of spray erupts from the shallows. A large bird flaps heavily from the surface, a Gray Mullet struggling in its talons. Adjusting its grip, it starts to gain height, wingbeats falling into a steady, powerful rhythm.

The Osprey is the only raptor that will immerse itself completely in a feet-first plunge-dive for fish. It has several unique adaptations for this strategy: long, fish-hook claws; spiny scales on the toes for extra traction; a reversible third toe that can help secure its slippery prize; oily plumage that minimizes waterlogging; and nostrils that seal shut on impact with water.

A closer look at this particular African individual, however, reveals an unexpected splash of color. The red band around one of its legs is evidence that it has another life in a different part of the world. The band was fitted in Scotland last June, when the bird was a nestling—one of many individuals, from Canada to Sweden, that help scientists learn more about movements of this highly nomadic species.

There is no mistaking an Osprey. When perched, it shows rich brown upperparts and white underparts, embellished with

a brown breast band, dark face mask, and jaunty crest. In flight, even at a distance, its distinctive flight profile of long, slightly drooping wings, crooked at the wrist, marks it out from other raptors. Indeed, it is unrelated enough to other raptors to belong in a family all of its own—the Pandionidae.

Ospreys are among the most widespread landbirds, found on every continent except Antarctica. Feeding almost exclusively on fish, they frequent aquatic environments in both temperate and tropical regions, from coasts and estuaries to lakes and large rivers. With the exception of the Australasian race, they breed exclusively in the Northern Hemisphere, with northernmost populations migrating south after breeding.

In North America, the Osprey breeds as far north as Alaska and Newfoundland, with birds from much of Canada and the United States migrating as far south as southern Brazil. Breeding populations further south, in Florida, Baja California, Belize, and the Caribbean, are resident, remaining on their breeding grounds. Similarly, in Eurasia, the species breeds from Scotland east through Scandinavia and across Central Asia to Kamchatka. Breeding birds from Europe and western Asia all winter in Africa, from Morocco to the Cape, while those from

OPPOSITE An Osprey tucks into its catch in the Everglades, Florida. Birds in this state are either migrants passing through or part of a local resident population.

ABOVE An Osprey with a nearly fledged chick on its nest in Finland.

central and eastern Asia winter in southern and Southeast Asia.

More southerly populations, such as those around the Red Sea, Persian Gulf, Canary Islands, Japan, and Indonesia, remain resident on their breeding grounds—as do those in Australasia.

Scientists today recognize four subspecies of Osprey, each with a different migration strategy. The Eurasian (nominate) *P. h. haliaetus* and North American form *P. h. carolinensis* are both largely migratory. The central American subspecies *P. h. ridgwayi*, which breeds on the Caribbean islands and in Belize, is non-migratory. The Australian subspecies *P. h. cristatus* is also largely non-migratory; this form is now thought sufficiently distinct by some authorities to constitute a separate species, the Eastern Osprey (*P. cristatus*), with Ospreys elsewhere reclassified as the Western Osprey accordingly.

In northern Europe, Ospreys are back on their breeding grounds by April. Pairs are monogamous, returning year after year to the same nest site and cementing their bonds with aerobatic displays. The nest is a large structure of sticks and driftwood, often more than 6 feet (2 m) across and constructed in a tall tree, on a rocky island or on human structures such as utility poles. Pairs breed at three to four years, a female laying two or three eggs, which both parents incubate for thirty-five to forty-three days. The young fledge after eight to ten weeks, the male having kept them supplied with fish while the female performed nest duties.

From August to September, migrant Ospreys start heading south. Females leave first, followed by males then juveniles. Their migration is one of the most studied of any bird species, with numerous individuals on both sides of the Atlantic having been tracked using ringing and satellite tagging. Studies have shown the birds travel relatively slowly and will use thermals over land, but may also make lengthy flights over open sea— even at night. They travel on average 160–170 miles (260– 280 km) per day, but make regular stop-overs, sometimes for a week or more during autumn. Their spring return journey is faster and more direct.

Ospreys from northwestern Europe, including the UK, overwinter along the coast of West Africa, notably in Senegal, Gambia, and Guinea-Bissau. Scottish birds fly the length of the UK before crossing into France, where they follow the coast to the south of Spain before skirting the western Sahara to their winter quarters. On their return journey, they can take a short-cut across the Sahara and the Bay of Biscay. Swedish birds have been recorded entering Africa via Spain, Italy, or along the Red Sea, their average journey taking 4,200 miles (6,700 km) over forty-five days. Birds from eastern Europe have been tracked as far as South Africa.

Some North American Ospreys fly even further: Birds banded in the eastern USA have been recorded 4,800 miles (7,722 km) away in Amazonas province, Brazil, and it has been calculated that Ospreys that nest in Quebec and overwinter in Brazil may fly more than 124,000 miles (200,000 km) over their fifteen-to-twenty-year lifespans. What's more, some of these birds cross more than 930 miles (1,500 km) of open ocean, as they short-cut from New England over the western Atlantic to the Caribbean.

After its first migration, a young Osprey may not return to its natal site for three years, and will not begin to breed until the year after that. Migration is hazardous for these young birds: One Swedish study found that more than half recorded Osprey mortalities took place on migration, many while crossing the Sahara. Hunters, electric power lines and fishing nets all take their toll, but with each year of migration an Osprey improves its strategy, learning the safest and most energy-efficient routes. The species has been recorded living up to thirty-two years in the wild.

Ospreys have long held a prominent place in cultures around the world. Nonetheless, they have suffered at human hands, both through persecution and through the destruction of their environment with DDT and other pesticide contaminants. The species' population declined heavily and rapidly during the twentieth century, but their subsequent recovery in many places has been a cause for celebration. In the USA, after the banning of DDT, the population grew by an average 2.5 percent per year from 1966–2015, and was boosted by the provision of artificial nest poles in areas where natural habitat had been lost. In the UK, Ospreys returned naturally to breed in Scotland in 1954, having been exterminated some fifty years earlier, and to England in 2001, after an absence of 150 years. Today the species is listed as Least Concern, with an estimated population of 460,000 individuals worldwide.

OPPOSITE An Osprey in Scotland emerges from the water after an unsuccessful plunge dive. The ability of this species to catch fish enables it to follow coastal routes while on migration.

MONTAGU'S HARRIER

Circus pygargus

SIZE
L: 17–19 in (43–47 cm)
Wt: M: 9.30 oz (265 g);
F: 12.2 oz (345 g)
WS: 38–45 in (97–115 cm)

APPEARANCE
Slim, medium-sized raptor with long wings and owl-like facial disc; male gray, with black wing-tips and black line across secondaries; female brown with white rump; immature rufous below; glides with wings held in diagnostic dihedral of all harriers.

LIFESTYLE
Preys on rodents, birds, reptiles, and large invertebrates captured from the ground in low gliding flight; nests on the ground; pairs perform aerobatic breeding displays; female lays 3–5 eggs; sometimes polygynous.

RANGE AND MIGRATION
Breeds in Europe, North Africa. and western Asia at temperate latitudes, inhabiting open country and agricultural land; winters in sub-Saharan Africa from Gambia to South Africa, and on Indian sub-continent.

STATUS
Least Concern; population estimated at 150,000–200,000 individuals; local declines as a result of pesticides and intensive agriculture.

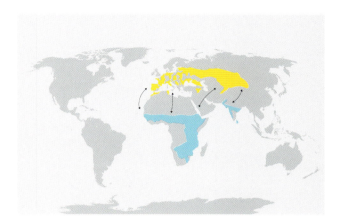

A SLIM, GRAY raptor cruises low over Tanzania's Serengeti Plains. Wheeling and dipping between the grazing herds, it periodically drops down on unsuspecting prey in the grass. A glance along the horizon reveals more quartering the savannah in the same buoyant flight, long wings held in a dihedral.

These birds are Montagu's Harriers, long-distance visitors named after British naturalist George Montagu (1753–1815), that, every winter, exchange the lowlands of Europe for the savannahs of Africa. They hunt small mammals, birds, reptiles, and large insects, using slow, agile flight and excellent hearing, courtesy of owl-like facial discs, to detect and capture prey in the long grass. Only adult males are gray: the larger females are mostly brown and immatures rich rufous beneath.

The Montagu's Harrier ranges across temperate Europe and eastern Asia, from Iberia north to central Russia, inhabiting open lowland terrain from Mediterranean heathland to Russian steppes. In autumn, European populations migrate to sub-Saharan Africa, occupying grassland habitats from the Sahel to northern South Africa, while Central Asian populations head south to the Indian subcontinent.

The populations that winter in eastern and southern Africa are from eastern Europe. Those from western Europe head for West Africa, as far as the Gulf of Guinea. The recent tracking of several individuals tagged in Britain found that each used different West African winter quarters. "Sally," for example, left England on August 14, 2016 and arrived in Ghana, her final destination, on January 20, 2017. She traveled far inland, crossing the western Sahara in Mali and Mauritania. "Mark," by contrast, traveled to Gambia, leaving England on August 19 and arriving on December 20, his route following a more coastal trajectory through Morocco and the western Sahara.

On their breeding grounds, pairs perform impressive aerial displays, males passing food gifts to females, talon-to-talon. They construct a hidden ground nest of grass, in which the female lays three to five eggs. Incubation lasts twenty-seven to forty days, the male feeding his mate throughout, and the young fledge twenty-eight to forty-two days later.

The Montagu's Harrier is listed as Least Concern, with an estimated global population of 150,000–200,000 individuals. In Europe since the 1940s, however, it has declined in many regions, the victim of DDT and other pesticides, and the increased early harvesting of cereal crops.

OPPOSITE A male Montagu's Harrier passes through a snowstorm in the Caucasus mountains, Georgia, en route to its central Asian breeding grounds.

BROAD-WINGED HAWK

Buteo platypterus

SIZE
L: 13.4–17.3 in (34–44 cm)
Wt: 9.3–19.8 oz (265–560 g)
WS: 31.9–39.4 in (81–100 cm)

APPEARANCE
Smallish, compact hawk, with large head and broad tapering wings; reddish-brown to dark brown above; white below, with breast and belly blotched and barred; white mid-band and terminal band across tail; rare dark plumage morph also occurs.

LIFESTYLE
Preys on small mammals, birds, frogs, reptiles, and large invertebrates, seizing them on ground after short fast glide; nests in tree fork beneath canopy, female lays 2–3 eggs on average; high, shrill call.

RANGE AND MIGRATION
Breeds in North America, east of the Rockies and west through Canada to British Columbia; migrates south through Mexico and Central America to winter quarters in South America, from northern Brazil south to Bolivia.

STATUS
Least Concern; population estimated at 1.7 million individuals.

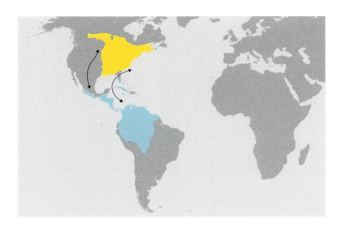

ON A WARM October day above the small town of Chichicaxtle, in Veracruz, Mexico, the sky teems with raptors. Dark specks mill and wheel against the blue in a "kettle" of birds, smaller parties arriving while others drift away southward. Among several species recorded by the watchers below, one dominates the throng: Broad-winged Hawks are here in vast numbers. Yesterday, more than 50,000 were counted and today's count looks set to rise even higher.

The Broad-winged Hawk is the smallest of North America's *Buteo* hawks (aka buzzards, to Europeans). In flight, it is quickly identified by its compact silhouette, with large head and broad, tapering wings. Seen closer, it is largely reddish-brown above and pale below, with mottling on breast and belly and distinct white bands across the tail. This species is common across much of eastern North America, inhabiting a variety of forest types, where it hunts from a perch in the understory for prey on the ground, including small mammals, frogs, lizards and nestlings. After breeding, it exchanges the North American forests for similar habitats in South and Central America, hunting around rainforest edges and plantations from Brazil to Bolivia.

The annual southbound movement of Broad-winged Hawks starts in September and forms a substantial part of one of the world's great migratory bird spectacles. From as far north as southern Canada, the birds head south, traveling at an average of 62 miles (100 km) per day, they migrate for around 70 days, completing journeys of 1,900–3,700 miles (3,000–6,000 km) before they reach their tropical destinations. En route, the birds use thermals to gain height and conserve energy, generally traveling at 1,800–4,270 feet (550–1,300 m) above sea level.

Migration begins on a broad front but the birds soon coalesce over major topographical features such as ridges, valleys, and coastlines, making sure to avoid sea crossings. Smaller flocks of tens or hundreds swell to spectacular aggregations of thousands at key bottlenecks, many of which—such as Hawk Ridge in Minnesota, Hawk Cliff in Ontario, and Hawk Mountain in Pennsylvania—have become famous as a result. Counts at the latter have peaked at 29,519 birds in one season (1978).

Gatherings in the USA, however, are dwarfed by those recorded in Mexico's Veracruz. There, trapped between the twin barriers of the Sierra Madre mountains to the west and the Gulf of Mexico to the east, the birds funnel through a strip of land some 20 miles (32 km) wide, where thermals from the warm coastal plain provide the perfect conditions

OPPOSITE A white tail band and compact silhouette are helpful pointers when identifying the Broad-winged Hawk among flocks of migrating raptors.

to carry them on their way. In peak years, up to six million birds of prey are recorded there during the fall migration, nearly one-third of which are Broad-tailed Hawks—virtually the entire world population of the species. This awe-inspiring phenomenon known as the "River of Raptors."

The conspicuous migration of Broad-winged Hawks has made the species relatively easy to study, and for many years regular annual counts have been made at all key migration bottlenecks. In autumn 2018, for example, Mexican conservation group Pronatura counted 844,256 Broad-tailed Hawks among 2,270,056 raptors passing over the town of Chichicaxtle alone. In the process, much has been learned about the species' migration strategies. One of five full migratory North American raptor species, the Broad-winged Hawk is the earliest to depart in autumn and the last to return in spring—a fact explained largely by its dependence on thermals, as it times its journeys to coincide with the most advantageous air movements. Atmospheric conditions also ensure that the return migration route follows an elliptical path: Prevailing winds push the birds further east toward the coast in autumn, whereas they follow a more inland route in spring.

Studies have also discovered that flocking increases the hawks' ability to find thermals—groups of birds looking out for other groups that are on the rise—and thus to navigate. Adults are more likely to flock than younger birds and, in mixed-age flocks, the older birds will generally be at the front. Younger, less experienced birds are proportionally more numerous among those that overwinter in south Texas and Florida, and don't complete the full journey south. A separate Caribbean subspecies (one of six recognized by taxonomists) is found on Cuba, Puerta Rico, and the Lesser Antilles, and does not migrate, being a permanent resident on the islands.

Back on their breeding grounds by April, Broad-winged Hawks pair up in spectacular aerial courtship displays, with much mid-air tumbling and cartwheeling. Birds breed from two years and pairs may stay together over several years. The nest is built in a forest tree, such as a larch, birch, or white oak, the large structure of sticks and twigs placed in the crook of a branch beneath the canopy. The female lays an average of two to three eggs which she incubates for twenty-eight to thirty-one days. Both adults care for the chicks, which fledge after a further thirty-five to forty-two days. The parents are very protective of their growing young and will defend the nest aggressively against predators such as crows, raccoons, and even Black Bears.

Today, the Broad-winged Hawk is faring reasonably well, with a significant population increase recorded from 1966 to 2016. Its population is estimated at 1.7 million and the bird is listed as Least Concern—although the Puerta Rican island subspecies is endangered. The huge migratory flocks continue to provide their celebrated tourist spectacles in the USA, Mexico, and Central America.

RIGHT Broad-winged Hawks often dominate the large "kettles" of migrating raptors that pass through central America and the south-eastern USA, gathering on thermals in their thousands.

RAPTORS AND OWLS

SWALLOW-TAILED KITE

Elanoides forficatus

SIZE
L: 20–27 in (50–68 cm)
Wt: 11–21 oz (310–600 g)
WS: 3.7–4.5 ft (1.12–1.36 m)

APPEARANCE
Slim, elegant, medium-large raptor, with long wings and long, forked tail; adults white below, with white head, dark gray back, black wing tips, and black tail; young duller, with shorter tail; characteristically buoyant, drifting flight.

LIFESTYLE
Inhabits swamp forests and wetlands, where preys on small mammals (including bats), birds, frogs, reptiles, nestlings, insects, and some fruit, plucked in flight from the treetops; builds exposed nest at top of tall tree; female lays 2–4 eggs on average.

RANGE AND MIGRATION
Breeds in Florida and, marginally, other southern US states; also in parts of Central America and across much of northern South America, south to southern Brazil; northern populations migrate south, across the Gulf of Mexico.

STATUS
Least Concern; population estimated at 150,000 individuals.

THIS UNMISTAKABLE RAPTOR has been described as North America's most beautiful bird of prey. It's easy to see why, with its elegant profile, dapper pied plumage, and graceful, drifting flight. Today, however, the species has a tenuous hold on North America and is abundant only in Florida, from where the population heads south in autumn to the tropics of South America, where the bulk population of the species breeds.

The Swallow-tailed Kite belongs to the Perninae subfamily of raptors, alongside Old World honey buzzards. The long, forked tail from which it gets its name is unlike that of any other raptor and its flight is equally distinctive, as it hangs on the breeze like a frigatebird (see pages 96–99), manoeuvering without a flap by twisting its tail and tilting its long wings. It also feeds on the wing, capturing small prey such as reptiles, nestlings, and large insects from the treetops and consuming them in flight.

This species breeds largely in forested wetlands, where it builds exposed nests on the top of trees up to 100 feet (30 m) in height. In Florida and a few other southern US states, this typically comprises swamps of Loblolly Pine or Bald Cypress. Pairs form long-lasting bonds. A female lays on average two to four eggs which she incubates for twenty-eight days, and the young fledge after a further thirty-six to forty-two days.

Swallow-tailed Kites have been extensively studied in Florida. Geolocator data has revealed that they migrate thousands of miles, as far as southern Brazil, and that their southbound journey begins with a single hop over the Gulf of Mexico. After a rest, they continue through Central America. Large flocks of this social species form communal roosts before migration, feeding together to build up fat reserves, and may be seen drifting overhead through key migration bottlenecks.

The Swallow-tailed Kite declined across the USA by as much as 80 percent during the twentieth century as the wetlands on which it depends were lost or degraded. Once breeding as far north as Minnesota, it now occurs in just seven states. Florida alone has a healthy and increasing population, notably in the Lower Suwannee National Wildlife Refuge, where numbers are assessed through aerial surveys of roosts, with the birds' conspicuous white heads in the treetops making them easy to count. The US population makes up only some 3 percent of the whole, however. Elsewhere, throughout its tropical range, the species is more numerous, and with an overall population estimated at 150,000 is listed as Least Concern.

OPPOSITE Swallow-tailed Kites flock around their pine tree roost in Naples, Florida, as they prepare to migrate south.

ELEONORA'S FALCON

Falco eleonorae

SIZE
L: 14–17 in (36–42 cm)
Wt: 12.3–13.7 oz (350–390 g)
WS: 34–41 in (87–104 cm)

APPEARANCE
Medium-sized falcon, with long pointed wings and medium-long tail; pale to buff underparts heavily streaked; gray upperparts and tail; dark cap and mustachial stripe contrasting with white throat; rare dark morph individuals, sooty black with pale patches on underwings; fast, agile flight.

LIFESTYLE
Preys on large insects caught in flight, switching to migratory songbirds during breeding season;

breeds on and around sea cliffs and islands, female laying on average 2–3 eggs in nest on ledge or in crevice; chicks hatch in late summer so parents can feed them on passing migratory birds.

RANGE AND MIGRATION
Breeds on islands and coastlines in and around the Mediterranean Basin, including Greece, Croatia, Sardinia, Balearic Islands, Morocco, and Canary Islands; migrates south directly across North Africa to overwinter in Madagascar.

STATUS
Least Concern; population estimated at 5,900–6,200 breeding pairs.

AMONG STUDIES OF migratory birds around the world, this dashing falcon makes headlines on two counts. Firstly, it has evolved a lifestyle that is dependent upon other migrants, timing its own breeding season in order to feed its young on songbirds heading south across the Mediterranean. Secondly, its own migration is one of the most challenging of any raptor, involving long crossings of both the Sahara Desert and Indian Ocean.

Eleonora's Falcon has the long tail and long pointed wings of a typical falcon, and is somewhere in size between the Peregrine Falcon (*Falco peregrinus*) and the European Hobby (*F. subbuteo*). Two color morphs occur: The typical form resembles a large hobby, with a dark cap and mustachial stripes, gray upperparts and tail, and pale streaked underparts; the dark morph is sooty black above and below, with paler patches on the primaries. In flight, the bird scythes through the air after prey with great speed and agility, and shares with the Eurasian Hobby the distinctive practice of holding its catches in its talons as it dismantles and consumes them in mid-air with its bill.

This species takes its name from Eleanor of Arborea, Queen of Sardinia, who in 1392 became the first ruler to grant protection to a hawk or falcon against illegal hunters. Today the

species still breeds on Sardinia, as well as other Mediterranean islands and shorelines, from the Canaries and the Balearics to Morocco, Algeria, Croatia, Cyprus, and Greece. Unusually for a falcon, it forms small breeding colonies, each pair choosing a nest site among cliff ledges, caves, and crevices. In these precipitous locations, the female lays an average of two to three eggs, which she incubates for twenty-eight to thirty days. The youngsters fledge some thirty-five days later.

Where this species differs from its falcon relatives is in the timing of its reproductive cycle. Eleonora's Falcon breeds in late summer, later than other species, which means that the growth of the chicks coincides with the peak autumn passage of southbound migrating songbirds. This is the trigger for the parents to shelve their usual diet of large winged insects such as dragonflies and pursue this new source of food. They hang in the air along the cliffs, waiting for the exhausted travelers to approach land then picking them off in high-speed chases, often low over the waves. The growing youngsters depend almost entirely upon this diet as they fledge and take their own first flights. In 2014, researchers in Morocco discovered that adults even practice the somewhat macabre habit of stripping the flight

OPPPOSITE An Eleonora's Falcon wheels over the blue waters of the Mediterranean. Its migration will take it south across Africa as far as Madagascar.

feathers from their catches and imprisoning them alive in holes and crevices for later consumption.

In November, after breeding, youngsters and adults alike depart on a mammoth migration across Africa to the Indian Ocean island of Madagascar. It was once assumed that birds from the western Mediterranean traveled east across the Mediterranean Basin in order to skirt the Sahara before heading south down the Red Sea coast to East Africa. Eastern birds do indeed take this route. However, geolocator studies conducted by the universities of València and Alicante, Spain, from 2007 to 2009, involving sixteen individual birds tagged on the Spanish Balearic and Columbretes Islands, astonished scientists by revealing that these birds flew directly across North Africa, crossing the Sahara Desert and the equatorial rainforests of the Congo Basin, before reaching the Indian Ocean coast in Kenya, then heading south to Madagascar via Mozambique.

In Madagascar, the migrants occupy their wintering quarters from December until March. They spread out across the tropical lowlands, forming feeding parties of up to twenty-five birds, often consorting with their close relative the Sooty Falcon (*Falco concolor*) to hawk insects over lakes, rice paddies, and forest canopies. However, their challenge doesn't end here. The return migration takes a different route, the birds flying directly northwest from Madagascar across the Indian Ocean, with some not making landfall until they reach the coast of Somalia. The complete annual return migration has been recorded at more than 5,900 miles (9,500 km) for some individuals. With non-stop crossings of both the Sahara Desert and the Indian Ocean, this stretches well beyond the physical limitations that scientists had assumed for a bird of this size.

Today, Eleonora's Falcon is listed as Least Concern, with an estimated population of 5,900–6,200 breeding pairs showing signs of gradual increase in some areas. The species' greatest threat lies on its Madagascan wintering grounds, where the spread of opportunistic agriculture is degrading the forests and wetlands on which it depends.

RIGHT During autumn migration on the island of Cyprus, an Eleonora's Falcon takes up a strategic cliff-top perch from which to pick off incoming migrant songbirds.

TURKEY VULTURE

Cathartes aura

SIZE
L: 24–32 in (62–81 cm)
Wt: 1.8–5.3 lb (0.8–2.1 kg)
WS: 63–72 in (160–183 cm)

APPEARANCE
Large, all-dark raptor with naked red face and white, hooked bill; long wings held up dihedrally in soaring flight; often perches with wings spread wide to warm up and dry; hops clumsily on the ground.

LIFESTYLE
Feeds on carrion of all kinds, though avoids putrefied carcasses; never kills prey (unlike related Black Vulture); may take some fruit and vegetable matter; detects food by sight and smell, soaring low over open country or forest; breeds in hidden cavity; makes no nest; female lays 1–3 eggs.

RANGE AND MIGRATION
Breeds across Americas, from southern Canada to Tierra del Fuego; northern populations migrate south in autumn to southern USA and neotropics; western subspecies may reach southern South America; tropical populations largely resident.

STATUS
Least Concern; population estimated at 4.5–5 million individuals.

WARM NOVEMBER DAYS offer an impressive sight over Panama City, as millions of raptors circle the gleaming tropical skyline. Dominant among them are Turkey Vultures: In 2014 alone, 1,864,861 were counted in just a few days. They use the thermals along the Pacific coastline to power their onward journey south. Many have come from as far north as British Columbia and some may continue as far south as Argentina.

The Turkey Vulture breeds across the Americas from Canada to Patagonia. A partial migrant, some populations make vast journeys while others barely move. In North America, birds from the southeast USA and Mexico don't migrate; those from the northeast travel to the southern states; and those from the west move to Venezuela, Colombia, and Ecuador. South American breeding birds are resident and northern migrants often leap-frog these birds on their passage south.

This is a familiar species to most Americans, abundant across farmland and deserts to mountains and semi-tropical forests. It shows a distinctive rocking flight, its broad wings tilted upward in a distinctive dihedral shape. Perched, its dark brown plumage (which appears black) contrasts with a naked red head and ivory hooked bill. Though known colloquially as "turkey buzzard," it is related neither to *Buteo* hawks and buzzards nor to Old-World vultures, but is one of the seven species that make up the Cathartidae family of New World vultures.

A scavenger, the Turkey Vulture uses smell—unusually among birds—to detect the gases that emanate from a carcass, and feeds on everything from roadkill to dead fish on the shore. Breeding takes place in hidden places such as caves, crevices, and hollow trees. The female lays an average of two eggs, incubated by both parents over thirty to forty days. The young fledge after sixty to eighty days.

Migrating Turkey Vultures start congregating in August and travel by day, moving between columns of air with minimal flapping, covering up to 200 miles (321 km) per day. Traveling in hundreds, they follow ridges and coastlines. As they head south, flocks swell, with thousands gathering at key bottlenecks at Corpus Christi, Texas, Veracruz, Mexico, and Panama.

The Turkey Vulture was long persecuted by ranchers, blamed incorrectly both for attacking new-born calves and spreading livestock disease. Numbers also fell during the twentieth century due to DDT and other contaminants in the food chain. Today, with an estimated population of 4.5 million individuals, it is listed as Least Concern.

OPPOSITE The broad wings of a Turkey Vulture allow it to maximize lift from thermals and updrafts.

EUROPEAN HONEY BUZZARD

Pernis apivorus

SIZE
L: 20–24 in (52–60 cm)
Wt: 1.3–2.4 lb (600 g–1.1 kg)
WS: 53–59 in (135–150 cm)

APPEARANCE
Medium-large brown raptor, with comparatively small bill, longish neck and pigeon-like face; brown above and pale below, with heavy barring on underwings and prominent dark double band across tail; male has gray head, female brown.

LIFESTYLE
Feeds largely on larvae of wasps, bees, and other insects, foraging for nests on the forest floor and in the understory; may also take small vertebrates, especially on winter quarters; makes large nest in tall tree, in which female lays 1–2 eggs.

RANGE AND MIGRATION
Breeds across much of Europe, from northern Spain north to Finland, south to Turkey and east to Kazakhstan and Central Asia; overwinters in sub-Saharan Africa, from Senegal to South Africa, following a variety of flyways across the Mediterranean.

STATUS
Least Concern; world population estimated at 280,000–420,000 individuals.

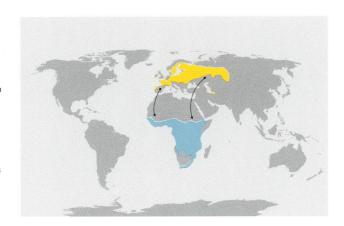

THE EUROPEAN HONEY Buzzard's name is a little misleading. Firstly, the bird does not eat honey: Although it can certainly be seen raiding bees' nests, it feeds on the insects' larvae, while wasp larvae actually forms a more important part of its diet. Secondly, it is not a buzzard: Although it superficially resembles the Common Buzzard (*Buteo buteo*), it belongs to an entirely different genus. Thirdly, although this bird breeds in Europe, it spends much of its life in Africa. During peak migration, wheeling flocks of these large raptors moving between the two continents are among the Mediterranean's more impressive migration spectacles.

The Honey Buzzard's similarity to a buzzard—in both size and coloration—is thought to have evolved as a form of protective mimicry; the bird's resemblance to its more aggressive namesake may afford some protection against predators such as the Northern Goshawk. Look closer and you'll see honey buzzards have a smaller, more pigeon-like head—blue gray in the male and brown in the female—and a less predatory demeanor. In flight, this species also shows flatter wings and a longer, narrower tail with two prominent bars near the base and one at the tip.

European Honey Buzzards occupy a wide breeding range across Europe, from northern Spain north to Finland, south to Turkey, and east to Kazakhstan and Central Asia. They inhabit forest and woodland habitats, often around meadows and clearings. There, they search the forest floor and understory for the nests of bees and wasps, hopping from branch to branch and shuffling their feathers as they look out for the tell-tale flying insects. Nest located, they fly down and dig it out with their talons, often carrying it away entirely. Scaly feathers on their face help protect against stings and their plumage is thought to be coated with a chemical deterrent.

Breeding gets under way by late April. A pair builds a stick nest on the branch of a large tree some 32–65 feet (10–20 m) above the ground, and coats it with so much living material that it appears to be a mass of greenery. The female lays one to two eggs, which both parents incubate for thirty-seven days. The chicks fledge after a further forty to forty-four days, but may not be independent from their parents for 100 days.

By September, most European Honey Buzzards have set off on migration, with the juveniles leaving two weeks after the adults. The birds use both magnetic orientation and a

OPPOSITE The European Honey Buzzard subsists almost entirely on the larvae of bees and wasps, so must migrate south when this food source becomes unavailable in winter.

visual memory of landmarks as they head south toward the Mediterranean, taking a variety of routes, according to their point of origin. Many make for the crossing points at Gibraltar in the west or the Bosphorus of Turkey in the east. At either nexus, they flock with other raptors, awaiting the passing thermals that will lift them across the sea into North Africa. However, honey buzzards are less dependent on narrow sea straits than most other raptors, and will also cross the Mediterranean at wider points—from Sicily into Tunisia, for example, and Greece into Libya—sometimes flying several hundred miles over open ocean. On these journeys, where no thermals are available, they tend to fly low and may drop down onto small islands to rest.

Once across the Mediterranean, birds that have taken a westerly route head for West Africa, while eastern populations head south through East Africa and can travel as far as South Africa. These migrants take up wintering quarters in moist woodland and arable bush, often using secondary forest and feeding along tracks and clearings, where they find a variety of wasps and other insect larvae. They may also turn to other prey, including small mammals, birds, and reptiles.

The return migration in spring does not usually follow the autumn route. Most European Honey Buzzards use a loop migration, choosing a more direct passage back to Europe to exploit prevailing wind directions in that season. Birds tagged in Hungary, for example, follow an anticlockwise loop, entering Africa via Gibraltar in autumn then returning to Europe in spring directly across the central Mediterranean. Observations from 2007–2008 over the island of Antikythera, southern Greece, found that multiple birds passed through in autumn but very few arrived in spring, when prevailing winds enabled a more direct crossing to the west. Whatever the route, geolocator studies have shown that a honey buzzard traveling to southern Africa may complete a journey of 4,192 miles (6,747 km) in forty-two days, with juveniles completing the same route in sixty-four days.

The European Honey Buzzard has long been a target for hunters on its Mediterranean flyways, with thousands killed for sport as they pass through key bottlenecks. Today, conservationists are working with local communities to stem the tide of slaughter. In April 2019, BirdLife reported that conservation camps near the Straits of Messina, Sicily, had helped reduce an annual toll of around 5,000 to just 100, and were thus calculated to have saved an estimated 85,000 honey buzzards since they were established. Today, the species is listed as Least Concern, with an estimated breeding population of 110,000–160,000 breeding pairs in Europe, making up some 75–94 percent of the global total.

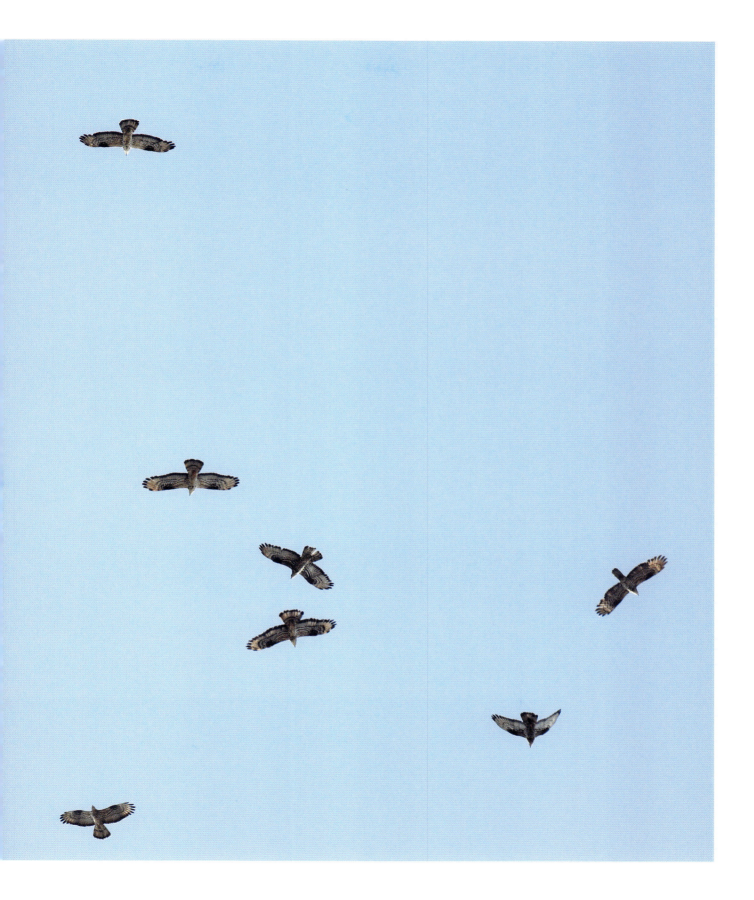

ABOVE European Honey Buzzards circle on a thermal above Eilat, Israel, as they make their way south towards African winter quarters.

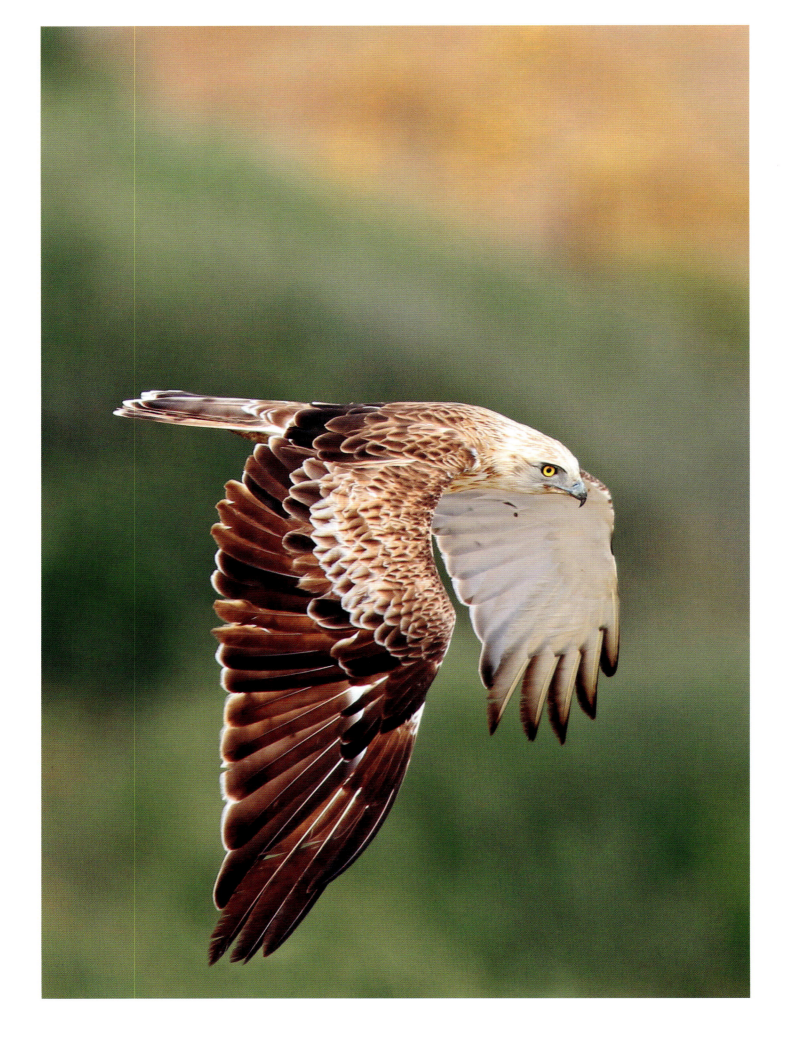

SHORT-TOED SNAKE EAGLE

Circaetus gallicus

SIZE
L: 24–26 in (62–67 cm)
Wt: 2.6–5.1 lb (1.2–2.3 kg)
WS: 5 ft 7 in–6 ft 1 in (170–185 cm)

APPEARANCE
Large raptor; big, owl-like head, shortish tail and long wings; bright yellow eyes; unfeathered tarsi; upperparts grayish-brown; underparts white, lightly barred brown on throat, upper breast, and underwings; tail has 3–4 brown bars.

LIFESTYLE
Feeds largely on snakes and other reptiles, hovering like big kestrel in order to spot prey on ground below; inhabits open terrain, from heathland to steppe; builds stick nest in tree on slope, female lays a single egg.

RANGE AND MIGRATION
Breeds around Mediterranean Basin in Europe and North Africa; also Russia, Middle East, Indian subcontinent, Lesser Sundas (Indonesia); European and Central Asian populations winter in sub-Saharan Africa, largely in the Sahel region.

STATUS
Least Concern; population estimated at 100,000–200,000 individuals.

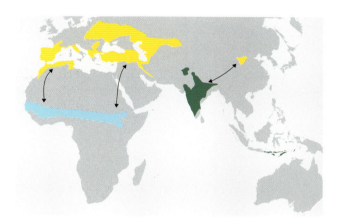

THE SHORT-TOED SNAKE Eagle pursues a counter-intuitive migration strategy: in parts of its Mediterranean range, it heads *north* to Africa. For years, scientists observing large autumn gatherings in Caprigila, central Italy, wondered why the birds flew toward France rather than south. At the same time, they wondered why so few were seen over the Straits of Messina, the crossing to Sicily favored by so many other migrants.

The answer, it transpired, lies in the bird's anatomy. Its broad wings are perfect for soaring on thermals over land but are not suited to the powered flight required to carry it across the 93 miles (150 km) of open sea that separate Sicily from North Africa. Birds from southern Italy take a detour, heading northwest into France, and continuing through Spain and crossing the Mediterranean at Gibraltar, before continuing south to wintering grounds in sub-Saharan Africa.

Studies conducted in 2010–2013 by the University of València, Spain, confirmed this. Seven juvenile Short-toed Snake Eagles were tagged with satellite geolocators in central Italy. In September, five of them joined adults on their northwest detour toward Spain. The other two, however, pursued their inherited instinct to travel south. Having crossed into Sicily, they were unable to continue to Africa and overwintered there,

1,800 miles (3,000 km) north of their traditional wintering quarters. In spring, one of the tagged individuals was shot—still a common fate around the region—but the other returned to its breeding grounds taking the northbound detour that autumn. Similar observations have been made in Greece, where Short-toed Snake Eagles breeding in Pellopenesus head north to enter Africa via the Bosphorus, rather than the shorter route south.

The Short-toed Snake Eagle is a large raptor, with a big head, long wings, and pale plumage. It feeds largely on snakes and other reptiles, often hovering high over a hillside in open terrain in search of prey. The breeding range extends from the European and African Mediterranean to southern Russia and the Middle East. All migrate to sub-Saharan Africa, where they winter just north of the Equator in the Sahel region. Sedentary populations occur on the Indian subcontinent and Indonesia.

Each pair generally builds a new stick nest in a tree on a hillside or cliff. The female incubates a single egg for forty-five to forty-seven days and fledging takes a further sixty to eighty days.

Today the species is listed as Least Concern. In Europe, however, agricultural intensification has caused declines in many areas. Persecution remains a threat, with many being illegally shot while migrating through the Mediterranean.

OPPOSITE The Short-toed Eagle feeds almost entirely upon snakes and is best identified by its very pale underparts.

STEPPE EAGLE

Aquila nipalensis

SIZE
L: 28–32 in (72–81 cm)
W: M: 4.4–6.8 lb (2–3.1 kg);
F: 5.1–8.5 lb (2.3–3.9 kg)
WS: 5.4–6.5 ft (165–200 cm)

APPEARANCE
Large brown eagle with rufous nape and blackish flight and tail feathers; shows broad wings in flight; immature more uniform, showing white band along wing coverts.

LIFESTYLE
Inhabits open terrain, from steppe and semi-desert to savannah; hunts small mammals and birds, and readily takes carrion; breeds on ground or low tree; female lays 2 eggs and raises both chicks.

RANGE AND MIGRATION
Two races occur: *A. n. nipalensis* breeds in Central and eastern Asia, from Altai Mountains south to Tibet and east to Mongolia; winters in southern Asia and Indian subcontinent; *A. n. orientalis* breeds across Central and western Asia, from Kazakhstan to southern Russia; winters in East and southern Africa and Arabia.

STATUS
Endangered; population estimated at 37,000 pairs.

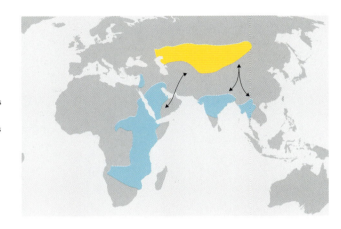

OBSERVERS IN EILAT, Israel, once counted 29,000 Steppe Eagles passing overhead during a single day of autumn migration, as the birds headed south from their Asian breeding grounds for the savannahs of Africa. Sadly, such numbers are no more. A steep decline has placed this species on the Endangered list, and it may even be changing its migratory habits.

The Steppe Eagle is a bird of open habitat, breeding in arid semi-desert terrain and wintering largely on tropical savannahs. Two subspecies occur: the easterly *A. n. nipalensis* breeds around the Altai Mountains in Central Asia and winters largely in the Indian subcontinent; The westerly *A. n. orientalis* breeds from Kazakhstan to southern Russia and winters in sub-Saharan Africa and in the Arabian Peninsula.

This wandering raptor has the longest migration of any large eagle. A 2012 study of sixteen birds fitted with satellite transmitters recorded one individual migrating from Botswana to Kazakhstan, covering 5,929 miles (9,543 km) in eight weeks at an average 110 mph (77 km) per day. One adult male tracked through its entire annual migration cycle was found to have spent 41.9 percent of its time on its breeding grounds in Kazakhstan, 31.5 percent on its wintering grounds in Ethiopia and Sudan, and 26 percent migrating between the two.

Other findings were revealing. Birds heading to southern Africa completed a loop migration around the Red Sea, crossing the south in autumn and returning in spring via the northwest—a detour of some 745 miles (1,200 km). Several overwintered in the Arabian Peninsula—a trend driven by the increasing number of livestock carcasses and large exposed garbage tips in the region. Flocks of 50–100 birds at such sites are not uncommon.

The Steppe Eagle is a "true eagle" of the genus *Aquila* and is largely dark brown with a rufous nape. Immatures show white underwing markings in flight. It hunts small mammals such as ground squirrels but will take anything from birds to flying ants, as well as scavenging. Breeding maturity starts at four years old and birds mostly nest in bushes or low trees. A female lays an average of two eggs, incubation lasts forty-five days, and the chicks fledge after another fifty-five to sixty-five.

Today, the Steppe Eagle is Endangered, with most of the estimated 37,000 pairs concentrated in Kazakhstan and Mongolia. Its global breeding population fell by an estimated 58.6 percent from 1997 to 2015, and it no longer breeds in eastern Europe due to the loss of steppe to agriculture, collision with power lines and wind turbines, and—in Pakistan—poisoning by the veterinary drug Diclofenac, which is transmitted to scavenging birds from dead cattle and has had a catastrophic impact on vultures across the Indian subcontinent.

ABOVE A Steppe Eagle wheels over the desert on its winter quarters in Oman.

SNOWY OWL

Nyctea scandiaca

SIZE
L: 20–28 in (52–71 cm)
Wt: 3.5–6.6 lb (1.6–3 kg)
WS: 49–59 in (125–150 cm)

APPEARANCE
Very large, white owl; female distinguished from almost pure-white male by spotting and barring on upperparts, crown, and flanks; yellow eyes, black bill almost covered by white facial disk, heavily feathered feet; long wings, with dark banding on tips.

LIFESTYLE
Largely diurnal; preys on lemmings and other rodents on Arctic tundra; takes birds and larger prey in winter; female lays 5–8 eggs in ground nest; population and distribution fluctuate with cycles in prey abundance.

RANGE AND MIGRATION
Circumpolar range across Arctic: in North America, from Western Aleutians east to northern Quebec and Labrador; in Eurasia, from Lapland across Arctic Russia; some populations remain on breeding grounds over winter; others migrate south: in North America, to southern Canada and the northern USA, sometimes south to Florida; in Eurasia, to Kazakhstan, Mongolia, and northern China.

STATUS
Least Concern. Population estimated at about 300,000 individuals worldwide.

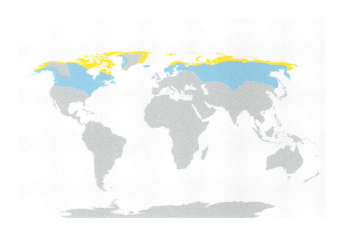

A SNOWY OWL in a cornfield may appear incongruous. After all, this big white bird is emblematic of Arctic wildlife—the avian equivalent of the Polar Bear—and, as such, hardly belongs among the brown stalks and husks of a winter prairie. However, much as Snowy Owls thrive in the cold, white depths of the Arctic, their highly nomadic lifestyle also sees them wandering to other landscapes. In some years, driven by fluctuations in the supply of rodents, they may turn up in great numbers far from their breeding grounds. These irruptive movements are popularly called "snow storms."

The Snowy Owl—*Ookpik* to the Innuit and Hedwig to Harry Potter—is unmistakable. Males are almost totally white, with a black bill and striking yellow eyes. The larger females have dark brown spotting and barring on their upperparts. This coloration, and the thick insulating plumage, even on the feet, are clearly adaptations to life in the cold north—and the bird's scientific name, *scandiaca*, reflects the fact that it was first described in Scandinavia.

In fact, the species' breeding range extends across the Arctic tundra worldwide: In North America, it breeds from the Western Aleutians across northern Alaska and Canada to Quebec and Labrador; in Eurasia, from Lapland east across Arctic Russia. During the 1960s and 1970s a pair even nested briefly on Scotland's Shetland Islands, and the species still turns up in Britain as a rarity. Despite being so widespread, it is a monotypic species, with only one subspecies recognized.

When winter brings cold and darkness to the Arctic, Snowy Owls respond in different ways. Some adults winter near their breeding grounds—even heading north, if they can find ice-free areas where food is available. Others head south, exchanging the tundra for lake shores, marshes, coastlines, and fields. In North America, they travel down into southern Canada and the northern USA, sometimes even as far south as Texas and Georgia. In Eurasia, they head south within Scandinavia and Russia and, further east, into Kazakhstan, Mongolia and northern China. Some populations also make east-west movements, traveling from Alaska to Russia and back, or from Norway to and from eastern Russia.

In certain years, however, Snowy Owls travel further and in much greater numbers. The winter of 2013–2014 was a case in point, producing the largest "snow storm" across the Great Lakes region and northeastern USA for a century. Impressive

OPPOSITE The Snowy Owl's white coloration is a camouflage adaptation to its Arctic breeding quarters, but this species wanders widely and may turn up far from the nearest snow.

numbers appeared on the east coast, with some birds traveling 2,980 miles (4,800 km) and appearing as far south as Jacksonville, Florida. Birds turned up in the most unlikely spots, including downtown Washington, DC. Such movements are complex and unpredictable, but the birds are not driven by starvation, as was once thought. Quite the opposite, in fact: these winters follow a summer of super-abundance of lemmings and voles, the birds' staple diet. During such times of plenty, females that usually produce five to eight eggs may increase their clutch size to twelve or fourteen, with rodent prey items captured by the male piling up around the nest. Thus, more young are produced and must disperse ever further and wider in order to find winter feeding territories of their own.

A North American study called Project Snowstorm has tagged numerous Snowy Owls in order to study their movements. Among other findings, it has established that young males tend to make the longest journeys and older females the shortest; that many use a series of short stop-offs on their way south, defending a temporary territory in each; and that, far from being driven by starvation as was once assumed, these long-distance travelers appear to be in excellent health, often weighing more than those left behind in the north. On its breeding grounds, this species specializes in lemmings and other small rodents, which it captures by ambush, gliding low over the tundra. On its wintering grounds, however, it broadens its diet and hunting strategies. It is known to capture duck and other wildfowl over the sea, for example, and to scavenge fish—and, on one occcasion, even a dead dolphin—from the shoreline.

The nomadic lifestyle of Snowy Owls means that pairs are seldom monogamous, although some may stick together for up to five years. Courtship starts from mid-winter and continues to March and April, the male backing up his hooting vocals with impressive flying and strutting displays. The nest is on the ground, located on a site free from snow and in a productive hunting area, with a good view of the surrounding landscape. The female scrapes a shallow depression in an elevated mound, which she then lines with vegetation and feathers. The eggs hatch at thirty-two to thirty-four days, with the chicks leaving the nest at twenty-five days and finally fledging at fifty to eighty days.

During this period, the parents toil hard: A single family may consume up to 1,500 lemmings before the young disperse. Meanwhile the male defends the nest vigorously and has been known to attack predators such as Arctic Foxes up to 600 yards (1 km) away from its brood. Indeed, birds such as Snow Geese (see pages 26–31) often nest near the owl to gain protection for their own nests.

The Snowy Owl is classed by the IUCN as Least Concern, with an estimated population of some 300,000 individuals worldwide. Numbers fluctuate according to prey availability, with the owls becoming locally abundant in a boom year then almost disappearing the next. Their greatest enemy may be climate change which, by bringing about the slow "greening" of the Arctic tundra in some areas, may deprive them of the very habitat for which they are so beautifully evolved. In this respect, the Snowy Owl is the key avian indicator of the health of Arctic ecosystems.

RIGHT Snowy Owls gather along the shoreline of British Columbia, Canada, as they disperse south for winter.

SHORT-EARED OWL

Asio flammeus

SIZE
L: 13–17 in (34–43 cm)
Wt: 7.3–16.8 oz (206–475 g)
WS: 33–43 in (85–110 cm)

APPEARANCE
Size of a large pigeon, with sandy to brown plumage, mottled upperparts, streaked upper breast, and white belly; bright yellow eyes, tiny ear tufts and wings long and pale beneath.

LIFESTYLE
Hunts small rodents over open ground in slow flight; nests on the ground, female laying 4–7 eggs; population size and movements reflect seasonal abundance of prey.

RANGE AND MIGRATION
All continents except Antarctica and Australasia; in the Old World, from Iceland to northeast Russia; in the Americas, across Canada and most of the USA and, discontinuously, northwestern and southern South America; also on oceanic islands, including Hawaii and the Galápagos; partial migrant, northern populations migrating south in winter to Central America, North Africa and Central Asia.

STATUS
Least Concern; population estimated at 2 million individuals.

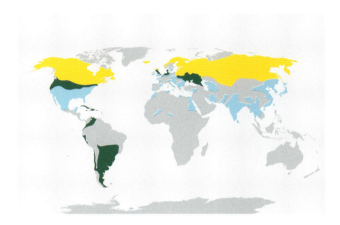

THE SHORT-EARED OWL is an owl that breaks the mold. Largely diurnal, it hunts like a harrier, slowly quartering open ground in search of voles, its staple diet. Unlike most other owls, it also nests on the ground. What's more, the long wings that power its buoyant flight also allow it to travel great distances, even over open ocean. The most nomadic of the world's owls, it migrates as and when conditions dictate and, in the process, has even managed to colonize remote oceanic islands.

The eponymous "ear" tufts of this species are not ears at all but rather a camouflage adaptation that serves to break up the bird's outline. Much more visible are its bright yellow eyes, which explain its scientific species name *flammeus*, or "flame-like." In overall coloration, it varies between subspecies from sandy yellow to darker brown, but is always mottled above and streaked below. In flight, it drifts over the ground with distinctively floppy, almost moth-like, beats of its conspicuously long wings, sometimes gliding with the wings held up in a dihedral shape.

This is one of the world's widest-ranging birds, found on all continents except Antarctica and Australasia. In the Old World, it occurs in a broad band across central and northern Eurasia,

from Iceland and the UK east to far northeastern Russia. In the Americas, it is found across Canada and most of the USA and, discontinuously, in northwestern and southern South America. It has also colonized several island groups, most notably the Caribbean, Hawaii, and the Galápagos. The taxonomy is complex, with eleven subspecies currently recognized. The nominate form *A. f. flammeus* is the one found on both sides of the Atlantic. Most island subspecies are sedentary and many will be in the process of speciation; indeed, some authorities now recognize the Galápagos Short-eared Owl (*A. f. galapagoensis*) as a species in its own right.

Northern breeding populations migrate south. In Europe, they head down to the Mediterranean and North Africa, some reaching the Sahel region; in North America, they head to the southern states, Mexico, and Central America (indeed, they may turn up in virtually any of the lower forty-eight states). From Russia, they depart for southern Asia. In some regions, including the UK, their migration may involve an altitudinal movement, the owls descending from upland breeding areas to low-lying river valleys and coastal plains.

Wherever it occurs, this species is a celebrated wanderer.

OPPOSITE The Short-eared Owl uses its exceptional eyesight and hearing to capture voles. When this staple diet is exhausted, it must migrate in search of better feeding grounds.

LEFT Unusually long wings for an owl enable the Short-eared Owl to undertake long migratory journeys.

Its movements are tied to the availability of voles, its staple diet. In vole population explosion years, when the rodents breed prolifically, it can quickly relocate to the most productive areas and adjust its breeding to coincide with the time of greatest plenty. At these times, individuals have even turned up mid-ocean on ships and oilrigs. Banding and satellite telemetry have confirmed that young Short-eared Owls travel the furthest, often moving up to 1,242 miles (2,000 km) after fledging. In a 2009–2010 North American study, scientists used satellite telemetry to track birds from their breeding grounds in Alaska over nineteen months. The majority headed southeast after breeding, following a corridor east of the Rockies south to the Prairie Provinces and Great Plains States, although a few also followed a coastal route west of the Rockies and south to California.

In the past, the UK saw periodic large influxes of Short-eared Owls from eastern Europe that arrived to take advantage of vole infestations and gathered in large communal roosts. Conversely, breeding birds banded in the UK have been recorded as far away as North Africa and Russia. An analysis of ninety-six years of data conducted by the British Trust for Ornithology has concluded that migrations across Europe have declined since the 1970s, both in number and distance, probably as a result of the contraction of large-scale vole breeding cycles.

Wherever they breed or wander, Short-eared Owls inhabit open country, including tundra, moorland, prairie, and coastal plains. They are most active during the early morning and late afternoon, when vole activity peaks. In bad weather, they may hunt from a perch, but generally they hunt in low flight, quartering the ground and flying into head winds so they can manoeuver at low speeds. Once a vole is sighted, they swoop down feet-first and grab it in their talons. Other prey include larger mammals and ground-dwelling birds such as plovers and larks. Some subspecies specialize in a location-specific but abundant food source: Galápagos Short-eared Owls ambush Wedge-rumped Storm-petrels (*Oceanodroma tethys*) as the small seabirds return to their burrows.

Breeding starts in March in the Northern Hemisphere and is heralded by the male's display, flying high above the ground with exaggerated wing beats and sometimes clapping his wings audibly. The female makes a nest on the ground, usually concealed in low vegetation. Several pairs may nest close together, and males may be polygynous, mating with several females, though pairing up with only one. The female lays an average of four to seven eggs but may produce an astonishing sixteen in bumper vole years. She incubates her clutch for twenty-one to thirty-seven days, and the offspring develop quickly, wandering out of the nest from as early as twelve days old and fledging in just over four weeks. During this period, the female will attempt to lure any inquisitive potetential predators away from the nest with a distraction display, feigning a damaged wing.

With a wide global range and an estimated population of two million mature individuals, the IUCN classes this bird as being of Least Concern. However, numbers have fallen in some parts of its range—notably North America, which has seen steep declines since the second half of the twentieth century—and some forms, notably the Hawaiian subspecies *A. f. sandwichensis,* are considered to be Endangered. The main threat in many areas is loss of habitat (and, thus, voles) to intensive agriculture.

LEFT A Short-eared Owl newly arrived from Scandinavia hunts through a blizzard on England's east coast.

06 | OTHER BIRD MIGRATIONS

THIS CHAPTER BRINGS together a handful of birds that don't slot so easily into the taxonomic groupings of previous chapters. Like all migrants, each has its own story to tell. Together they illustrate the breadth and diversity of bird migration, showing that almost every order and family of birds harbors species that are born to travel.

No bird voice heralds spring with quite the clarity of the Common Cuckoo. Well known for its brood parasitism—laying eggs in the nests of other birds—this bird's two-note territorial call is deeply embedded in western culture, from Beethoven's Pastoral Symphony to German cuckoo clocks. Only in the last century or so, however, have scientists discovered that its annual autumn departure takes it to sub-Saharan Africa, and only in much more recent times have they worked out exactly where, with satellite telemetry revealing that newly fledged birds—who have never seen their parents—cross the Mediterranean and Sahara by multiple routes and end up largely in the forests of the Congo Basin.

The Common Swift, the most widespread of more than 100 swift species, is the ultimate aerial bird. Sleeping, feeding, and even mating on the wing, individuals may remain airborne for more than a year. Small wonder that this fleeting summer visitor to Europe has no problem completing long-distance migrations: Scientists estimate that an individual may travel more than 124,000 miles (200,000 km) in a year between its breeding and wintering quarters, following weather fronts in pursuit of airborne food.

It is hard to believe that hummingbirds are the closest relatives of swifts, with divergent evolution having adapted their wings for hovering in front of flowers rather than zooming around the open skies. Nonetheless, these tiny, turbo-charged American nectar guzzlers produce some of the most impressive of all migration feats. The Ruby-throated Hummingbird may fly 500 miles (800 km) across the Gulf of Mexico in a single non-stop flight, wings buzzing at 50 beats per second.

Most landbird migrants described in this book breed in northern and temperate latitudes. The Southern Carmine Bee-eater, however, is an example of an intra-African migrant.

This spectacularly colorful bird breeds in dazzling colonies in river sandbanks in the dry season, when water levels fall low enough to dig nest burrows, and then migrates in a circle—first south to South Africa and then north to equatorial Africa. From November, it is joined by European migrants such as the European Roller, named for its tumbling courtship displays, which compete with the locals for the rich supply of insects that appear with the tropical rains.

The antithesis of the aerial agility of bee-eaters and rollers is surely represented by game birds—plump, sturdy-legged ground-dwellers that only take flight under duress. Even so, the Common Quail bucks the trend by being a partial long-distance migrant, with some populations completing major journeys between Eurasia and Africa. The species even migrates between broods in a single calendar year, the offspring from the first breeding attempt maturing quickly enough to move further north and have chicks of their own just a few weeks later.

The Pin-tailed Sandgrouse is not a gamebird, despite the name, but belongs to a family of fast-flying, ground-nesting birds related to pigeons, whose cryptic plumage provides excellent camouflage. An inhabitant of arid grasslands and semi-desert, this species migrates southwest from northern parts of its Central Asian range, sometimes making large irruptive movements when conditions dictate.

Such irruptions are also typical of the Budgerigar, a small migratory parrot of the Australian outback. Better known to most as a cagebird, this sociable seed-eater forms enormous flocks that migrate in search of rainfall and fresh grass.

Finally, there's the European Turtle Dove. This much-beloved bird, a time-honored symbol of peace and fidelity, has now become better known as an emblem of the plight of migratory birds everywhere. The victim of intensive agriculture on its European breeding grounds, habitat loss on its African wintering grounds, and indiscriminate slaughter as it migrates between the two, populations of this species are plummeting across Europe. If conservationists can turn around the fortunes of the European Turtle Dove, it will offer hope for migratory birds everywhere.

OPPOSITE The European Bee-eater is one of the most numerous and conspicuous Afro-Palearctic migrants on its wintering grounds in sub-Saharan Africa.

COMMON CUCKOO

Cuculus canorus

SIZE
L: 12.5–13.3 in (32–34 cm)
Wt: 3.9–4.6 oz (110–130 g)
WS: 22–24 in (55–60 cm)

APPEARANCE
Dove-sized, with falcon-like flight silhouette of pointed wings and long tail; yellow eye and fine, slightly curved yellow bill; upperparts and head gray in male and gray-brown in female; underparts barred; juvenile brown and heavily barred; flight fast and direct; perches with wings drooping and tail raised.

LIFESTYLE
Feeds largely on insects, including hairy caterpillars; a brood parasite: female lays eggs in nests of host birds, which raise young cuckoo as their own; different populations use different host species and match the color of their eggs accordingly.

RANGE AND MIGRATION
Breeds across Europe and Asia, from Ireland to Japan, north to Lapland and south to Turkey; migrates to overwinter in Central and southern Africa; a small population also overwinters in Southeast Asia.

STATUS
Least Concern; population estimated at 40–72 million individuals worldwide.

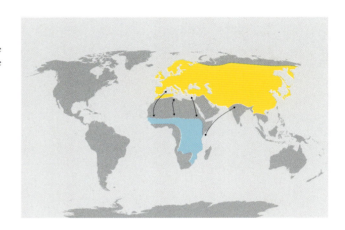

CU-CKOO, CU-CKOO, CU-CKOO. There is surely no more instantly recognizable bird call. That strident minor third repeats over and over, carrying across the hillsides as the singer takes up a prominent vantage point and lets rip, throat swelling and tail pumping.

The singer is, of course, the Common Cuckoo, whose onomatopoeic English name derives from the Old French *cucu.* Its two-note territorial call has featured in popular culture since at least the thirteenth-century Old English canon "Summer is Icumen In" (summer is a-coming in), with its joyful line "*Cuccu, cuccu, wel singes pu cuccu*" ("cuckoo, cuckoo, sing loudly, cuckoo!"). It has since appeared in Shakespeare plays, Beethoven symphonies, and Wordsworth poems. The source of all this celebration is the arrival of spring, which the bird—a summer migrant—is thought to herald. However, only in the last century have we known where Common Cuckoos are arriving *from.* Even Shakespeare might have been amazed to discover that those birds heralding spring around Stratford-upon-Avon had started their journey in Africa.

The Common Cuckoo is a slim, dove-sized bird, with a long tail and yellow bill. Males are soft gray above and females brown, both finely barred below. In flight, its rakish profile closely resembles a bird of prey—and its size and coloration are notably similar to that of a Eurasian Sparrowhawk—but the thin bill instantly distinguishes it from a raptor, as does its signature posture of raised tail and drooping wings when perched.

This species inhabits largely open or lightly wooded terrain, typically on hillsides, where its insectivorous diet includes a particular taste for hairy caterpillars that are toxic to most other birds. Its breeding range covers all of Europe, north to Lapland and south to Turkey, and extends east across Central Asia to China, Japan, and the Russian far-east. Four separate subspecies are recognized, with the majority of the population migrating to winter in sub-Saharan Africa. A few also find non-breeding quarters in Southeast Asia.

The precise location of the Common Cuckoo's African winter quarters was long shrouded in mystery. The species is unusual among Afro-Palearctic migrants in that it travels on a very broad front, with many birds taking a direct route cross the Sahara desert. In the UK, it is one of the earliest summer migrants to leave; adults, which play no part in the rearing of the young, depart by late June. An ongoing British Trust for

OPPOSITE A male Common Cuckoo, newly arrived in Scotland, takes up a prominent perch to make its unmistakable call.

LEFT An adult Reed Warbler tends to the young Common Cuckoo that has taken over its nest and evicted the warbler's own eggs. The cuckoo will never see its parents.

Ornithology project used geolocators to track numerous male Common Cuckoos south on their autumn migration. Results showed that some took a westerly route south, via Spain and Morocco, while others headed east, crossing the Mediterranean via Italy and the Balkans. However, all these routes converged in west and Central Africa—in the Congo Basin. Data from return journeys also revealed that the birds took a more westerly route back in spring, thus completing a loop migration.

Common Cuckoos migrate alone by night, with youngsters having no parents on hand to offer guidance. Studies elsewhere have shed more light on their prodigious flying capacity. One bird christened Skybomb Bolt, that was tracked from Beijing, China, made a non-stop four-day flight over the Indian Ocean, from India to Somalia. Another from Beijing, this one christened Flappy McFlapperson, also made it to Somalia but via a land-based route around the Arabian Peninsula. Common Cuckoos have been recorded as far south as South Africa, so it is likely that some individuals complete a return trip of more than 10,000 miles (16,000 km) every year.

Just as remarkable as the cuckoo's migration are its breeding habits. This species is an obligate brood parasite: In other words, its reproductive cycle depends upon other species of bird rearing its young. Each breeding season, a female will covertly lay up to twenty eggs, each in the nest of another bird—the host. Different species serve as hosts in different regions: in western Europe, the Dunnock, Meadow Pipit, and European Reed Warbler are all favorites. When the cuckoo egg hatches after eleven to thirteen days, the youngster ejects all the other eggs or chicks, leaving the host parents to feed and rear it as their own. This places a huge burden on the parents—by fourteen days, a young Common Cuckoo is three times the size of its European Reed Warbler "parents"—but they are driven by its begging behavior to complete the process, which takes about a week longer than with their own chicks. Sometimes hosts detect the scam and eject the cuckoo egg but, more often than not, they are fooled—a deception enhanced by the cuckoo's ability to match its egg color to that of its hosts.

A Common Cuckoo never meets its parents. When a chick fledges after seventeen to twenty-one days, it must prepare to fly to Africa alone. The challenges are considerable and, in recent times, appear to be increasing. In Europe, the Common Cuckoo is in decline—the breeding population in England, for example, fell by 70 percent between 1991 to 2016. The causes are complex: Satellite studies have uncovered high mortality rates on the European leg of UK birds' southbound autumn route, perhaps because fires and habitat loss in the Iberian Peninsula rob them of vital food at southbound staging posts. Global warming may also play a part: With the UK spring now occurring an average of 5.1 days earlier than fifty years ago, many of the UK's host species are breeding earlier, making the Common Cuckoo's arrival often too late to find suitable hosts. Worldwide, however, the species is listed as Least Concern, with a global population estimated at 40–72 million individuals.

RIGHT The powerful flight of a Common Cuckoo helps power it on return migratory journeys of more than 10,000 miles (16,000 km).

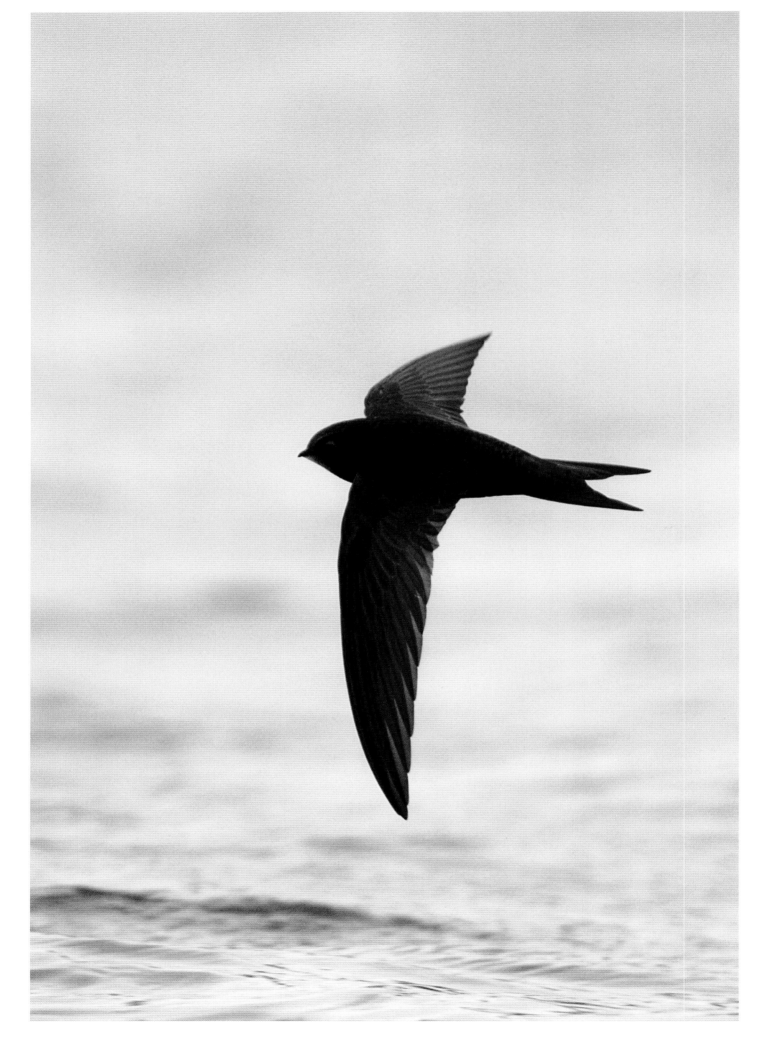

COMMON SWIFT

Apus apus

SIZE
L: 6.3–6.7 in (16–17 cm)
Wt: 1.2–1.9 oz (35–56 g)
WS: 15–16 in (38–40 cm)

APPEARANCE
Sooty-brown (though appearing black), with cigar-shaped body, short, broad bill, forked tail, and long wings held swept back in a crescent shape; invariably seen in flight—other than at nest, where clings to vertical surface with tiny feet.

LIFESTYLE
Feeds on airborne insects, spiders and other "aerial plankton" caught on the wing; produces food balls, which it feeds to young in nest—a simple structure of windblown material generally built in a crevice in a building; female lays 2–3 eggs; young may enter state of torpor while awaiting return of adults from foraging trips.

RANGE AND MIGRATION
Breeds across Europe and Asia, from Spain to Siberia, north to Lapland and south to Turkey; migrates to overwinter in Central and southern Africa.

STATUS
Least Concern; population estimated at 95.5–162.5 million pairs worldwide.

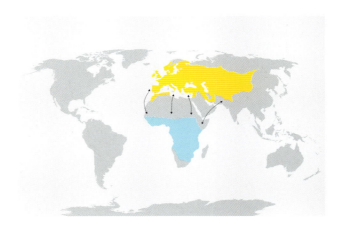

SWIFTS CELEBRATE SUMMER with spine-chilling screams. Watching a party dashing through the sky at dusk, their rakish crescent silhouettes zooming around church towers and past city walls, their shrill calls echoing in the streets below, it's not hard to understand how this species once acquired the nickname "Devil-bird."

Although sometimes confused with swallows, swifts are not songbirds but belong with hummingbirds in the order Apodiformes. This term derives from the Ancient Greek for "without feet" and refers to the ancient belief that swifts, whose tiny legs are barely visible, are simply legless swallows. Certainly, no bird has less use for legs: Swifts are supremely adapted for an aerial existence, performing many tasks in flight that other birds must perform on the ground. They feed on the wing, subsisting on insects and other "aerial plankton" that they capture in their gaping bills. They also drink on the wing, swooping down to scoop up water; gather nest material—feathers, grass, and other windblown material; mate in mid-air, the two birds briefly appearing to be one; and can even sleep in flight by climbing to a great height, then descending slowly while taking a series of power naps.

Some statistics are mind-boggling. A 2010 project monitoring UK swifts on migration found that three birds did not touch down once in ten months. This is the longest proven continuous flight of any bird—and it is quite possible that some non-breeding swifts may spend years continuously airborne. Scientists estimate that an individual may fly more than 124,000 miles (200,000 km) in one year. Their capacity for speedy travel allows Common Swifts to exploit food bonanzas far from their breeding sites, often forming feeding parties of hundreds or thousands.

The Common Swift breeds across much of Eurasia, ranging from Spain to Siberia (and, north to south, from Norway to Morocco). They colonize many habitats—but in general their habitat is the air rather than the land, traveling wherever they can find flying insects. Before human times, they bred mostly on crags, cliffs, and large trees, but their adoption of buildings as nest sites means that, today, most breed around human structures and settlements. Wherever they nest, all of them migrate south to spend winter in sub-Saharan Africa, from the equatorial central south to South Africa.

OPPOSITE The Common Swift is supremely aerodynamic, able to spend many months at a time on the wing without landing.

Swifts pair for life. In spring, they get together at their nest sites, which are typically located in a building crevice and fashioned from feathers, paper, and other windblown material glued together with saliva. The female lays an average of two to three eggs. Incubation lasts nineteen to twenty days and the chicks fledge at six to eight weeks, much longer than in passerines. Both adults share parenting duties, traveling far and wide to find food, which they collect in food balls in their throat. If the parents are away for more than a day or so, the young enter a state of torpor, very unusual in birds, in which their metabolism slows down and they can conserve energy until food is available again. Fledglings are self-reliant immediately, and leave the nest within days to fly to Africa.

After breeding, with the insect supply already decreasing, the swifts head south. Birds of the nominate form, *A. a. apus*, which breeds from the UK to Siberia, winter across equatorial Africa and south to Zimbabwe and Mozambique. A second subspecies, *A. a. pekinensis*, which breeds from Iran to China, winters in the arid southwest of Africa, notably in Namibia and Botswana. Common Swifts wander huge distances on their wintering grounds, following weather systems to the best feeding areas. Some turn up as "accidentals" far off track in places as remote as Iceland, the Azores, and even Bermuda.

In the UK, the Common Swift's visit is more fleeting than any other migrant's: It arrives in early May and leaves just three months later in early August. Able to feed on the wing, swifts have less need to build up the fat reserves required by most migrating songbirds and can set out straight away after breeding. The new fledglings leave first, along with unsuccessful breeders and immature yearlings. Breeding males are next, then breeding females. Departure is triggered by changes in day length—thus Common Swifts that breed in the far north in Finland leave later, in late August.

In Europe, the swifts head south on a broad front. Those from western and Central Europe cross the western Mediterranean into northwestern Africa, typically heading around the Atlantic coast in order to avoid the Sahara. Those from Russia and southeastern Europe cross over the eastern Mediterranean and skirt the Sahara to the east. Some may cross the Sahara more directly. Either way, they reach the Sahel in mid-August then continue toward Central and southern Africa and, by September, are on their winter quarters. They do not settle at one destination, however, but keep wandering, following weather fronts toward fresh rainfall and more food.

As the northern spring approaches, some immature Common Swifts remain in Africa. However, most head back north, with the southernmost starting their journeys as early as late January. They arrive throughout May and June, but weather determines the more precise date: Swifts may travel hundreds of kilometers to skirt depressions—especially in the Baltic, Scandinavia, and North Sea regions. Nonetheless, spring migration is generally faster than autumn, driven by competition for good nest sites.

Technology is revealing more about swift movements. In 2010, the British Trust for Ornithology used tiny geolocators to track fifteen Common Swifts from their UK nests. Data extracted from nine of the birds retrieved the following summer revealed that they had traveled down through Spain and West Africa then inland eastward to the forests of the Democratic Republic of Congo, where they spent much of the winter. From there, some diverged, wandering as far as Mozambique, Angola, and South Africa. On the return, they headed out across the Atlantic near the mouth of the Congo and across to Liberia. Here they paused for around ten days, presumably to refuel, then completed a rapid final leg back to Britain. One bird, numbered A322, completed the last 3,100 miles (5,000 km) to its nest site in Cambridgeshire in just five days, covering 12,400 miles (19,950 km) in total.

The Common Swift is listed as Least Concern, with an estimated global population of 95.5–162.5 million pairs. In some regions, however, it is in decline. The UK population fell by 51 percent between 1995 and 2015 and has continued to fall by an average of 3 percent each year. The causes are complex and include changes to its food supply, both in the UK and Africa. One critical factor is the loss of traditional nest sites due to modern building and renovation techniques. Conservationists are working with urban planners and householders to introduce new swift-friendly buildings.

OPPOSITE During the breeding season Common Swifts band together in "screaming parties," performing high-speed fly-pasts over their nest sites.

EUROPEAN NIGHTJAR

Caprimulgus europaeus

SIZE
L: 9.6–11 in (24.5–28 cm)
W: 1.8–3.6 oz (51–101 g)
WS: 20–23 in (52–59 cm)

APPEARANCE
Size and build of small falcon, with large head, long, pointed wings, and longish tail; tiny legs; short bill with broad gape and prominent rictal bristles at base; plumage gray, brown, and ochre in cryptic camouflage patterning that resembles dead leaves; male has prominent white markings on outer primaries and outer tail; buoyant, agile flight; perches lengthwise along branches.

LIFESTYLE
Nocturnal; feeds on larger airborne insects, captured in short sallies from perch; roosts on ground by day; nests on ground, female laying 1–2 eggs; male defends territory with continuous "churring" call.

RANGE AND MIGRATION
Breeds across temperate Eurasia, from Spain to Mongolia, south to North Africa and Pakistan; migrates to overwinter in Central and southern Africa.

STATUS
Least Concern. Population estimated at 3.1–5.5 million individuals worldwide.

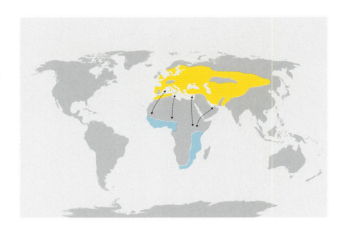

THE EUROPEAN NIGHTJAR is a mysterious bird. Nocturnal by habit and beautifully camouflaged, it is seldom seen. The "jar" refers to its call, a rolling purr that may continue unbroken for up to ten minutes without revealing its whereabouts. Once, when herders witnessed the bird flitting around their goats at dusk, they feared it was stealing milk, though the bird was really feeding on insects drawn to their livestock and lights. This myth explains the species' scientific name: *Caprimulgus* is Latin for "goat-sucker."

Like all nightjars, this species has the slim, long-winged build of a small falcon. Close up, you will also see large owl-like eyes, equipped with a reflective layer (the tapetum lucidum) to maximize its low-light vision, and a swift-like short bill and wide gape—an adaptation for capturing moths, beetles, and other insects—during its agile, silent flight. By day, its cryptic camouflage conceals it on the ground by mimicking dead leaves.

European Nightjars breed across temperate Eurasia, from North Africa and Iberia to Mongolia. Across its range, it inhabits largely open country, including heathland and woodland clearings. After breeding, most migrate south to tropical Africa, where they occupy dry acacia steppe mostly. Western European birds take a westerly route to West and Central Africa while eastern birds head to eastern and southern regions.

European Nightjars migrate in August, flying by night and living off fat reserves. They moult their body feathers before departure followed by their wing and tail fathers on arrival. In a 2015–2017 British Trust for Ornithology survey, more than thirty birds tagged in the UK took various routes south over the Sahara, but most ended up in the Democratic Republic of Congo. Their return journeys followed a different route.

On their breeding grounds, males establish territories with their "churring" calls and fluttering displays, clapping their wings and flashing white markings on their primaries and tail feathers. The female lays one or two eggs directly onto the ground. Incubation lasts seventeen to twenty-one days and chicks fledge sixteen to seventeen days later.

The European Nightjar is listed as Least Concern, with a world population of about 3.1–5.5 million mature individuals. The UK population rose by 36 percent from 1993–2004, which may reflect climate change. Nonetheless, threats remain in the form of habitat loss and pesticides, and the species is very vulnerable to disturbance from the likes of dog walkers.

OPPOSITE The fluffy down of a chick is just visible beneath this Common Nightjar at its nest in Norfolk, England.

EUROPEAN ROLLER

Coracias garrulus

SIZE
L: 11.4–12.5 in (29–32 cm)
W: 4.5–5.4 oz (127–154 g)
WS: 20.4–22.8 in (52–58 cm)

APPEARANCE
Robust, jay-sized bird, with large head and strong, hook-tipped bill; head, breast, and tail pale turquoise, back rufous-brown, wings brilliant blue and black; perches upright on wires, on top of bushes and other exposed vantage points.

LIFESTYLE
Frequents largely dry, open country with patchy vegetation, where feeds on large insects and small vertebrates captured largely from the ground; pairs perform colorful, tumbling courtship displays; nests in holes, in trees, and sometimes sandbanks; female lays 4–6 eggs.

RANGE AND MIGRATION
Breeds across temperate Eurasia, from Spain to western China, south to North Africa and north to the Baltic states; migrates to overwinter in sub-Saharan Africa, from Senegal to South Africa.

STATUS
Least Concern; population estimated at 277,000–660,000 individuals worldwide.

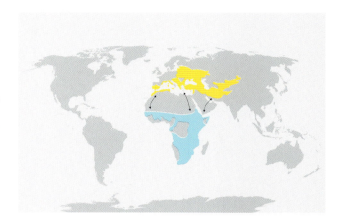

IN SOUTH AFRICA'S Kruger National Park, a pale blue bird sits at the top of a thorny acacia bush. A fat bush-cricket hops out of the long grass, momentarily exposed on an elephant trail, and in a dazzling flash of electric blue wings, the bird swoops down to seize the juicy prize in its powerful bill.

The bird is a European Roller. Scan across the savannah and there are more—each on top of a bush, scanning the ground below. They arrived a month ago, seasonal visitors from Europe, and now they have set up territories, displacing the resident Lilac-breasted Rollers (*C. caudatus*), which have retreated from open grasslands to woodland fringes, breeding now under way.

Rollers get their name from their tumbling display flights. The European Roller is the only species of this mostly African family found in Europe, where it frequents dry, open terrain in the south and east. Two subspecies occur: One ranges from Europe through Central Asia to southwest Siberia, the other from Iraq and Iran to China's Xinjiang province. All winter in sub-Saharan Africa, from Senegal east to the Horn of Africa and south to the Cape. Avoiding tropical forest and desert, they move to open acacia savannah.

Recent telemetry studies have shown that birds from across Europe take parallel routes south, crossing the Mediterranean at many points and finding winter quarters on the same longitude. Those from southwest Europe go to Angola and Namibia, while those from eastern Europe end up further east in Zimbabwe and Botswana. After crossing the Sahara, all the birds make a stop-over of one month in the Sahel, before arriving at their destination in early November to coincide with the start of the rains.

Back on their breeding grounds, European Rollers establish territories with colorful tumbling displays. They nest largely in tree-holes—often those vacated by woodpeckers—and mob intruders aggressively. A female lays four to six eggs, which she incubates for seventeen to twenty days. The chicks fledge at twenty-six to twenty-seven days.

European Rollers have declined significantly in some regions, falling by 25 percent in Europe from 1990 to 2000. Northern populations have been hardest hit, notably in Russia and the Baltic states. Habitat loss is a concern, as is hunting—notably in the Mediterranean and the Arabian Peninsula, with thousands killed annually for food in Oman. Nonetheless, with a global population estimated at 277,000–660,000 individuals, the species is listed as Least Concern.

OPPOSITE European Rollers are the only member of their colorful family to occur in Europe. On their African winter quarters, they join other roller species to exploit the rich harvest of insects.

SOUTHERN CARMINE BEE-EATER

Merops nubicoides

SIZE
L: 13–15 in (33–38 cm)
Wt: 1.5–2.3 oz (44–66 g)
WS: 18 in (46 cm)

APPEARANCE
Slim, elegant, starling-sized bird, with long central tail feathers and long decurved bill; plumage a rich combination of reds and pinks, with powder-blue crown, rump, and under-tail coverts; juveniles browner.

LIFESTYLE
Feeds on flying insects, including bees, wasps, dragonflies, and locusts, captured in sallies from perch; disarms stinging prey by

striking against branch; inhabits lowland tropical river valleys and savannah woodland; breeds in sandbank colonies; deep nest tunnel excavated; lays 2–5 eggs.

RANGE AND MIGRATION
Breeds in lowland river valleys in southern Africa, notably in Zimbabwe, Zambia, and northern Botswana; after breeding, migrates further south to South Africa and Mozambique, then returns north to equatorial Africa, notably Gabon, Tanzania, and southeastern DRC.

STATUS
Least Concern; population size not quantified.

AUGUST IN ZAMBIA'S Luangwa Valley sees one of Africa's most impressive bird spectacles. As river levels fall, forcing hippos into shrinking pools, Southern Carmine Bee-eaters arrive to take up their riverbank nesting colonies. In a dazzling display of pinks, reds, and blues, these elegant, long-tailed birds gather in flocks hundreds-strong, as they busy themselves digging and renovating their sandbank tunnels.

The Southern Carmine Bee-eater is—along with its relative, the Northern Carmine Bee-eater—the largest of Africa's bee-eaters. It is distinguished from other members of this colorful family by its overall rich red and pink plumage, set off by a powder-blue crown and rump and embellished with long central tail plumes. Like all bee-eaters, it catches insects in flight, darting out in aerial sallies to snap up bees, dragonflies, and locusts, before returning to its perch and bashing the life out of its catch against a branch. On its non-breeding grounds, it may capture fleeing insects from grass fires or even hunt from the backs of other animals, including the Kori Bustard (*Ardeotis kori*).

This species is an intra-African migrant: It does not migrate in and out of Africa but rather follows a migration cycle within the continent. Breeding colonies are located on low-lying

rivers in southern Africa, largely in Botswana, Zimbabwe, and Zambia—notably along the Zambezi and Luangwa. The birds arrive to breed in August. By late November, once the young have fledged, they are on the move again, the majority heading further south, as far as northern South Africa and Mozambique, where they disperse across the savannahs. By March, they are heading back north, overflying their breeding areas to wintering quarters in equatorial Africa, including in Tanzania, Gabon, and the eastern DRC.

Back on their breeding grounds, the bee-eaters form colonies of up to 1,000. Pairs get together with fluttering display flights. They then either renovate the previous year's hole or dig a new one, using their feet to excavate a tunnel 3–6 feet (1–2 m) long into vertical river banks. The female lays two to five eggs. Incubation lasts three weeks and chicks fledge twenty-three to thirty days after hatching. The birds will act co-operatively to mob predators such as monitor lizards, taking to the air in a blizzard of wings.

Little is known about the population size and conservation status of this species. It is vulnerable to insecticides and water pollution but is currently listed as Least Concern.

OPPOSITE The Southern Carmine Bee-eater is an intra-African migrant, arriving to breed on low-lying rivers in southern Africa during the dry season, when water levels are low.

RIGHT Southern Carmine Bee-eaters in Zambia's Luangwa Valley erupt from their riverbank nesting colony in a blaze of color.

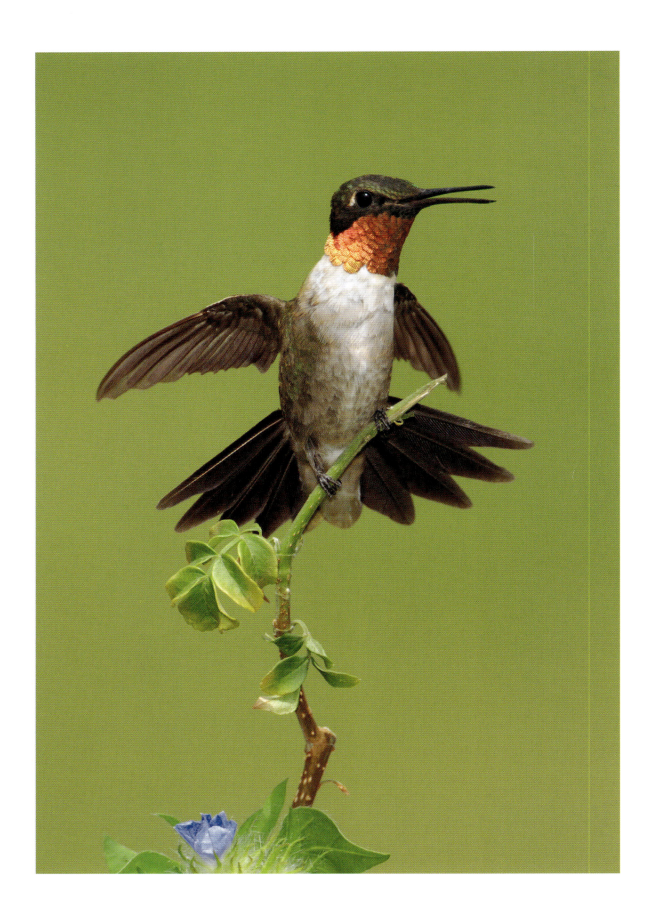

RUBY-THROATED HUMMINGBIRD

Archilochus colubris

SIZE
L: 2.8–3.5 in (7–9 cm)
Wt: 0.07–0.21 oz (2–6 g)
WS: 3.1–4.3 in (8–11 cm)

APPEARANCE
Tiny bird, with long, fine bill; male has emerald upperparts and crown, black face mask, and iridescent red throat; female pale below and green above; flies at high speed, wings buzzing audibly like an insect's; can remain stationary in mid-air and fly backward.

LIFESTYLE
Feeds largely on nectar, extracted from flower using long bill and tongue while hovering; also takes some small insects; inhabits woodland, gardens, and clearings, including suburbia; aggressively territorial on feeding grounds; female lays 1–2 eggs in tiny cup nest on twig; male provides no parental care.

RANGE AND MIGRATION
Breeds in the USA east of the Rockies and north to central Canada; migrates south to winter in southern Florida, southern Mexico and Central America, some birds flying directly across the Gulf of Mexico.

STATUS
Least Concern; population estimated at 7 million individuals.

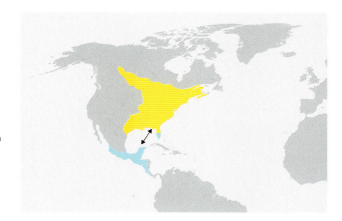

ARCTIC TERNS MAY fly the furthest and Bar-headed Geese the highest, but when it comes to sheer expenditure of energy, the Ruby-throated Hummingbird must surely take the gold medal. Weighing no more than a teaspoon of sugar, and beating its wings at more than fifty times per second, this tiny bird is capable of crossing the Gulf of Mexico in a single, non-stop, twenty-hour flight of over 500 miles (800 km).

The Ruby-throated Hummingbird is the commonest North American hummingbird and the only species that breeds east of the Rockies. Its breeding range extends from Florida north across most of the eastern United States and into southern Canada, where it reaches Alberta in the west. After breeding, the whole population migrates south to warmer climes, settling in southern Florida, southern Mexico, and Central America, south to Panama. On its breeding grounds it inhabits open woodlands, forest edges, parks, and gardens, switching to tropical forest edges and plantations on its winter quarters.

This species gets its name from the male's iridescent red gorget, which may appear dark from a distance but flashes like a jewel in direct light. He also has an emerald back and crown and a dark face mask. The drabber female is green above and white below, without the showy throat. It is one of the smaller hummingbirds, scarcely bigger than a large insect, but has a relatively long bill. The feet are tiny, serving only to help the bird shuffle along a perch or scratch its head.

As with all hummingbirds, the long thin bill of this species is an adaptation for probing flowers for their sugary nectar—a high-energy food that powers their high-octane lifestyle. They obtain this food by zipping from flower to flower and hovering in front of the blooms while extracting nectar with their tongue. An adaptation of the shoulder socket unique to hummingbirds allows them extraordinary control in flight; they are the only birds in the world that can fly backward. Red and yellow blooms are often preferred, but this species is also attracted to garden feeders that supply a colorless sugar solution. It may also feed on tiny insects, capturing them in flight or plucking them from spider webs. On cold nights, hummingbirds may conserve energy by entering a state of torpor, in which their metabolism slows down.

Ruby-throated Hummingbirds set out on their autumn

OPPOSITE The minuscule Ruby-throated Hummingbird completes one of the most energy-costly migrations known in the bird world.

OTHER BIRD MIGRATIONS

migration in August, males leaving before females. They head south from their breeding grounds, feeding early each morning to take on fuel for the day's flight. Upon reaching the Gulf of Mexico, some birds work their way around the coast but others opt for a direct flight over the sea, sometimes flying up to 500 miles (800 km) non-stop before making landfall on Mexico's Yucatán Peninsula. The extreme calorific energy required for this astonishing feat comes courtesy of a pre-flight feeding binge, during which a bird may almost double its body weight with extra fat reserves. The pectoral muscles that power this flight are proportionally massive, and the bird's heart-rate may rise to 1,260 bpm. Banding has shown that older birds tend to be heavier, thus demonstrating a greater capacity than younger birds to take on the necessary fuel.

This species does not typically follow a loop migration but uses the same route on its spring return journey. The proportion of the migrating population that makes the sea crossing is not known, but doubtless many individuals cross the Gulf of Mexico for a second time, often making landfall in Florida or Louisiana by late February. This may add up to a trans-oceanic round trip of 1,000 miles (1,600 km). They then work their way north to their feeding grounds. Each shows a strong fidelity to its annual route: Banders have sometimes banded the same individual bird at the same location on the exact same date over several successive years.

Breeding, like most aspects of hummingbird life, is a speedy affair. The male performs dashing fly-pasts either side of the female in a courtship display that lasts just a few minutes. The female then builds a tiny nest on a downward-sloping twig—typically that of a deciduous tree; in urban areas, human structures such as loops of chain or wire may serve just as well. She lays one or two eggs, at which point the male leaves, and she then copes with all the parental care. Incubation lasts ten to fourteen days, after which she feeds her brood by regurgitation— hovering in front of them as she would a flower. The young leave the nest at eighteen to twenty-two days.

Ruby-throated Hummingbirds may live up to nine years. They are targeted by numerous predators—anything quick enough to catch them, from raptors to roadrunners; even large praying mantises lurking near flowers have been known to capture and consume them. A broader threat to the species may lie in climate change, with a 2001–2010 study showing that birds are now arriving earlier on spring migration than last century, which may have implications in terms of food availability. Nonetheless, with a population estimated at seven million, the species is listed as Least Concern.

ABOVE Nectar from flowering plants fuels the astonishing journeys of the Ruby-throated Hummingbird.

COMMON QUAIL

Coturnix coturnix

SIZE
L: 6.2–7 in (16–18 cm)
Wt: 3.2–4.6 oz (91–131 g)
WS: 12.5–13.7 in (32–35 cm)

APPEARANCE
Very small, pear-shaped game bird; streaky brown, with white eye-stripe and white throat in male; sticks to ground cover, only flying if flushed.

LIFESTYLE
Feeds on seeds from grasses and cereal crops; also takes some insects, especially during breeding season; nests on the ground; male calls repetitively at dawn and dusk to defend territory; female lays 8–13 eggs.

RANGE AND MIGRATION
Breeds across Europe and Central Asia, from Spain to China, south to Turkey and Morocco and north to southern Scandinavia; partial migrant: some populations travel to sub-Saharan Africa, overwintering in Nile Valley, Sahel, and southwest; others to Indian subcontinent; also scattered resident populations in Africa, including Morocco, East Africa, southeast Africa, and Madagascar.

STATUS
Least Concern; population estimated at 15–35 million individuals.

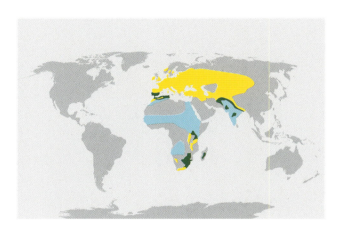

WET MY LIPS, wet my lips. The quick three-syllable call of the Common Quail is a characteristic spring sound of grassland across much of the Old World. Spotting this diminutive gamebird is another matter. It prefers to run through long grass rather than fly and may only flush when you are virtually on top of it.

The surprisingly long wings of this species reflect the fact that it is the only European gamebird to migrate. It can do this at a tender age, allowing some populations to breed in two different locations in the same year. Common Quails that breed in North Africa and Iberia may be on the nest in mid-February. Their hatchlings mature in just twelve to fifteen weeks and by April or May migrate north, reaching destinations such as Britain, where, in June, they produce a brood of their own. This behavior is unique and more reminiscent of insects such as the Painted Lady butterfly.

The Common Quail is the smallest European game bird. Starling-sized and roughly pear-shaped, it sticks to cover in grassland and arable habitats—including fields of cereal crops—where its streaky brown plumage provides excellent camouflage. A lover of sunny, well-drained habitats, it feeds largely on grain and seeds but may also take some insects, especially during the breeding season.

This species has a complex distribution. Its breeding range extends across much of Europe and Central Asia, from Spain to China, south to Turkey and Morocco, and north to Finland. Most populations migrate to wintering quarters in sub-Saharan Africa, in the Nile Valley, across the Sahel, and in the Southwest, around Angola. However, Africa is also home to several resident populations, including in Morocco, East Africa, southeast Africa, and Madagascar. Birds from the eastern Asian range winter largely on the Indian subcontinent.

Common Quails migrate by night. The journeys vary in length from 600 to 3,000 miles (965–4,828 km), crossing the Mediterranean on a broad front. On the breeding grounds, males circle females in strutting courtship displays, making their incessant territorial calls. Between eight and thirteen eggs are laid in a small scrape on the ground. The hen incubates for sixteen to eighteen days and the chicks fledge nineteen days later.

Common Quail has long been hunted for food. It appears in Egyptian hieroglyphs dating back to 5,000 B.C., and it is in Egypt that it now faces its greatest threat, with thousands netted along the Mediterranean coast every autumn as they head south. Nonetheless, it remains a numerous bird and is listed as Least Concern.

OPPOSITE The Common Quail is Europe's only migratory species of game bird.

PIN-TAILED SANDGROUSE

Pterocles alchata

SIZE
L: 12.2–15.3 in (31–39 cm)
Wt: 8.8–14.1 oz (250–400 g)
WS: 21–25 in (54–65 cm)

APPEARANCE
Robust, pigeon-sized bird with small head, short bill, and short, feathered legs; breeding male elaborately marked in chestnut, green, black, ochre, and cream, with white belly and underwings and long, pointed central tail feathers; female and non-breeding male plainer, with extensive barring on upperparts.

LIFESTYLE
Feeds on ground, taking seeds and other small plant food, plus some insects; flocks visit water daily, at dawn or dusk, calling loudly in flight; nests on ground; female lays 2–3 eggs; male transports water to chicks using uniquely absorbent breast feathers.

RANGE AND MIGRATION
Breeds in southwest Europe, North Africa, Middle East, and southwest Asia, north to Kazakhstan; birds from northern regions migrate south to Middle East and Indian subcontinent; other populations sedentary but nomadic.

STATUS
Least Concern; population estimated at 170,000–250,000 mature individuals.

SANDGROUSE ARE BIRDS of semi-arid terrain across Africa, Asia, and southern Europe that have evolved a unique strategy for delivering water to their young. The Pin-tailed Sandgrouse is no exception: At daybreak, with the female on the nest—a scrape on the ground—the male flies to the nearest water hole, where he wades in to soak his absorbent breast feathers before flying back to deliver the moisture to his thirsty chicks.

However, even the hardiest birds sometimes have to move and the Pin-tailed Sandgrouse is a partial migrant. It occurs in two subspecies: One breeds in southwest Europe; the other in a fragmented band across northwest Africa, the Middle East, and southwest Asia. Populations from the north of this range are migratory, traveling south after breeding to overwinter in the Middle East and on the Indian subcontinent. Elsewhere the species is largely sedentary, but like many birds of arid regions it is also nomadic—prone to sudden irruptive movements when resources dwindle and it is obliged to move on.

Pin-tailed Sandgrouse are stocky, pigeon-sized birds with small heads and feathered tarsi—the latter an adaptation against extreme ground temperatures. From a distance, their subtle camouflage makes them hard to pick out against the stony, sandy terrain. Up close, this plumage is beautifully ornate—especially that of the breeding male, which sports a yellow-green head and chestnut breast, with elaborate black piping and cream spotting across its soft gray-ochre upperparts. He also has long, pointed central tail feathers, hence the name, which are absent from the more soberly colored female.

Like all sandgrouse, this species feeds on seeds, buds, shoots, and other small plant material, flocks generally foraging together on the ground. At dawn every day, they fly to water, keeping up their constant harsh *kattar kattar* contact calls as they wing rapidly overhead. In the breeding season, the female scrapes a shallow nest depression, in which she lays two to three eggs. Incubation lasts nineteen to twenty-five days, the male taking turn by night and the female replacing him by day. The chicks can fly at four weeks but depend upon their parents for two months.

This species has shown recent declines across its European breeding range, due to the loss of dry grassland to agriculture and irrigation schemes. Numbers may be increasing in Turkey, however, with climate change a possible factor. With an estimated population of 170,000–250,000 individuals, it is currently listed as Least Concern.

OPPOSITE A Pin-tailed Sandgrouse alights beside a waterhole in the Reserve Ornitológica de El Planerón in northern Spain.

RIGHT Pin-tailed Sandgrouse are nomadic in parts of their range, with populations moving in response to regional fluctuations in water and food supply.

EUROPEAN TURTLE DOVE

Streptopelia turtur

SIZE
L: 9.4–11.4 in (24–29 cm)
Wt: 3–6 oz (85–170 g)
WS: 19–22 in (47–55 cm)

APPEARANCE
Small, slim dove; blue-gray head, neck, and breast; black and white bars either side of neck; chestnut back, scalloped in black; small, black bill; black, diamond-shaped tail with white sides and white terminal band—striking in flight.

LIFESTYLE
Inhabits open woodland and arable farmland; feeds on ground, largely on seeds of weed plants such as fumitory; female lays 2 eggs in flimsy stick nest built in tree fork.

RANGE AND MIGRATION
Breeds across Europe, North Africa, and Middle East, east to Central Asia; migrates to overwinter in sub-Saharan Africa, occupying a broad band across the Sahel, from Senegal in the west to Ethiopia in the east.

STATUS
Vulnerable; declining population estimated at 13–48 million pairs worldwide.

"ON THE SECOND day of Christmas," goes the traditional carol, "my true love gave to me two turtle doves and a partridge in a pear tree." Today, the partridge and pear tree may still be available but European Turtle Doves, sadly, are in short supply. Numbers across Europe fell by 78 percent from 1980 to 2013 and recent figures from the UK, where the bird was once common, show a shocking 94 percent decline since 1995. Once a symbol of peace and fidelity, this dainty little pigeon has now come to symbolize the sorry plight of many Afro-Palearctic bird migrants.

The European Turtle Dove is the only European pigeon species to undertake a long-distance migration. Its breeding range extends across Europe and North Africa, north to the Baltic and east to Central Asia. All populations migrate south after breeding, to overwinter in a broad band across Africa south of the Sahara, from Guinea and Senegal in the west to Ethiopia in the east, exchanging the open woodland and arable farmland of their temperate breeding grounds for the tropical acacia savannah of the Sahel.

At each stage of this migratory cycle, however, the turtle dove is under threat. This species is an obligate granivore, feeding exclusively on seeds. On its breeding grounds, the intensification of agriculture has so depleted the supply of seed-bearing weed plants, such as the Common Fumitory on which it has long relied, that many birds are failing to breed or producing fewer broods. On its migration route, it must brave the barrage of hunters' guns around the Mediterranean Basin—notably in Italy, Cyprus, Malta, and the South of France, where more than two million are shot every year. On its African wintering grounds, the thorn thickets where the birds have always roosted are being lost to subsistence farming, as a growing human population places even more pressure upon the land. On top of this, an avian disease called trichomoniasis is leaving some migrants too weak to complete the journey.

The European Turtle Dove is the smallest of Europe's pigeon species, identified by its blue-gray head and breast, black-and-white neck bar, and prominent white edges to its dark, wedge-shaped tail. Contrary to popular belief, the mottled tortoiseshell pattern on the bird's chestnut upperparts does not account for the bird's name. Rather it derives this from the Latin *turtur*, which is an onomatopoeic description of its call. Being a shy species, and inclined to hide in dense foliage, this soft, purring *turrr, turrr, turrr* is often the only clue to its presence.

OPPOSITE A Turtle Dove drinks from a puddle in Spain. Like all pigeons, this species has the capacity to suck up water without raising its head.

European Turtle Doves pair for life. They arrive on their European breeding grounds in April, where males display to females on the ground and in the air, cracking their wings together during swooping glides over the treetops. The pair makes a flimsy platform nest of twigs in a concealed tree fork, on which the female lays two white eggs. Incubation lasts thirteen to fourteen days, after which both parents care for the young, feeding them on regurgitated semi-digested grain until they fledge twenty days later. In good conditions, a female will produce two or three broods a year.

Within weeks of leaving the nest, young turtle doves embark on their perilous flight to Africa. Return migration starts in September. The doves migrate at night, flying at around 37 mph (60 km/h). They cross the Mediterranean by many different routes, with some flying directly over the Sahara. Most birds from western Europe take a westerly route to West Africa, with UK birds tracked to winter quarters in Senegal, Guinea, Ghana, and Burkina Faso; those from further east take up more easterly quarters, as far as Sudan and Ethiopia.

The European Turtle Dove's recent decline has seen the bird listed as Vulnerable. In 2012, a coalition of UK conservation groups, including the Royal Society for the Protection of Birds and the British Trust for Ornithology, launched Operation Turtle Dove, which brought together scientists and conservationists up and down the bird's migratory flyway. In the UK, research aims to encourage turtle dove-friendly farming practices; supportive farmers are trialling different seed mixes, while researchers are working with captive-reared birds to determine preferences. In Africa, partner organizations such as Naturama in Burkina Faso are conducting census work to determine exactly how European Turtle Doves use their wintering habitat and what impact local changes may be having—thus aiming to develop farming practices in Africa that benefit both birds and people. Meanwhile satellite tracking is shedding more light on the species' migration routes and challenges, thus informing calls for international action—for instance, to control hunting along flyways or protect key staging areas.

The Turtle Dove has long held a special place in European culture. Even the Bible celebrates it as a harbinger of spring: "The time of the singing birds is come, and the voice of the turtle is heard in our land." (Song of Solomon 2:11–12). Its recent rapid decline should serve as a clarion call to conservationists everywhere.

LEFT A migrating Turtle Dove on the island of Lesbos, Greece. Huge numbers of this species are shot every year as they pass over the Mediterranean.

BUDGERIGAR

Melopsittacus undulatus

SIZE
L: 7 in (18 cm)
Wt: 1.1–1.4 oz (30–40 g)
WS: 12 in (30 cm)

APPEARANCE
Small, sparrow-sized parrot, with tiny bill and long pointed tail; green, with yellow throat and forehead, cobalt tail, and black scalloping on back and wings; domesticated varieties come in many other colors, including blue, yellow, white, and gray.

LIFESTYLE
Inhabits semi-arid grassland and scrubland, where feeds on seeds of grasses and other ground plants; flocks fly to water every morning to drink; nests in hole in tree or fencepost; female lays 4–6 eggs.

RANGE AND MIGRATION
Found across most of Australia, except for Tasmania, Cape York, and some coastal regions in north, west, and east; migrates north in spring but may also undertake nomadic movements at any time of year.

STATUS
Least Concern; population unquantified but estimated at many more than 5 million.

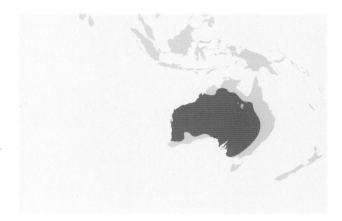

A CLOUD MOVES fast and low across the Australian outback. Against a clear blue sky, it swirls like a tornado, flashing vivid green over the sun-baked grassland. However, this is no meteorological phenomenon: The cloud consists of birds—Budgerigars, to be precise, moving in hundreds of thousands like a single organism. The rush of innumerable wings and cheeping voices swells into a jet-engine whoosh as they pass overhead.

It might seem odd to think of Budgies in free-flying flocks—especially as this colorful little bird is more often seen behind bars, where it has become the third most popular family pet worldwide, treasured for its cheerful chirruping, bright colors, and ability to mimic speech. This familiar cagebird is descended from a pocket-sized wild parrot that is native to the arid savannahs and scrublands of central Australia—and key to its survival in this harsh, drought-stricken environment is its ability to move on, sometimes in enormous numbers, to wherever it can find water.

Budgerigars were first kept in captivity in the 1850s. A great variety of breeds have since become popular all around the world, from blue and white to yellow and gray. In the wild, however, this gregarious parrot species comes only in green, embellished with a yellow throat and forehead, a cobalt tail, and delicate black scalloping on the back and wings. Males are distinguished from females by their blue cere. The short, downward-pointed bill is adapted not for dismantling cuttlefish bones but for stripping seeds from spinifex, saltbush, and other low-growing plants of Australia's arid grasslands and scrublands.

Like all granivores, Budgerigars need to drink regularly. Each day thus starts with a visit to water—either natural waterholes or livestock watering stations—where the birds arrive in small flocks, drinking in rotating ranks at the water's edge before flying off for the day's feeding. The species' ability to find water—detecting falling rain from up to 40 miles (64 km) away—may explain its name: *Betcherrygah* means "good food" in the language of the Gamilaraay people of central Australia and is thought not to refer to the bird itself but rather to its capacity to lead the way to water, and thus to new growth and food.

Budgerigars inhabit much of Australia, being absent only from Tasmania, Cape York, and some coastal regions. They undergo a regular seasonal migration, moving north in spring and returning south in autumn. However, conditions in the Australian interior are harsh and unpredictable, with cycles

OPPOSITE Favorable conditions may trigger the Budgerigar's breeding cycle at any time of year.

OTHER BIRD MIGRATIONS

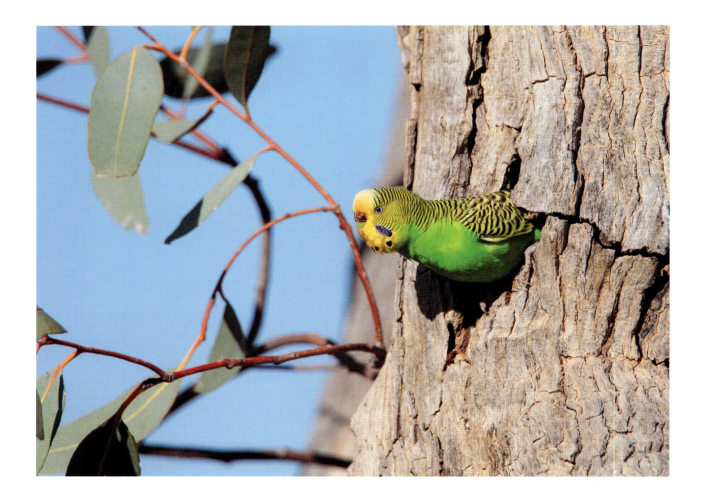

of severe drought and heavy localized rainfall, and the birds have evolved to respond accordingly. Small advance parties will scout the terrain, scouring the horizon for rainfall—or for the movement of grazing animals, such as kangaroos, that indicate fresh growth. These smaller flocks may quickly coalesce, forming mass gatherings of hundreds of thousands, occasionally even millions. On longer journeys, birds may fly for fifty hours non-stop. Once they locate favorable seed-rich conditions, they may start their breeding cycle immediately.

Breeding for Budgerigars generally takes place from June to September in northern Australia and from August to January further south. These highly sociable birds develop strong bonds, with "allogrooming"—that is, social grooming—being key to their daily routine. Loose breeding colonies form, with each pair building their nest inside a hole—in a tree, fence post, or even fallen log. The female lays from four to six eggs, which she incubates for eighteen to twenty-one days while her mate feeds her. The chicks fledge after another thirty to thirty-five days. When times are good, this species may produce several broods a year. Population growth can thus be prolific.

Budgerigars are supremely well adapted to withstand the challenges of their harsh environment. Recent research has revealed that they are able to minimize water loss through their skin by controlling their internal temperature. Nonetheless, droughts and heat can take their toll: In January 2009 more than 15,000 dead birds—mostly Budgerigars, along with some finches—were found at the Overlander Roadhouse near Carnarvon, Western Australia, victims of dehydration and heat exhaustion. Other threats include bush fires and invasive species that replace the native seed plants on which they depend. Conversely, irrigation schemes and livestock farming have introduced water supplies to previously arid regions, allowing the birds to flourish.

Millions of Budgerigars exist around the world as cagebirds. Australia's wild Budgerigar population has not been quantified, however, and may fluctuate considerably from year to year, according to conditions. The species is listed as Least Concern.

ABOVE In common with most parrot species, Budgerigars are hole-nesters.

OPPOSITE Localised rainfall and the fresh growth that follows can produce enormous aggregations of Budgerigars, the birds flocking to productive areas in hundreds of thousands.

GLOSSARY

Aspect ratio In aeronautics, this is the proportional relationship between the span and chord (depth) of a wing. A long, narrow wing, such as that of an albatross, has a high aspect ratio and is better for slow, energy-efficient flight. A short, wide wing, such as that of a sparrowhawk, has a low aspect ratio and is better for fast, manoeuverable flight.

Banding (UK: ringing) Bird banding—or, in the UK, ringing—is the attachment of a small, individually numbered metal or plastic band (or ring) to the leg of a wild bird to enable individual identification. The subsequent recapture or recovery of the bird can provide information on migration, as well as many other aspects of its biology and life history. When birds are banded, biometric data is usually also taken in order to learn more about the age and health of the bird.

Bioaccumulation The chemical process by which substances, including toxins, are absorbed at a low level of a food chain and pass up as a residue through each link in the chain, with the potential to harm animals at the top—typically predators, such as Ospreys.

Brood parasitism A reproductive strategy in cuckoos and some other families of bird in which adults lay their eggs in the nest of other species, known as hosts. The host birds, if taken in by the deception, rear the brood parasite's chick—often at the expense of their own young. Having outsourced their parenting duties, brood parasites are able to devote their energies to producing more eggs.

Dimorphic Occurring in two distinct forms within one species. Most ducks are sexually dimorphic, for example, with males being more colorful than females. Some species also occur in more than one color morph. The Common Cuckoo, for example, comes in gray and rufous-brown variants. These differences do not correlate with subspecies, to which greater genetic distinctions apply.

Facial disk A concave arrangement of feathers on the face of certain birds, most notably owls but also in certain diurnal birds of prey, including harriers. It surrounds the eyes and serves to collect and direct sound waves towards the ears. The feathers can be adjusted to alter the focal length of the disk, enabling the bird to focus at different distances.

Family Taxonomic level above genus and below order. The albatrosses, for example, make up the Diomedeidae family, one of four families in the order Procellariiformes. In turn, they fall into four different genera, which collectively comprise twenty-two separate species.

Flyway A regular flight path used by migrating birds between their breeding grounds and their wintering quarters. Flyways span continents and cross oceans. They have evolved to offer the optimum route between two destinations, generally circumventing obstacles such as mountain ranges or wide expanses of water. Ornithologists recognise eight or more principal flyways around the globe, each subdivided into smaller flyways at a regional level—tributaries to the main artery. "Flyway" is also sometimes used to denote the entire range of a migratory bird, encompassing both its breeding and non-breeding grounds, and its staging areas in transit.

Genus (plural: genera) Taxonomic level above species and below family. The albatross family Diomedeidae is divided into four genera, which collectively comprise twenty-two species. A bird's genus can be seen in the first part of its binomial species name—as in the Wandering Albatross: *Diomedea exulans.*

Geolocator A lightweight, electronic tracking device fixed to a bird in order to map its migration routes and sometimes provide additional ecological information. A light level geolocator periodically records ambient light levels, producing data that can be used to calculate latitude and longitude readings of a bird's movements and thus determine its location. Some transmit the data using satellite or radio telemetry. The smallest require recapture of the bird in order to obtain the data. The devices may be attached to the bird by a harness or a band on its leg. The lightest weigh just 0.01 oz (0.3 g). Battery life varies from six months to five years.

Hypoxic Lacking in oxygen. Hypoxia is a condition in which the body or part of the body is deprived of adequate oxygen supply at the tissue level.

Irruption A dramatic, irregular migration of large numbers of birds to areas where they do not typically occur, sometimes far from their normal ranges. Irruptions are typically triggered by a crash in food supply or by extreme weather conditions. An irruptive migrant is a species that usually migrates only short distances but occasionally moves far south in very large numbers.

Kleptoparasitism A feeding technique in which an animal takes prey or other food from another animal that has caught, collected or otherwise prepared it. The Great Frigatebird, for example, is a habitual kleptoparasite on other seabirds, although it is not reliant on this strategy. The term is also used to describe the theft of nest material or other objects from one animal by another.

Leapfrog migration An autumn movement by the northern breeding component of a species' population to winter quarters that lie further south than those occupied by the southern breeding component of the same species. The northern breeders thus "leapfrog" the southern ones.

Loop migration A migration in which the outward and return journeys follow different routes, the bird thus completing a loop in the course of its yearly migratory cycle. Loop migrations allow birds to exploit varied resources or conditions at different times of year. For example, Rufous Hummingbirds follow a coastal route in spring on their way from Mexico to Alaska but take advantage of mountain wildflowers on an interior southbound route in autumn.

Loop migration is common in many seabirds, which use seasonal variations in wind patterns to assist their flight.

Magnetoreception A sense that allows an organism to detect a magnetic field in order to perceive direction, altitude or location. It is used by a range of animals for orientation and navigation, and plays a significant role in bird migration.

Migratory divide Migratory strategy whereby two or more populations of the same species follow different migration routes. Thus red-necked phalaropes that breed in the UK and Iceland migrate southwest across the Atlantic to the Caribbean and central Pacific Ocean, while those that breed further east in Europe migrate southeast to the Arabian Sea.

Nominate The first-named race of a species, in which the scientific name is the same as the species name. Thus *Hirundo rustica rustica* is the nominate race of the Barn Swallow *Hirundo rustica,* which also occurs in five other races around the world.

Order Taxonomic level above family and below class. Thus, the Procellariiformes order, to which albatrosses belong, comprises four families and is one among some twenty-eight orders in the class Aves (birds).

Partial migration Pattern of migration in which some populations of a species migrate and others do not. In North America, for example, the Red-winged Blackbird is a partial migrant: most birds that breed in northern regions migrate south for winter whereas most that breed in southern regions remain on or around their breeding quarters all year.

Passage migrant Term applied to a migratory bird when travelling through a particular region. In Britain, for example, the Wood Sandpiper is largely a passage migrant. It breeds to the north, in the Arctic, and winters to the south, in Africa, but twice a year large numbers pass through in transit—or "on passage"—between the two.

Passerine Any bird belonging to the order Passeriformes. Sometimes known as perching birds or songbirds, passerines are distinguished from other orders by the arrangement of their toes (three pointing forward and one back), which facilitates perching, and by the structure of their vocal apparatus which, in many species, allows complex song. With some 6,600 identified species, the passerines comprise the largest order of birds and are among the most diverse orders of vertebrate.

Pelagic Of seabirds that spend most of their time (except when nesting) on the open ocean, far from land. Pelagic birds include albatrosses, petrels, shearwaters, and tropicbirds. Many have evolved special adaptations to their ocean-going lifestyle, including glands at the base of the bill that allow them to excrete excess salt. Coastal seabirds, such as gulls and cormorants, are tied more closely to land.

Polyandry A pattern of mating among animals, in which a female has more than one male mate. The opposite—in which a male has more than one female mate—is more common, and known as polygyny.

Sedentary Of birds that are permanently resident in one area and do not migrate. The Tawny Owl, for instance, is a sedentary species in Europe. Many tropical rainforest species are largely sedentary: their environment changes comparatively little, providing abundant food, warmth, and rainfall through the seasons, so they have little need to move.

Shorebird (UK: wader) Any member of the suborder Charadrii (order Charadriiformes) that is typically found on beaches or inland mudflats, where it wades on long legs in mud or shallows to glean small food items from the ground or water. Many species forage and roost in large flocks. Typical shorebirds include sandpipers, plovers, curlews, and avocets. In Britain, shorebirds are known as "waders" or "wading birds"—this term in North America being reserved for larger, long-legged water birds such as herons or spoonbills.

Staging area A place habitually used by migrants in transit between their breeding and wintering quarters. Staging areas typically offer abundant food and safe roosts, allowing the birds to refuel and rest during their journey. Large estuaries and mudflats along flyways serve as vital staging areas for millions of water birds of many species. Threats to such places can have a dramatic impact on populations of migratory birds.

Taxonomy The science of classification. Taxonomists trace the evolutionary heritage of each organism, determining which can be classified as species, which species make up a genus, which genera form a family and so on.

Telemetry The collection of measurements or other data at remote or inaccessible points, and their automatic transmission to receiving equipment for monitoring. In satellite telemetry, an animal carries a small tracking device, or tag, and its location is calculated via satellites that orbit the Earth. This information can either be stored on the device or transmitted.

Wing loading In aeronautics, the total weight of a bird (or aircraft) divided by the area of its wing. A bird with a low wing loading, such as a vulture, has a larger wing area relative to its mass than a bird with a high wing loading, such as a duck. Wings generate lift due to the flow of air over the surface. Larger wings move more air, so a bird with a low wing loading will have more lift at any given speed.

Wintering Also known as "overwintering," this describes a bird's occupation of the non-breeding quarters to which it migrates after the breeding season is over. For northern hemisphere birds, this takes place during the northern hemisphere winter—although birds that "winter" south of the Equator will be doing so during the southern hemisphere summer.

FURTHER INFORMATION

BIBLIOGRAPHY AND FURTHER READING

A wide range of publications, both in print and online, provided material for this book. The following list includes sources that were an important reference to the author and also recommends further reading for those who wish to explore further.

Couzens, Dominic, *Bird Migration* **(New Holland, 2005)**
Concise and highly readable account of bird migration aimed at the non-scientist, with excellent illustrations and photographs. Concentrates on British and European species.

Elphick, Jonathan, *Atlas of Bird Migration: Tracing the Great Journeys of the World's Birds* **(Firefly, 2011)**
Excellent resource, covering all aspects of bird migration. Large format, with numerous illustrations and photographs. Includes a catalog of migrants, with individual accounts of more than 500 species.

Flegg, Jim, *Time to Fly: Exploring Bird Migration* **(British Trust for Ornithology; 3rd edition, 2004)**
Comprehensive account of migratory birds in Britain and Ireland by a former director of the British Trust for Ornithology and ringer of over 30,000 birds. Includes maps for over 100 species.

Harris, Tim, *RSPB Migration Hotspots: The World's Best Bird Migration Sites* **(A & C Black, 2013)**
Beautifully illustrated coffee-table book showcasing thirty of the locations worldwide where the planet's most dramatic bird migrations can be witnessed.

Hughes, Janice, *The Migration of Birds* **(Firefly, 2009)**
Readable and entertaining account of the mysteries of bird migration, with an enjoyable historical context and excellent illustrations.

Newton, Ian, *Bird Migration* **(Collins New Naturalist Library, 2010)**
Authoritative account of bird migration by a leading expert on bird ecology and biogeography. Emphasis on British and European species.

Nicolson, Adam, *The Seabird's Cry* **(William Collins, 2018)**
Powerful book from a renowned nature writer that tells the story of ten species of migratory seabird, looking at their lifecycles, the threats they face, and the passions they inspire. Winner of the Wainwright Prize 2018.

Toms, Mike, *Flight Lines: Tracking the wonders of bird migration* **(British Trust for Ornithology, August 2017)**
Joint project from the British Trust for Ornithology and The Society of Wildlife Artists (SWLA) that highlights the challenges that migrant birds face. Artists and storytellers are paired with researchers and volunteers to tell the stories of migrant birds and the work being done to secure their future.

OTHER SOURCES

The following articles and papers provided important information for species accounts in this book.

Black-necked (Eared) Grebe Jehl *et al.*, "Flying the Gauntlet: Population statistics, sampling bias and migrations routes of eared grebes downed in the Utah Desert," *The Auk* 116 (1999)

Wandering Albatross Weimerskirch *et al.*, "Extreme variation in migration strategies between and within wandering albatross populations during their sabbatical year and their fitness consequences," *Nature* (March 9, 2015)

Red-necked Phalarope van Bemmelen *et al.*, "A Migratory Divide Among Red-Necked Phalaropes in the Western Palearctic Reveals Contrasting Migration and Wintering Movement Strategies," *Frontiers in Ecology and Evolution* (April 4, 2019)

Short-tailed Shearwater Carey *et al.*, "Trans-equatorial migration of Short-tailed Shearwaters revealed by geolocators," *Emu— Austral Ornithology* (December 22, 2016)

Sooty Tern Jaeger *et al.*, "Geolocation Reveals Year-Round at-Sea Distribution and Activity of a Superabundant Tropical Seabird, the Sooty Tern *Onychoprion fuscatus*," *Frontiers in Marine Science* (December 6, 2017)

Great Frigatebird Weimerskirch *et al.*, "Diversity of migration strategies among great frigatebird populations," *Journal of Avian Biology* (February 10, 2017)

White Stork A. Flack *et al.*, "Costs of migratory decisions: a comparison across eight white stork populations," *Science Advances* (2016)

Lesser Flamingo Simmons, "Declines and movements of lesser flamingos in Africa," *Waterbirds: The International Journal of Waterbird Biology* vol. 23, Special Publication 1 (2000); Aebischer *et al.* "Satellite tracking of flamingos in southern Africa: The importance of small wetlands for management and conservation," *Oryx* vol. 37, no. 4 (October 2003); Parasharya *et al.*, "Long-distance dispersal capability of Lesser Flamingo between India and Africa: genetic inferences for future conservation plans," *Ostrich, Journal of African Ornithology* vol. 86 (2015)

Willow Warbler Sokolovskis *et al.*, "Ten grams and 13,000 km on the wing—route choice in willow warblers *Phylloscopus trochilus yakutensis* migrating from Far East Russia to East Africa," *Movement Ecology* 6, 20 (2018)

Red-billed Quelea Dallimer, "Migration Patterns of the Red-billed Quelea *Quelea quelea* in Southern Africa: Genetics, Morphology and Behaviour," *Ibis* (2001)

Red-backed Shrike Sjöberg *et al.*, "Barometer logging reveals new dimensions of individual songbird migration," *Journal of Avian Biology* (June 29, 2018); Tøttrup *et al.*, "Migration of red-backed shrikes from the Iberian Peninsula: optimal or sub-optimal detour?" *Journal of Avian Biology* (February 10, 2017)

Honey Buzzard Agostini *et al.*, "Loop migration of adult European Honey Buzzards *Pernis apivorus* through the Central-Eastern Mediterranean," *Italian Journal of Zoology*, vol. 79, issue 2 (2012)

Osprey Horton *et al.*, "Juvenile Osprey Navigation during Trans-Oceanic Migration," *PLOS One* (December 10, 2014)

Short-toed Snake Eagle Mellone *et al.*, "Resolving the puzzle of Short-toed Eagle migration," *Ibis* (2016)

Steppe Eagle Meyburg *et al.*, "Steppe Eagle migration strategies—revealed by satellite telemetry," *British Birds* 105 (9) (September 2012)

Short-eared Owl Johnson *et al.*, "Seasonal Movements of the Short-Eared Owl (*Asio flammeus*) in Western North America as Revealed by Satellite Telemetry," *Journal of Raptor Research* 51 (2) (June 1, 2017)

Common Cuckoo Hewson *et al.*, "Population decline is linked to migration route in the Common Cuckoo, a long-distance nocturnally-migrating bird ," *British Trust for Ornithology Publications* (July 1, 2016)

European roller Finch *et al.*, "Migratory connectivity in European Rollers," *Ibis* (2015)

PROTECTING AND STUDYING MIGRATORY BIRDS

The following organisations are all involved in the study and conservation of migratory birds. Some offer citizen science projects in which volunteers can participate.

Audubon Society (www.audubon.org) North America's leading conservation organisation, with over 450 chapters across the United States. Promotes the protection of migratory birds, with publications, wildlife preserves, and citizen science projects.

Birdlife International (www.birdlife.org) Global partnership of conservation organisations that works to conserve migratory birds, their habitats, and global biodiversity. Its online Data Zone (datazone.birdlife.org) provides a comprehensive reference to all the world's bird species and their migratory movements.

BirdTrack (www.bto.org/our-science/projects/birdtrack) Citizen science project created in partnership between the BTO, the RSPB, Birdwatch Ireland, the Scottish Ornithologists' Club, and the Welsh Ornithological Society to monitor migration movements and distributions of birds throughout Britain and Ireland. Contributes important data to migration science, while allowing participants to submit and share records.

British Antarctic Survey (www.bas.ac.uk) World-leading centre for polar science, with numerous research programmes dedicated to migratory seabirds.

British Trust for Ornithology (www.bto.org) UK charity that focuses on the understanding of birds and changing bird populations. Since 1933, the BTO has been working with volunteers to advance ornithology through surveys and monitoring schemes.

Cornell Lab of Ornithology (birdsna.org) Comprehensive reference for over 760 bird species that breed in the United States and Canada, with expert, in-depth species accounts, together with sounds, images, video, and distribution maps.

ebird (ebird.org) Online resource that co-ordinates observations from birdwatchers worldwide to create huge data sets that help inform the study and conservation of migratory birds.

IUCN (www.iucn.org) The International Union for the Conservation of Nature. An international NGO founded in 1948 that gathers data in order to monitor the conservation status of all plant and animal species on Earth. The IUCN Red List assigns each species a conservation category, ranging from Least Concern to Critically Endangered.

Journey North (journeynorth.org) Citizen Science program based at the University of Wisconsin–Madison Arboretum, USA, enabling people across North America to report and map migratory bird movements in real time. Now has over 60,000 registered participating sites.

RSPB (www.rspb.org.uk) The Royal Society for the Protection of Birds is the United Kingdom's largest nature conservation charity. It lobbies for conservation, encourages citizen science, manages nature reserves, and works with numerous international partners to promote bird conservation and research worldwide.

Seabird Tracking Database (www.seabirdtracking.org) The world's largest collection of seabird tracking data, curated by Birdlife International. Aims to help further seabird conservation work and support the tracking community. Includes data for over fifty species of seabird, collected from around 100 breeding colonies and provided by more than 100 researchers.

Smithsonian Migratory Bird Center (nationalzoo.si.edu/migratory-birds) Center at the world's largest museum and research complex dedicated to understanding, conserving, and championing bird migration, located at the Smithsonian's National Zoo in Washington, DC. Programs investigate why migratory bird populations are declining, while raising awareness about migratory birds and the need to protect their habitats across the Western Hemisphere.

World Migratory Birds Day (www.worldmigratorybirdday.org) Global annual awareness-raising campaign highlighting the need to conserve migratory birds and their habitats, through public events such as bird festivals, education programmes, exhibitions, and bird-watching excursions. A joint initiative, founded in October 2017, between the Environment for the Americas (EFTA), the Convention on Migratory Species (CMS), and the Agreement on the Conservation of African-Eurasian Migratory Waterbirds (AEWA).

INDEX

ACKNOWLEDGMENTS

Author (Mike Unwin)

I would like to thank all those whose hard work and encouragement lie behind this book. It was a pleasure once again working with the team at Quarto. I am grateful to Philip Cooper for getting the ball rolling, to Michael Brunström for presiding over the project, to David Callahan for his editorial expertise and keen birder's eye, and to Paileen Currie for putting together such a lovely set of layouts. I am also grateful to Jean Thomson Black and her team at Yale for believing in the book, and for keeping us on the ball with their detailed and helpful scrutiny at every stage.

As ever, it was both a privilege and a pleasure working with David Tipling, whose stunning pictures not only reflect his love and knowledge of birds but also reveal the eye of an artist. Having made my own, less distinguished attempts to photograph migratory birds, I am well aware of the challenges it entails. Somehow David's eye is attuned both to the individuality of these winged wonders and to the drama of the broader spectacles they create. The results speak for themselves.

I am grateful to all those naturalists and conservationists whose passion, skill, and dedication over the years has taught us what we now know today about the miracle of bird migration—and who are today alerting the world to the threats that so many species face.

Finally, I would like to thank my own family: my parents, who encouraged my love of nature from the earliest days; and my wife Kathy, and daughter Florence, with whom I have shared many memorable wildlife moments watching migratory birds, both at home and on our travels.

Photographer (David Tipling)

Watching half a million Sandhill Cranes arriving to roost at their traditional staging site on the Platte River in Nebraska or witnessing a lone Short-eared Owl flying in off the North Sea close to my home on England's east coast are equally exciting experiences. Visually, they are very different, but both generate that same frisson of excitement that accompanies the sight of birds on migration. Such encounters often give opportunities to make powerful photographs, too.

We live in an age where there is an apparent glut of great images of migratory birds. This is especially true for larger species such as cranes, for which photography is relatively straightforward. But for smaller birds the challenge is far greater. It soon became apparent to me when selecting images for this book that there are still many challenges left for the intrepid bird photographer to illustrate birds on the move. For many species, we have only just scratched the surface.

As this book has evolved so has the picture selection. Fine tuning resulting in the regular swapping of pictures is important in ensuring the book has as much visual impact as possible and this is a team effort. It has been a great pleasure to work once more with Mike Unwin, who shares a passion for great photography and whose input to the picture selection is invaluable. A big thank you, also, to our wonderful designer Paileen Currie and our editor Michael Brunström who kept everything on track.

PICTURE CREDITS

All photographs by David Tipling (birdphoto.co.uk) except for the following:

page 15 (top left) Design Pics Inc./Alamy; **page 20** Nathaniel Attard/BirdLife Malta; **page 23 (top)** Chris Schenk/Alamy; **page 23 (bottom)** Mike Unwin; **page 33** Dong Lei/Nature Picture Library; **page 39** Neal Mishler/Alamy; **page 45** Steve Oehlenschlager/Alamy; **page 56** Roberta Olenik/Alamy; **page 59** Auscape/Alamy; **page 60** Donovan Klein/Alamy; **page 61** Auscape/Alamy; **pages 76–77** Ole Jorgen Liodden/Nature Picture Library; **pages 83–84** Mark Cawardine/Nature Picture Library; **page 92** Pete Morris/Alamy; **page 95** Luciano Candisani/Alamy; **page 96** Pete Oxford/Alamy; **pages 98–99** Chris & Monique Fallows/Nature Picture Library/Alamy; **page 138** Paul Sterry/Alamy; **page 167** All Canada Photos/ Alamy; **page 188** G. Lacz/Alamy; **page 191** Jabruson/Nature Picture Library; **page 213** Alan Murphy/Nature Picture Library; **page 215** Alan Murphy/Nature Picture Library; **page 216** Stephanie Starr/ Alamy; **page 222** Alan Murphy/Nature Picture Library; **page 227** Markus Varesvuo/Nature Picture Library; **page 228** M.Wolke/ Alamy; **page 231** Markus Varesvuo; **page 235** Connor Stefanison/ Nature Picture Library; **page 256** Markus Varesvuo/Nature Picture Library; **page 259** Wim van-den Heever/Nature Picture Library; pages **260–261** Will Burrard-Lucas Nature Picture Library; **page 262** Alan Murphy/Nature Picture Library; **page 265** Rolf Nusbaumer/ Nature Picture Library; **page 267** Frederic Desmette/Alamy; **page 276** Martin Willis/Nature Picture Library; **page 278** Marc Anderson/Alamy; **page 279** Roland Seitre/Alamy